JOACHIM GASQUET'S CÉZANNE

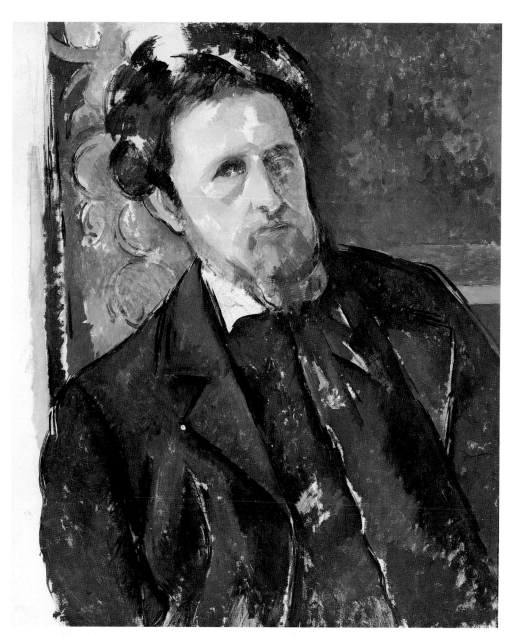

Portrait of Joachim Gasquet, 1896–97

JOACHIM GASQUET'S CÉZANNE

A Memoir with Conversations

Translated by Christopher Pemberton
Preface by John Rewald
Introduction by Richard Shiff

with 61 illustrations

THAMES AND HUDSON

[Dedication in original]

'To Louis Vauxelles'

Translated from the French by Christopher Pemberton

The Preface by John Rewald is an extract from his book *Cézanne, Geffroy et Gasquet, suivi de Souvenirs sur Cézanne de Louis Aurenche et de Lettres inédites*, published by Quatre Chemins-Editart (Paris 1959), copyright © 1959 John Rewald

Printed and bound in Singapore

CONTENTS

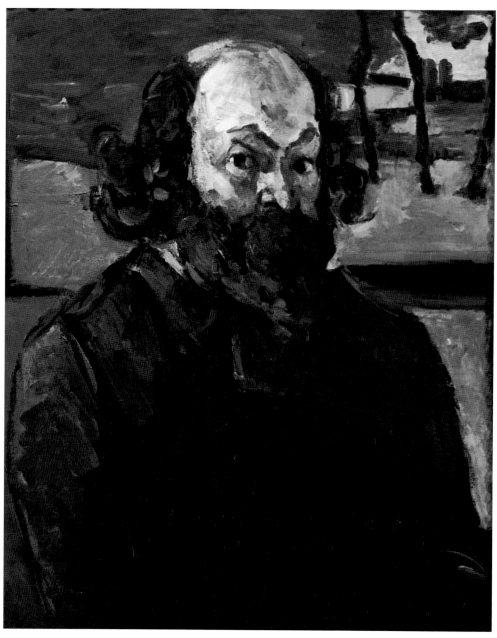

Self-portrait, 1873–74

John Rewald

PREFACE

Basically we know precious little about the relations between Cézanne and Joachim Gasquet, who was at the same time one of his last friends and one of his first biographers. And the little we know we owe to Gasquet himself, Gasquet who was more of a poet than an historian, more an apologist than a scrupulous witness. In the book he devoted to the artist[1], published fifteen years after Cézanne's death and seven years after the appearance of Vollard's biography[2], Gasquet painted himself as the intimate companion of the famous old man, without dwelling, quite naturally, on anything which might detract from their friendship. But one thing seems certain: this friendship ended in a rupture which, according to Edmond Jaloux, the friend of both Gasquet and Cézanne, the poet 'was reluctant to elucidate.'

According to Gasquet, when he reconstructed his 'imaginary conversations' with Cézanne for his volume on the artist, he used, among other sources, letters addressed to him by the painter. In a special note he pointed out that these documents would be published after his death (which occurred shortly after his book appeared). But around 1935, when I was compiling Cézanne's correspondence[3], I called on Gasquet's widow and was told by her that these precious documents had been lost forever. They were kept in the drawer of an old table that was sold one day with its contents. It has since been proven that this story was an invention. Eventually Mme Joachim Gasquet gave to the Bibliothèque Méjanes at Aix-en-Provence many of her husband's manuscripts as well as his correspondence. Among these papers a cache of letters from Cézanne to Gasquet was discovered. They were published by me in 1959; not all of them were unpublished, since the most important ones and a few extracts had appeared in Gasquet's book. And there may have been more letters than those that have survived. But one thing became clear: even where the poet had drawn inspiration from Cézanne's letters for his 'imaginary conversations' with him, he had not

quoted them literally but instead had rewritten them in his own flowery language that is far removed from that of the painter. Cézanne's vocabulary and forms of expression had nothing to with Gasquet's.

The relations between the two men followed a course somewhat parallel to most of the painter's friendships, almost all of them characterized by an initial infatuation followed by an insurmountable mistrust. It is surely no accident that the portrait Cézanne made of Gasquet remained unfinished, just like the earlier ones of Zola and – though to a lesser extent – Geffroy.

It so happens that Cézanne detached himself from Gustave Geffroy at the same time that he made the acquaintance of another man of letters, Joachim Gasquet. His first meeting with Gasquet took place in March or April 1896 on the *terrasse* of a café. The painter was joined there that day by one of his old schoolmates, Gasquet's father, with his son, and two other companions of his youth. The rather touching attachment Cézanne felt for everything that bound him to Aix and his childhood placed that meeting under very favourable auspices. Besides, still upset by the recent experience of his first one-man show in Paris, he seemed deranged in his solitude, fearful of new faces, even suspicious.

Cézanne was at that time 57 years old, already suffering from diabetes, and appeared older; the poet Gasquet was exactly 23 (two years younger than Cézanne's son). But faced with the young man's ardent enthusiasm, the old misanthrope permitted himself to be convinced by his sincerity, and when Gasquet praised a *View of Sainte-Victoire* which he had admired at a small local exhibition, Cézanne offered it to him on the spot (or at least that is what the poet reports, although the gesture is contradictory to the painter's habits). According to Gasquet, this first meeting was prolonged by a dinner and – during the following days – by long walks and interminable discussions.

Joachim Gasquet was in every way different from his older colleague, Gustave Geffroy. The latter was at that time in the vanguard of liberal forces, a collaborator in the journal *La Justice*, which had been founded by Camille Pelletan and was managed by Georges Clemenceau. He excelled in polemics, willingly embraced the cause of the disinherited, among them artists whom the public refused to recognize, and drew from every event conclusions of a moral or social order. Gasquet, brought up in the bigoted setting of a small provincial town, smitten by Symbolist literature and by philosophy, an active royalist, regionalist, *félibre* and devout Catholic, was politically as far removed from Geffroy as possible. If Geffroy could have been regarded as 'a man of the

Left', Gasquet was undoubtedly a chauvinist; in 1917 he even wrote a book on *The Blessings of War*. Yet there can be no doubt that Cézanne's sympathy leaned towards young Gasquet's ideology rather than towards Geffroy's.

With his handsome Greek face, his fair colouring, his thick long hair and his golden beard, Gasquet at that time, according to the memoir of Edmond Jaloux, resembled a young Dionysos. His eloquence, his gift for improvisation, his humanistic qualities, all made him an extremely attractive man. He was exempt from daily cares, thanks to his father's affluence, which allowed him to devote himself freely to his literary projects without obliging him to submit to a rigorous discipline. His father had one of the most popular bakeries in Aix; he was a bourgeois, with a dignified face, a grave manner, and looked like a small-town notary. Being modest in his tastes, Henri Gasquet refused to give up his trade in spite of his wealth.

The friendly relations between the painter and young Gasquet soon experienced their first shadows. The walks and the conversations were too abruptly changing the painter's habits of solitude. And once again he seems to have been impelled towards one of those sudden returns into himself, as was his wont. Apparently fearful of getting involved in too many confidences by this new and talkative admirer, Cézanne wrote a short note to say he was leaving for Paris. In fact, Cézanne wasn't leaving at all. He had simply found this a convenient excuse to sidestep an intimacy which threatened to become oppressive. But, as fate would have it, two weeks later the painter and the poet passed each other on the town's main avenue. Cézanne thereupon wrote the long embarrassed and explanatory letter which Gasquet quotes in full. The breach was healed and Cézanne suggested that he paint Gasquet's portrait, which was to remain in a less advanced state than those he painted of Geffroy and Henri Gasquet.

During May the two men must have seen each other again frequently, as confirmed by the following letter of 21 May 1896:

> Dear Monsieur Gasquet, Obliged to return to town early this evening, I was unable to be at the Jas [de Bouffan]. I beg you to forgive this mischance.
> Yesterday afternoon at 5 o'clock I had not received either Geffroy's *Le coeur et l'esprit* nor the *Figaro* article. I have sent a wire to Paris about this.
> Tomorrow then, Wednesday, if you wish, at the usual time...

This letter contains a phrase which is, to say the least, troubling – the one in which Cézanne speaks of ordering two publications by telegram

from Paris. It seems probable that 'the *Figaro* article' had been brought to his attention by Gasquet in such an urgent way that Cézanne felt an extraordinary impatience to get hold of it. One may well wonder why the poet had called the artist's attention to this piece. It was an article on painting by Emile Zola, published on 2 May and concerning the two Salons of 1896. It contains such an offensive reference to Cézanne that it would have been more charitable not to reveal it to him, who for thirty years had been linked in close friendship to the novelist. It is hardly possible that Gasquet was unaware of the break in this friendship since the appearance of *L'Oeuvre* in 1886, or that he did not know that Cézanne still retained an affection mixed with sadness for the now famous man who had been his inseparable boyhood companion. However, Gasquet's political views and religious beliefs, so fundamentally opposed to Zola's liberalism and atheism (which coincided with Geffroy's views), may have led him to inform the painter of an article which could only revive his resentment and his rancour against the novelist.

Zola's article was to be described later by Geffroy as 'a kind of victory fanfare played as a funeral march.' What Zola appears to be doing in the article is saying farewell to all the artistic convictions he had fought for during his youth, when he was an impassioned defender of Manet and a friend of those who were shortly afterwards called the 'Impressionists'. Remembering that period, Zola spoke of his enthusiasm thirty years before and explained in passing: 'I had grown up virtually in the same cradle as my friend, my brother Paul Cézanne, in whom one is only now beginning to discover the touches of genius of an aborted painter.' A singular accolade which describes Cézanne as a brother, almost a genius, but at the same time an aborted artist!

By a curious coincidence, Cézanne's letter also refers to a book by Geffroy, which he was simultaneously ordering from Paris by wire. This presents a true mystery, for *Le coeur et l'esprit* had already appeared at the end of 1894 and the author had himself sent a copy of it inscribed to the artist. Had Cézanne left the book in Paris (his letter of thanks was dated from there) and did he now want it sent in order to show it to Gasquet? Or did he simply wish to hide from Gasquet the fact that he already had the book with its flattering inscription, and preferred to obtain a new copy? Since we must believe that he had often spoken against Geffroy in the company of his new friend, the painter may have felt some embarrassment about revealing that he had formerly been on such cordial terms with him. Once launched on his path of denigration,

he had to dissimulate his friendly relations with the writer in order to camouflage a little what might seem to be ingratitude.

The fact is that Cézanne slandered Geffroy not only to Gasquet but also to his dealer Vollard, to whom he wrote rather enigmatically: 'Geffroy has written a book, *Le coeur et l'esprit*, in which there are some very beautiful things, among them a feeling for the impossible. How could this distinguished critic arrive at such a complete castration of sentiment? He has become a businessman.'[4]

At Aix, the frequent meetings between Cézanne and Gasquet, devoted partly to the latter's portrait, were interrupted at the beginning of June 1896 by the painter's departure with his wife and son for Vichy. It was there that the artist received the first number of a little review founded by Gasquet, *Les Mois dorés*. The poet apparently asked at the same time whether Cézanne would like to be associated with the enterprise. But considering that his 'advanced age' prohibited him from joining a venture of young people, and using the pretext that his 'inexperience of life' would only hamper 'the progress of those setting out in life', Cézanne declined in veiled terms, though cordially.

At the end of the same month, still in Vichy, Cézanne received the second issue of Gasquet's review, which he acknowledged with a friendly letter, saying that it 'reminded him of the homeland he missed'. No doubt encouraged by Cézanne's kind reception of his little periodical, which was devoted principally to poetry, Gasquet undertook to write an article on the painter. This was a rather risky undertaking, in view of the way the artist had reacted to the writings of Geffroy. It is true that Gasquet, less knowledgeable about art than Geffroy, would speak mainly of that soil of Provence which Cézanne loved so much.

The article 'Juillet' was not exclusively about Cézanne but is already in Gasquet's soporific style. On the other hand, the amazing thing is that Cézanne should not have been dismayed by the entirely literary interpretations and dubious inventions of the text, for example the statement that he adored 'with ecstasy and simplicity' that Provençal sun that 'visited his heart and his canvases'. However, the almost blind loyalty towards anything that linked him to his Provence must have led the painter to be indulgent. Even Gasquet's announcement that he intended to devote a book to him does not seem to have alarmed the old master, usually so opposed to any publicity. Cézanne's attitude in this situation seems to have been dictated above all by resignation, reflected also in a letter he wrote from Paris to Gasquet to thank him for the two most recent issues of the review.

At the end of June 1897 Cézanne was back in Aix where he remained until the following year. It is certain that he saw Gasquet again, even though he worked only little at the Jas de Bouffan, and went often to the village of Le Tholonet, to the Château Noir (halfway between Aix and Le Tholonet) and the Bibémus Quarry.

The two letters Cézanne wrote to Gasquet from Le Tholonet are letters of excuse. It seems that the painter was going through a period of weariness and nothing was more natural than that he should try to protect his solitude.

In October Cézanne's mother died, a loss which affected him deeply. In the event the Jas was sold and Céanne lost that corner of his native land to which he was most attached. He began to work mostly at the Château Noir. But in the summer of 1898 he was in Paris, and received there a new number of *Les Mois dorés* which contained an article by Gasquet on Provence. He described Cézanne as 'a rustic and noble' Provençal artist. Did Cézanne see that there was something a bit ridiculous in trying to reduce him to the level of a regional artist, did he understand that Gasquet's enthusiasm for his work was part of the frantic efforts he was making to bring lustre back to Provence, efforts in which the painter found himself included because of his subjects rather than his pictorial innovations? Perhaps; but one has to believe, nonetheless, that Cézanne resigned himself to this approximate understanding which might be acceptable to him since it offered the hope of progress. In his letter of ackowledgment, Cézanne praised 'the superb lines in which you exalt the blood of Provence', referring to the title of the article, *Le sang provençal.* The outcome of this letter was that Gasquet appeared uninvited in Paris. Once contact was reestablished, they must have spent a lot of time together again, notably visiting the Louvre, as reported by the poet in his 'imaginary conversations'. Although the words Gasquet was later to put into the artist's mouth bear the seal of his own dithyrambic style, it is probable that Cézanne did his best to initiate the young man into the mysteries of art, even though he knew that Gasquet was no more capable than Geffroy of grasping his ideas. Nevertheless the poet knew how to listen (or so we must hope) and how to make his old friend talk, and Cézanne, far from Aix, must have appreciated in him an enthusiastic companion from the south.

After a long silence, Cézanne returned to Aix in autumn 1899 to look after the removal of his belongings from the Jas de Bouffan. He rented an apartment in rue Boulegon in Aix and had an atelier arranged for him there. During the construction work, he accepted the hospitality

offered by Gasquet, and it was apparently during this visit that their relations became disturbed. According to some reports, the poet lacked delicacy in his behaviour towards the old man who felt he was being 'exploited'. The poet, who already owned the *View of Sainte-Victoire* and perhaps other of Cézanne's works, such as *The Old Woman with a Rosary*, seems to have given him the impression of wanting 'to get his hooks into' his canvases. It is true that, towards the end of his life, the painter was quick to suspect people around him of similar intentions. But there can be no doubt that this constant fear played a large part in the cooling-off of his relations with Gasquet.

Whatever the case, if there was a falling-out, it was not complete, for Cézanne and Gasquet continued to maintain fairly cordial relations. But from then on the painter expressed himself in terms of disillusionment on the subject of Gasquet.

In the autumn of 1900 Cézanne seems to have seen more of the poet, in whose home he met several of Gasquet's young friends. But he was ill at ease among them, and a letter of early 1901 indicates that their meetings had tailed off. Yet, even as late as May 1902, Cézanne was writing to the poet to ask him to lend one of his paintings for an exhibition. Gasquet gave reasons for refusing to do so, and Cézanne accepted his refusal politely.

After 1904 Gasquet's name barely appears in Cézanne's letters and any such references are rather pejorative. The two men never saw each other again.

1 Joachim Gasquet: *Cézanne*, Paris, 1921 (second ed. 1926)
2 Ambroise Vollard: *Paul Cézanne*, Paris 1914
3 Paul Cézanne: *Correspondance*, Paris, 1936
4 Unpublished passage of a letter to Ambroise Vollard, Aix, 9 January 1903. When Vollard reproduced this letter, he suppressed the lines quoted here in order not to offend Geffroy who lived until 1926.

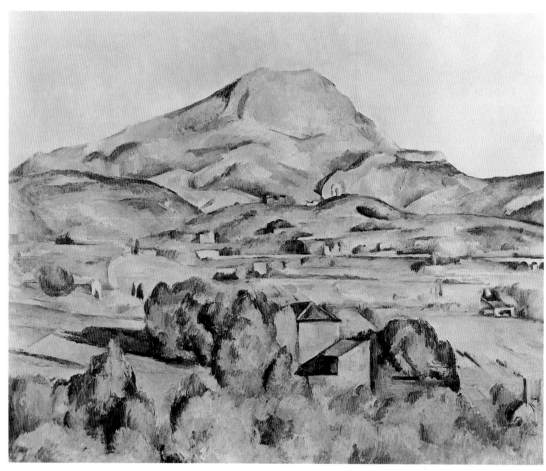

The Arc Valley and Mont Sainte-Victoire, 1892–93

RICHARD SHIFF

INTRODUCTION

By 1921, when Joachim Gasquet published his book on Paul Cézanne, much of its information was already available. Other witness accounts – particularly those by Emile Bernard, Maurice Denis, and Ambroise Vollard – preceded Gasquet's in conveying the artist's thoughts.[1] But this new text had its own distinct quality: it dramatized Cézanne's intellectual musings so as to integrate them with shifts in his immediate emotional state; Gasquet introduced more of Cézanne's personality than did Bernard or Denis; and overall, his account had greater plausibility than Vollard's. As a result, his book affected subsequent interpretation on a broad front, eventually frustrating historians' attempts to discern the various lines of affiliation among writers on Cézanne; for Gasquet drew copiously from his predecessors, usually without obvious indication of their presence. His text is an odd compilation of documents reassembled apart from initial contexts and interspersed with a set of observations that are sometimes quite different, Gasquet's own.[2]

Traces of Gasquet abound. When Roger Fry was preparing his definitive critique of Cézanne's oeuvre (published in 1927), he took his epigraph from Gasquet's book, the painter's quoted remark, 'art is a harmony parallel to nature'. At the end of his study Fry argued that Cézanne repressed romantic excesses by means of a disciplined classical style; this formulation also may derive from Gasquet, who offered a similar interpretation at several points in his narrative.[3] Later, in 1945, Maurice Merleau-Ponty used Gasquet's account to support his claim that Cézanne consciously struggled with the phenomenological dimension of painting. To this end, Merleau-Ponty cited a passage of philosophical speculation which, coincidentally, had interested Fry: 'The landscape is reflected, humanized, rationalized within me ... I would see myself as the subjective consciousness of that landscape, and my canvas as its objective consciousness' (150; 132).[4] And in 1968 Meyer Schapiro recalled Gasquet's story of how Emile Zola solidified his re-

lationship to the painter with a boyhood gift of apples, 'the Cézanne apples' (39; 18–19).[5] With this as a reference point, Schapiro proceeded to analyse the complex psychological significance of apples and other objects in Cézanne's still-lifes.

These celebrated critical interpretations by Fry, Merleau-Ponty, and Schapiro bear witness to the fact that the details of Gasquet's colourful narrative have been given credence and his text has become quite celebrated itself. Yet most commentators argue, with good evidence, that Gasquet followed his own interests and attached to the painter an inappropriately poetic mode of verbal expression.[6] It has always been recognized that Gasquet produced a very liberal reconstruction of Cézanne's thinking calculated to serve his own purposes. But because his text is so richly nuanced and seems so true in many respects, historians have been disinclined to reject it. Perhaps it would be too much to expect an academic scrupulousness from a man who never tried to claim historical objectivity: 'however objective one would like to be,' Gasquet concedes, perhaps disingenuously, 'a little of oneself is always unconsciously creeping in' (146; 128).

The interview-dialogue form that Gasquet chose was at the time, as it is even now, an especially popular device for conveying ideas about art. With an orderly set of questions and the liberty to reconstruct answers, one is able to channel impassioned, and perhaps disorderly, thinking about a very elusive subject. The interviewer guides the course of discussion, all the while seeming to defer to thoughts of genius emanating from the master artist. Auguste Rodin's *L'art: entretiens réunies par Paul Gsell* is one example from among many precedents for Gasquet's project of entering into a 'conversation'.[7] It was published with Rodin as author, but the interviewer Paul Gsell played an active role in constructing the exchange and determining its content; included are conversations conducted in the artist's studio and at the Louvre, just as in Gasquet's book. Such accounts sought to vivify aesthetic doctrine, linking it to real artistic personalities in situations with which the reader could feel familiar (those sufficiently interested in art to read a book about the still somewhat mysterious Cézanne had themselves surely walked through a museum). Gasquet's Cézanne engages in rambling philosophical excursions punctuated by colloquialisms, verbal humour, crude language, and sudden changes of mood, all as he sets about his professional daily activities – painting at the site, studying in the Louvre, working in the studio. The narrative is intimate, revealing all the artist's idiosyncrasies. He emerges as an obsessive thinker and pain-

ter, as well as a sensitive and volatile individual, the antithesis not only of proper bourgeois provincials, but of dry academics and dispassionate intellectuals. In short, he is made to fit the stereotype of the creative genius – but the genius next door, the local variety.

Beyond this generalization, who was Cézanne, as Gasquet saw him? There is a 'family' relationship that needs to be considered. In an obvious sense, Cézanne must have been a father figure since he belonged to the generation of Gasquet's actual father, one of the painter's old schoolmates. This was no casual substitution, for Gasquet could find mirrored in Cézanne the creative aspirations that were the young poet's own and which his father Henri lacked. At the least, the Provençal painter provided an ideal surface for the projection of the values Gasquet associated with his birthright. Cézanne had not only been raised in the same town of Aix-en-Provence, but had lived under similar conditions: both men were sons of successful entrepreneurs, growing up in privileged domestic environments that allowed the children to dream of art. The source of the older Gasquet's wealth was his bakery; and so the very first sentence of his son's book sings of the local grain of Aix, which 'is said to produce the best bread in the world' (33; 11). Provence is the setting for a life that is Gasquet's as much as Cézanne's.

In his youth, Cézanne struggled with his father, the town's prominent banker, over choosing his profession (Gasquet tells a version of the story [56; 34–36]). By 1896, however, when Gasquet first encountered him, the painter had long been enjoying an independent income; he may have been emotionally buffeted by a lack of local approval verging on open hostility, but he was hardly damaged materially. Cézanne's life thus represented a kind of worldly freedom as much as his art signified creative and aesthetic freedom. Perhaps Gasquet tacitly recognized that the latter freedom depended on the former; for, like Cézanne, he used an independent income to secure viability as an artist. Yet as a visibly refined figure who indulged in a château, banquets, and personal luxuries, he could not have appeared more unlike the scruffy old man, who cultivated uncouthness. In actual style of life, there is little to relate the two. The difference is implicit in Gasquet's own description of how the painter lived: 'In his dining room, there was a landscape of Aix and a still-life. That was the extent of his luxury. His work was all he cared about' (128; 108). Such asceticism may have made Cézanne seem all the more an ideal type, a purer form of artist than Gasquet, whose sensuality was less singularly channeled, would himself ever attempt to be.

It is clear at least that Gasquet's Cézanne represents resistance to the

bourgeois pragmatism of the citizens of Aix. He is entirely absorbed by his art, suffering fits of enthusiasm like those that marked the writer (it was said that Gasquet's intellectual and sensory exaltation left him 'in a state of continual intoxication' – his style is the best demonstration).[8] How unlike the detachment and understatement of the elder Gasquet, who, as Cézanne paints his portrait, participates only laconically in the three-way conversation (205–224; 187–208). Henri Gasquet cares little about the philosophy of art and merely defers to his son Joachim: 'Do I seem a bit cracked to you Henri,' Cézanne asks; 'No. No. The boy understands you' (220; 203). It is one of a number of mildly comic moments in the dialogue. Cézanne provided Gasquet with a model for those qualities that his real father never developed, qualities that the son was free to cultivate. Indeed, he displayed them in the exuberant, often bombastic statements he assembled to represent Cézanne's thought. The more extreme examples of rhetoric and witticism combine with fragments of prose that are often just as speculative yet entirely genuine, having been gleaned from the artist's letters.

Gasquet composed his text initially during the winter of 1912–13, but it appeared in print only after the War in 1921, perhaps reworked.[9] This was a period of intensified nationalism in France as well as continuing intense interest in Cézanne's painting, which by that point was commonly associated with the radical aesthetics of both Paul Gauguin's primitivism and Pablo Picasso's cubism. Despite the use other artists were making of Cézanne's formal innovations and oddities, Gasquet argued that the Cézannean revolution had in fact been directed at reform and a return to traditional values. He linked the painter's practice to a rather conservative sense of nationalism by presenting him as a classicist of a special sort – not a follower of abstract artistic principles to be gathered from generalized academic teaching, but instead one who immersed himself in a nature very close to home, Aix-en-Provence, the native soil of both painter and writer. Classicism came from, and belonged to, the land as much as the mind.

Gasquet's advocacy of classicism paralleled the aesthetic program of Action française, the right-wing, royalist movement he and his political and literary associates supported. Action française took the position that 'there is a French "nationalism" in art and literature: it is a form of classicism.'[10] Although opinionated, Cézanne himself appears to have been inactive politically; but he and the cultural wing of Action française had at least one thing in common – an antipathy to Parisian intellectual leftism. This did not prevent some rightist critics from debunking the

artist's connection with classical values; indeed, although everyone had an interest in Cézanne, he always remained controversial. In 1919 Camille Mauclair wrote that this painter had 'aspired in his confusion to give impressionism a kind of classical stylization', creating in the process little more than paintings of 'brutal, barbaric gaudiness'. Where Gasquet found scrupulous attention to nature as well as orderly refinement, and hence a truly classical French spirit, Mauclair saw only barbaric, foreign elements. Some of the facts of the case were visual – Cézanne's brilliant (or, to Mauclair, gaudy) colours; and some were social – the painter's isolation and the marginality of his career. Whereas Gasquet identified Cézanne's regional sensibility with his development of a classical art of national consequence, Mauclair carped that the painter represented a minor provincial school, 'for which the local reputation would have sufficed'.[11] Mauclair was actually the more sophisticated viewer, but that explains nothing. It was, as so often, a matter of two critics with different agendas, deriving conflicting connotations and interpretations from the information at hand.[12]

The naturalistic classicism that Gasquet attributed to Cézanne agreed with the principles of Naturism, the literary movement the poet championed during the late 1890s, when he had his most intimate conversations with the painter. In an essay on Naturism in which he used Cézanne's attachment to the land around Aix as an example of artistic nurture, Gasquet made a broadly religious claim that he associated with classical paganism: while the material world created and sustained human life at each and every moment, that godlike life was in its turn creating the world.[13] The poet's many references to a kind of organic reciprocity, to Cézanne's belief that nature came alive in him as he painted, that he and nature became one, relate to this 'naturist' doctrine (and they are among the passages that most fascinated Fry and Merleau-Ponty). Here is an example: 'In the great classical lands – our Provence, [or] Greece and Italy as I imagine them – the light has a spiritual quality, and the landscape is like a hovering smile of acute intelligence . . . The delicacy of our atmosphere is linked to the delicacy of our qualities of mind. They exist one within the other' (152; 135). Gasquet's Cézanne expresses this reciprocity of mind and matter in a succinct yet mystifying statement of what painting accomplishes: 'We must live in harmony, my model, my colours and I, and together catch the same passing moment' (212; 195).[14]

For all his poetic excesses, Gasquet appreciated the sense of the local, the familiar, and the humble in Cézanne: the painter's painstaking in-

volvement in details of observation, his penchant for the most homely of still-life objects, and even his unpretentious regional accent. The writer wished to recover in the study of the land and language of his native Aix a timeless Mediterranean culture already revived and sustained by those whose art had responded to the sensory and emotional impact of the region. Cézanne was carrying on the best of this tradition because it was in his nature, as a pure Provençal, to do so. Gasquet repeatedly signaled the artist's 'natural' connection to classical Mediterranean culture by noting his 'latin instinct'. It was an inheritance from Italian forebears on his father's side, whereas from his mother's Creole family he received the contrary, a 'disorderly imagination' (42; 22).

Implicit in virtually all features of Gasquet's analysis are some traditional dichotomies, especially familiar to the critical and political discourse of the years surrounding the Great War. With respect to them Gasquet makes his allegiances clear: he favors southern over northern, latin over teutonic, classic over romantic, provincial purity over Parisian decadence, monarchical order over revolutionary anarchy (one could continue the list). The tone is set irrevocably on Gasquet's first page where he describes the country that Cézanne painted – 'one which Poussin would have loved with . . . the rational line of its hills' (33; 11). It is southern, classical, orderly by its very nature (and therefore accessible to a disciplined passion as well as a passion for discipline). Just as the land represents the classical spirit, so a work of art can represent the nation in which that spirit lives. Accordingly, when viewing the Victory of Samothrace at the Louvre, a work famously associated with both Greece and France, Cézanne says with excitement: 'It's an idea, it's a whole nation, a heroic moment in the life of a nation' (176; 163).

The thought may well belong to Gasquet and not Cézanne, but many contemporaries concurred that Cézanne was a new Poussin, even a new Greek, and certainly classical. His classicism was distinguished in being drawn from nature, rather than from artistic examples: 'classical by way of nature,' wrote Emile Bernard; 'so naturally a painter and so spontaneously classical,' exclaimed Maurice Denis.[15] It becomes evident (especially in view of Denis's formulation) that the 'nature' involved can be internal as well as external, the 'natural' character of the artist as well as that of the land. The two natures converge in an artist's 'sensation' since the vision and the feeling one experiences before nature belong to both the seer and the seen.[16] Gasquet said as much by recalling a moment in which the painter, gesturing toward the landscape, spoke of 'the nature that is there,' and then, tapping his forehead, referred to 'the nature that

is here, both of which have to fuse in order to endure' (150; 132). The same notion underlies a famous passage Gasquet apparently derived from what Bernard claimed he heard the master say: 'What I want is to be a true classic and rediscover a classic path by means of nature, by sensation' (158; 140).[17]

If these are not Cézanne's actual words, he did, at least, express related thoughts in several of his letters (and so did his old mentor, Camille Pissarro).[18] Yet he probably intended something different from what Bernard, on his part, understood. Seeking a coherent theory, Bernard considered Cézanne's study of nature as a means to an end, namely, to reestablish valid classical principles that could be applied in any artistic endeavour. In effect, Bernard's Cézanne was bringing classical order to nature rather than using nature to experience a classical order, one already present but perhaps masked.[19] Gasquet's sense of how classical order relates to the experience of nature may be closer than Bernard's to the painter's own since it involves a more explicit reciprocity. Although Cézanne wishes to discover a technique or 'formula' (173, 159), it eludes him; indeed, he expects no final success. He maintains his search by attending scrupulously to nature, following his sensation. The resulting classicism is like the French spirit. Mysterious and transcendent, it has no 'formula' but rather manifests itself through the creative conjunction of a classical landscape (Provence) and a receptive artistic sensibility (Cézanne): 'The landscape is reflected, humanized, rationalized within me' (150; 132). In this way art establishes a rational order while imposing neither preconceived systems nor mere conventions (derivative convention is what Bernard, for one, feared most).[20] The intellectual and moral order becomes apparent – that is, visible – 'naturally.' Because Gasquet believed that the realization of such natural order was the foundation of all great modern art, he could elsewhere describe Dominique Ingres's practice in the same way as Cézanne's: 'he idealizes everything naturally'.[21] The same critical formulation held, since one good classic does as another.

The great predecessor was not Ingres, of course, but Nicolas Poussin – student of the Mediterranean landscape, Frenchman of the Golden Age, and contemporary of René Descartes. Gasquet's passage on Cézanne's sense of Poussin and proper artistic method amplifies the pervasive theme of classicism; it also exemplifies the writer's recontextualization and dramatization of borrowed material. It is worth reviewing in some detail (210–211; 192–194). The scene occurs in the studio; the elder Gasquet, who hardly attends to the conversation, is having his

portrait painted. His son asks what Cézanne 'really mean[s] by classical,' since the painter so often says he wants to be classical. A simple stage direction for the reader follows: 'He pondered for a moment.' Then Cézanne blurts out his most renowned statement, as if for Gasquet alone to hear; the reader, of course, is there overhearing: 'Imagine Poussin completely repainted from nature. That's what I call classical.'[22] Done. And Gasquet bluntly informs the reader that Cézanne 'began to paint again.'

A moment later the artist resumes his speculation. He notes that Poussin's classicism does not confine him; it allows him to remain true to himself, to his own experience – this is again the 'naturalistic' or reciprocal element in Cézanne's classicism as Gasquet conceives it. Becoming classical is thus tantamount to discovering what the artist already possesses, a potential for experiencing his life and his environment in the most immediate and expressive manner. Accordingly, Cézanne continues by referring to Poussin's being 'a piece of French soil completely realized, [Descartes's] 'Discourse on Method' in action, a period of twenty, fifty years of our national life set down bodily on canvas . . . I'd like to carry on the same way from him, retrieve him from his period, without spoiling him, without spoiling either him or me, if I were classical, if I could become classical.'[23] Cézanne aims to become 'a Provençal Poussin,' which is to say that he will return Poussin to nature, his nature, Cézanne's. The classical past (Poussin's art) and the classical present (visions of Provence) merge in the intensity of Cézanne's experience as he paints the model at hand: 'Absolute submission to the object [is required] . . . You are the object, Henri, for this quarter of an hour . . .' (211–212; 194)

Around the time Gasquet met Cézanne, Poussin was indeed being praised for having returned to the direct study of landscape, rescuing art from a stultifying academicism that drained its classical vigour; art degenerated whenever painters were taught to imitate painters instead of nature.[24] In a related way, Cézanne is said to have complained (in 1902) that with the growth of museums and increased numbers of exhibitions – after all, even he had begun to show – artists no longer looked at nature but saw only pictures.[25] So Gasquet's sense of the issues to be addressed by Cézanne's art accorded with the concerns of the period, regardless of how foreign his own mode of expression might have been to the painter. If Gasquet articulated the thought of his own generation more than Cézanne's, it remains true that that generation provided the critical discourse by which Cézanne still tends to be known.

As a result, Gasquet's text remains remarkably suggestive for students of Cézanne's art as well as faithful to its own historical moment. This book will continue to stimulate interpretations that seek historical foundation even though no particular 'fact' in the account can be accepted without corroboration. Gasquet did not leave any pure documentation behind; his Cézanne is itself an interpretation, just as any painting by the artist is. Whether Gasquet's portrait of Cézanne has its own classical qualities is yet another matter of interpretation.

1 The most important publications include: Emile Bernard, 'Paul Cézanne,' *L'Occident* 6 (July 1904): 17–30; Emile Bernard, 'Souvenirs sur Paul Cézanne et lettres inédites,' *Mercure de France*, n.s., 69 (1, 16 October 1907): 385–404, 606–627; Maurice Denis, 'Cézanne,' *L'Occident* 12 (September 1907): 118–133; Ambroise Vollard, *Cézanne* (Paris: Vollard, 1914). Gasquet belonged to the same generation as the others who wrote on Cézanne, being only slightly younger.

2 For identification of passages that correspond to material from antecedent publications, as well as from Cézanne's letters (published and unpublished), see P. M. Doran, *Conversations avec Cézanne* (Paris: Macula, 1978), 106–161, 206–214. Gasquet took some of the statements in his book from Cézanne's answers to the parlor game of questions called 'Mes confidences,' probably datable to 1896. On this, see Doran, 101–104, 206; and Fabrice Touttavoult [Jean-Claude Lebensztejn], *Confessions* (Paris: Belin, 1988), 60–61. A brief text by Georges Lecomte ('Camille Pissarro, ' *Les hommes d'aujourd'hui* 8, no. 366 [1890]) should be added to those identified by Doran. It is the probable source for a passage on purification of the impressionist palette and optical mixture; see this translation, 164, and the second French edition (Joachim Gasquet, *Cézanne* [Paris: Bernheim-Jeune, 1926]), 148. Subsequent citations to Gasquet's *Cézanne* are included in the text; references to this translation precede corresponding references to the French edition. Translations other than from Gasquet's *Cézanne* are mine.

3 Roger Fry, *Cézanne: A Study of His Development* (Chicago: University of Chicago Press, 1989 [1927]), 1, 83. For Cézanne's statement on harmony (the source of which is his letter to Gasquet, 26 September 1897), see Gasquet, 150; 131. For Gasquet's references to romantic passion and classical control (a context in which Gasquet, like Fry, compares Cézanne to Gustave Flaubert), see 52, 86, 114; 30, 62, 92.

4 Maurice Merleau-Ponty, 'Le doute de Cézanne' (1945), *Sens et non-sens* (Paris: Nagel, 1966), 30. Cf. Fry, *Cézanne*, 68. Merleau-Ponty stressed the capacity of one's consciousness *of* an object to become the equivalent of attributing consciousness *to* an object, so that a thing might 'think itself' within the perceptual experience.

5 Meyer Schapiro, 'The Apples of Cézanne: An Essay on the Meaning of Still-Life' (1968), *Modern Art: 19th and 20th Centuries* (New York: George Braziller, 1978), 4.

6 The most informed account is John Rewald, *Cézanne, Geffroy et Gasquet, suivi de souvenirs sur Cézanne de Louis Aurenche et de lettres inédites* (Paris: Quatre Chemins-Editart, 1959); see esp. 53–55. See also the introductory statements by C. H. Pemberton and John Rewald, in this volume.

7 Auguste Rodin, *L'art: entretiens réunies par Paul Gsell* (Paris: Grasset, 1911). Closer to Gasquet's interests, and within a few weeks of his publication, Emile Bernard also offered a set of recollected 'conversations'; 'Une conversation avec Paul Cézanne,' *Mercure de Fance*, n.s., 148 (1 June 1921): 372–397.

8 Eugène Montfort, 'La mort de Gasquet,' *Les marges*, 15 June 1921, 85.

9 See Marie Gasquet, 'Biographie de Joachim Gasquet,' in Joachim Gasquet, *Des chants de l'amour et des hymnes* (Paris: Flammarion, 1928), 56.

10 *Revue de l'Action française*, 19 December 1901, as cited in Jacques Paugam, *L'age d'or du Maurrassisme* (Paris: Denoël, 1971), 87.

11 Camille Mauclair, *L'art indépendant français sous la troisième république* (Paris: La renaissance du livre, 1919), 26, 28.

12 The points on which Gasquet and Mauclair differed were apparently sensitive ones, regardless of whether the two writers were responding to one another. In his own brief statement Gasquet's associate Edmond Jaloux enjoined the same issues – Cézanne was characteristically Provençal, highly intelligent, and cultivated; his art captured the 'noble cadence of the horizons [of his native land]'; yet critics tended 'to transform him into a wild man, a barbarian of genius' ('Souvenirs sur Paul Cézanne', *L'amour de l'art* 1 [December 1920]: 285–286). As critics sought to master Cézanne's recalcitrant paintings by choosing apt descriptive terms, they established metaphors of 'solidity' and 'construction' that still prevail today. This particular literary device easily leads to opposing evaluations (like Gasquet's and Mauclair's) depending on whether emphasis is put on the simplicity of the painter's 'constructive' technique, which may appear excessively crude, or on the formal resolution of its product, which may seem quite definitive. For an early example of the use of such descriptive metaphors, cf. Adrien Mithouard, 'Le classique de demain,' *L'Occident* 1 (April 1902): 297: '[Cézanne] is a primitive builder [*un rude constructeur*], his works of a Roman massiveness standing like masonry.' In his criticism Mithouard avoided political debate. Yet the terms of his discourse (similar to those of his associate Maurice Denis) rendered such rude but solid construction desirable within a nationalistic, racial politics involving belief in the spiritual transference of cultural forms and values from the ancient East (Greece and Rome) to the modern West (France); cf. Adrien Mithouard, 'De l'Occident,' *L'Occident* 1 (December 1901): 5.

13 Joachim Gasquet, 'Notes pour servir à l'histoire du Naturisme,' *La plume* 9 (1 November 1897), 674.

14 See also 150–151, 168, 180, 214–215; 131–132, 153, 166, 198. On the interest of Fry and Merleau-Ponty, see note 4.

15 Bernard, 'Paul Cézanne,' 24 (supposedly quoting Cézanne himself); Denis, 'Cézanne,' 124.

16 Cf. Richard Shiff, *Cézanne and the End of Impressionism* (Chicago: University of Chicago Press, 1984), 187–189.

17 Cf. Bernard, 'Paul Cézanne,' 24; Bernard, 'Souvenirs sur Paul Cézanne et lettres inédites,' 401.

18 See, e.g., letters to Louis Aurenche, 25 January 1904, and to Emile Bernard, 26 May 1904, in John Rewald, ed., *Paul Cézanne, correspondance* (Paris: Grasset, 1978), 298, 302–303. See also Pissarro's letter to Lucien Pissarro, 26 November 1896, in John Rewald, ed., *Camille Pissarro: lettres à son fils Lucien* (Paris: Albin Michel 1950), 427: 'We [impressionists] ask nothing more than to be classical, but by reaching that state through our own sensation.'

19 See Shiff, *Cézanne and the End of Impressionism*, 124–132.

20 Cf. Bernard, 'Souvenirs sur Paul Cézanne et lettres inédites,' 627.

21 Joachim Gasquet, 'Un peintre de la volupté: Dominique Ingres,' *L'amour de l'art* 1 (October 1920), 185.

22 'Imaginez Poussin refait entièrement sur nature, voilà le classique que j'entends.' The statement exists in many variations, has never been definitively attributed to Cézanne himself, and can be translated in a number of somewhat different ways. On this statement, Cézanne's relationship to Poussin, and the general problem of Cézanne's classicism, see Theodore Reff, 'Cézanne and Poussin,' *Journal of the Warburg and Courtauld Institutes* 23 (1960): 150–174; Shiff, *Cézanne and the End of Impressionism*, 124–219, esp. 180–184; and Richard Shiff, 'The Original, the Imitation, the Copy, and the Spontaneous Classic,' *Yale French Studies* 66 (1984): 27–54.

23 There is a certain irony here since Poussin spent most of his career painting in Italy. But recall that one becomes French by claiming one's classical Mediterranean heritage.

24 Cf. Raymond Bouyer, 'Le paysage dans l'art,' *L'artiste* n.s., 6 (August 1893): 123. Because of the association of classicism with a return to the study of nature, brilliant colour (believed to signify an artist's direct observation of natural effects) could be regarded as a formal aspect of classical painting along with the more traditional feature of clearly delineated shapes.

25 See Jules Borély, 'Cézanne à Aix' (written 1902; published 1926 in *L'art vivant*), reprinted in Doran, *Conversations avec Cézanne*, 22.

CHRISTOPHER PEMBERTON

TRANSLATOR'S INTRODUCTION

Written for the most part in 1912–13, Gasquet's book appeared a few weeks before his death at the age of 48. It was reissued by the same publisher (Bernheim Jeune, Paris) in 1926, and has never been translated into English before, though it has been frequently quoted from.

The author's aim was to construct a portrait of 'the way [Cézanne] talked, and the way, I believe, he thought.' The result is a very personal memoir. It falls into two halves, first the leisurely, ornate biographical sketch with its evocation of Cézanne's youth in Aix and its intimate portrait of him in old age; and then the Conversations, imagined as taking place respectively during the course of a day's landscape painting, a visit to the Louvre, and a portrait sitting in Cézanne's studio at Aix.

The Conversations are the most serious part of the book, in the sense that they deal not only with passing comments but with a reasoned philosophy of painting much wider than anything we have from other sources. Poet, journalist and patriot, Gasquet was an ardent trader in broad cultural ideas: we have to accept that some of the phrases and extensions of thought are his. In the end the degree of their authenticity will remain a question of judgment, but a positive awareness of his own character, ideas and philosophy of life can help us to form some conclusions.

The Conversations are to some extent an amalgam of first-hand and borrowed material. Sections from Emile Bernard are dovetailed into the narrative. In passages specifically about the painter's task Gasquet keeps the wording and punctuation of borrowed texts intact, while using them in his own way.

As well as the short biography written by his wife Marie, there are accounts of Joachim Gasquet by his Aixois contemporaries Edmond Jaloux, Louis Bertrand, Louis Aurenche and Jean Royère, young writers for whom he was a figurehead in the still comparatively 'dead town' of Aix at the time he first met Cézanne, in the spring of 1896.

At 13 he had edited a publication called *The Grasshopper*, and by his twenties he had founded *The Syrinx*, a review to which Emmanuel Signoret and Paul Valéry contributed. He and his friends lived in an atmosphere of poetry recitals, with special meetings and meals in his room above his father's bakery, 'warmed by the old-fashioned ovens below, and smelling of yeast.' Literary meeetings were later to be his passion, and his wife would complain that 'he wasted his time going from cenacle to cenacle'. At his death it was probably for his association with the society of Provençal poets known as Le Félibrige that he was best known.

On 23 January 1896, two months before meeting Cézanne, Joachim had married Marie Girard, referred to by Cézanne that summer as 'the queen of the Félibrige who presides so magnificently over the revival of art in Provence'. The young couple were extrememly hospitable and it was in their house that Cézanne met Royère, Aurenche, and two young companions to whom he especially turned in his last years, the poet Léo Larguier and the painter Charles Camoin, both doing their military service at Aix. John Rewald alludes to the cooling off in his relationship with the Gasquets, beginning perhaps when he was their guest while waiting to move into his rue Boulegon studio in 1899. One contributing factor was that their style was gradually becoming too grand for him.

'They are like academics,' he wrote to his son by 1903. And to Camoin, 'How do you expect me to go to their salon where all I can say is 'Nom de Dieu'?' In 1902 they moved to what Cézanne called 'château life' at Eguilles, seven miles north-west of Aix. Although they pressed him to visit, it seems that he seldom went, though he wrote notes to say that he was 'with them morally'. After Cézanne's death, Joachim was to sell his *View of Sainte-Victoire* (now in the Courtauld Institute) and *The Old Woman with a Rosary* (now in the National Gallery), gifts from Cézanne which had hung alongside the two Van Goghs in the Gasquets' house in the rue Arts et Métiers.

The main events of Joachim's later life can be followed in Appendix I. On his father's retirement from the family bakery he had independent means. From 1900 onwards he experimented with writing 'aesthetic' novels, nature poems in a semi-symbolist, semi-'neo-classical' idiom, and fragments of plays based on Greek myths, continuing at the same time to publish popular articles on Provençal worthies and his favourite writers and thinkers. He was also a close friend of Charles Maurras and associated himself with the politics of the extreme right, 'a new order for France'. For a brief spell in 1906 he co-edited *Le Témoin* in Paris, but after six months it went bankrupt. He then travelled

increasingly, visiting Germany and speaking and writing about European culture. Early in 1914 he wrote in *La Jeune Europe*, 'War, no. A night of terrible dreams is passing over Europe at the moment of its birth ... all births are frightening. My young Europe! The moment has come to summon Orpheus to your cradle.' Evidently he hoped it was to be his moment – his 'Chant Filial' was thought to be one of his best poems – but the outbreak of hostilities offered him a different role. He volunteered at once and in 1915 was mentioned in despatches as Lieutenant Porte-Drapeau to his regiment at Verdun. He survived a three-day ordeal without water at Morte-homme, and was invalided out after trying to return to the front in 1917. He never fully recovered from these experiences and died of cancer of the gall bladder in May 1921, aged 48.

After his death Jacques-Emile Blanche, who painted his portrait in later life, applied to him the epithet given to d'Annunzio, 'L'Animateur'. At the unveiling of his statue in the Parc des Princes in Paris, Louis Bertrand described him as a man who 'lived to the full. He regarded thinking as the highest pleasure, but liked helping himself generously to all kinds of physical pleasures and parties, and bringing everyone round him into his life. Taking large doses himself, he doled them out to others, and made his listeners drunk.' Royère, his most acute critic, said 'he had to the highest extent the faculty for going into ecstasies and adulterating what he admired,' adding, however, 'you have to read between the lines of his magnificent plastic declarations to find the tenderness, the gentleness and the indispensable irony – all of which qualities he had.' When he died, his early novels and most of his lyrics were as yet unpublished. His critical articles and tracts, such as 'Les Pays de France' or 'L'Art vainqueur', had placed him as a dilettante right-wing journalist.

Their first walks together in April 1896 had a rejuvenating effect on Cézanne. 'I am seeing spring for the first time,' he is quoted as saying. He told Henri Gasquet he had 'profound feelings of fellow citizenship' for his son. Besides having a common background, they were both passionate about French and classical literature, especially the poets, although Cézanne was the better scholar. It was this as much as local loyalties that gave their friendship its special zest. Later, when he devised the Conversations and their settings, Joachim typically had the Socratic dialogues in mind. To English readers a readier comparison would be with Boswell's Conversations, Gasquet's youthful ebullience, his combination of admiration and encouragement drawing out of

Cézanne a vein of ironic playfulness, a freshness of observation and a downrightness that remind one at times of Johnson, particularly in the comments on literary style, which Joachim was well qualified to memorize and which, in their didactic tone, may well have had a bearing on his own writing.

To what extent can we detect the 'adulteration' mentioned by Royère? We can approach the young Joachim by reading his *Narcisse*, written in the mid-'90s as a skit on the Narcissus theme:

> I have doubts, more than others do . . . all too many . . . Sincerity is wholeness of heart, it is at the root of our existence, it owes its nourishment to the very source of our life. It is love, friendship, music, reason. I hate the excessive. I hold the most precious state to be a sense of proportion, the habit of beauty, disgust of the sublime. And yet I read Nietzsche, Carlyle, Dostoevsky, Dickens, black suns, perversities which, through the heart, cloud over the lucidity of one's senses. They undermine one's intelligence with their heart, they impart a fever to everything they touch. All these unhappy people who want to regenerate themselves through suffering. Are they ironic? I understand them less and less.
>
> For us health is the sovereign thing. To be well, devour the day with an appetite, plunge into the sea with our beloved one . . . Help me, dear doctor, to become once more a rising fountain, to rediscover the real trunk, the ancient soil, the good Roman reality, the Greek colonizer, the beautiful sap, the wise peasant, the practical Provençal . . . Goethe, Plato, Virgil, Schopenhauer have stolen away my reason, I am drowning in books . . . You bookworm, one becomes master of oneself by seeking pleasure, and by action . . . away with people, cattle who disregard the abattoirs, I will run away, read Dante, seek the sea, the poetry of the sky.

His friends saw Gasquet himself in this portrait of a young '90s intellectual in a state of confusion after a literary 'high'. This, with or without such relapses of self-doubt – they certainly came later, as his last and best lyrics show – was Joachim's regular state of mind. He saw himself as the spokesman of a Provençal renaissance, with Provence as the inheritor of classical values reinvigorating French life and politics. Temperamentally, he was more involved with heroic or archaic Greece than classical Greece or Rome; with the primary sources of Greek religion and mythology, in particular the cults of Orpheus and Dionysus. In other words he was a philhellene of the advanced school of Nietzsche. In all this, except for the right-wing politics which perhaps also stemmed from this source, he seemed to be moving away from his Catholic upbringing. The hedonistic tone of his early novels and lyrics was

regarded by his tutor and posthumous editor Bertrand as pagan, prob-
ably one of the reasons they were not published at the time. In this
memoir he uses the word 'pagan' with a certain relish: it stands for ani-
mal vigour and peasant wisdom in a way that is peculiarly his own. Ber-
trand says that he became more pagan as he grew older; certainly in this
book his Catholic upbringing is also strongly evident. His final image of
Cézanne is that of saint and martyr, just as it is with a quotation from
Renan's *Life of Jesus* that he begins Chapter IV. All the same, he finds
aspects of Cézanne's orthodox piety puzzling and not quite credible.

Cézanne's last reference to Joachim is in a letter written to his son in
1906, when the visit of a senior minister to Aix was expected. 'Where are
you, Jo,' he writes in an aside, 'on earth, or in the course of life?' The
tone is indulgent, suggesting that Gasquet is seldom around, or if he is,
he has only one foot on the ground; he may put in an appearance, or he
may not. Between Cézanne and his son, Jo is a figure of fun, but there is
no malice.

What did Cézanne himself, fastidious as he was, think of Gasquet's
style? Early on in June 1896 he had gratefully accepted the flowery tri-
bute in *Les Mois dorés*: 'The air in his pictures thinks, knows, wishes,
reminding us of rocks and trees speaking in biblical times.' His ac-
knowledgments of articles received were scrupulously polite. In 1898 he
wrote wryly, 'You have a way of seeing things through such a prism that
any words of mine in thanks would pale by comparison.' In 1900 he
advised Joachim to give up trying to imitate Pindar, with 'frills that are
mannered and obscure and of interest to no one', in favour of a more
popular style. He disliked Gasquet's version of the Arabian Nights but
probably did not tell him so.

As regards his conversation, the famous letter from Cézanne to Gas-
quet tells us something: 'You come along, playing the philosopher and
want to finish me off . . .' And yet soon afterwards, Gasquet was at it
again. 'All this talk of yours about Monet and the atom', or 'You were
going on about Kant . . .': Cézanne called it *bafouillage*, taking non-
sense, something one did because 'it was fun, like having a glass of
wine.' His attitude was essentially that one must have theories, but then
forget them. He was always, however, going off on 'flights' himself
('these 'emballements' will be my ruin'), and no doubt he got just as
excited as Gasquet.

It is tempting to examine Joachim's vocabulary for the 'getting drunk'
Bertrand refers to. His words often suggest a high temperature:
'inflamed', 'feverish', 'furnaces', 'pyres'. When he has Cézanne speak in

The Motif of 'a jet of steam above the universal furnace', he makes one think of the yeasty fumes rising from his father's old-fashioned bakery oven. His metaphors favour upward motion: blood rising to the head, sap rising through tree trunks, jets through fountains; and vast spaces: 'an emanation from the depths', thoughts hovering in 'a universe of light and love'. Fire and air are his elements, whereas Cézanne seems to have more to do with earth and water. 'I prefer a form of painting that has more solid foundations,' says Cézanne; 'does it move, is it firm?' or 'I was bathing in a blue-russet', 'we swim in our full depth', or 'bath of knowledge', 'soak one's brushes in the sun, do one's washing in it'.

As Royère puts it, 'there is a veritable antimony between the lyricism of Gasquet and the painting of Cézanne.' He adds, however, 'There is no more convincing proof of the breadth of Gasquet's understanding, his aesthetic intelligence, than the sincerity, despite this opposition, of his admiration for Cézanne.'

Royère was well placed to make such a judgment, and it needs to be set against John Rewald's view that Gasquet had only a limited capability for grasping Cézanne's ideas. As we look back at this lovable, flamboyant *parti-pris* idealist, who hardly came to terms with reality but, after much groping, apparently found fulfilment as a soldier and as the poet of his own wasted life, it is true that it is difficult to see how he could have got caught up so deeply with the most serious painter of his and indeed our age, and have gone so far in understanding him. And yet how, otherwise, can it be that this portrait of Cézanne as a thinker and a theorist moves us so strongly? His meditations, for example, on colour – so formidable, dense, original, and consistent in character; his musings about solar energy, with its mystical moral component; and his subtle view of his own place in the history of painting? The patterns of thought cohere, and are too original to be entirely Gasquet's invention.

On the strength of his other writings, including the first part of this work itself, Gasquet does not prepare us for the analytical power of the Conversations. We must presume that the timing of their meeting, and the special connection which made each see the other in an idealized light, liberated something in Cézanne, powerful forces relating to his early life, to which his 23-year-old admirer responded with the breadth of understanding, the intelligence, and the sincerity Royère describes.

Gasquet's idealism places him among those writers whose moral and aesthetic sensibilities need a catalyst for their special kind of intelligence. Throughout his life he was in search of a cause and a subject about which he could feel completely sincere. In Cézanne he found one.

PART ONE

What I know or have seen of his life

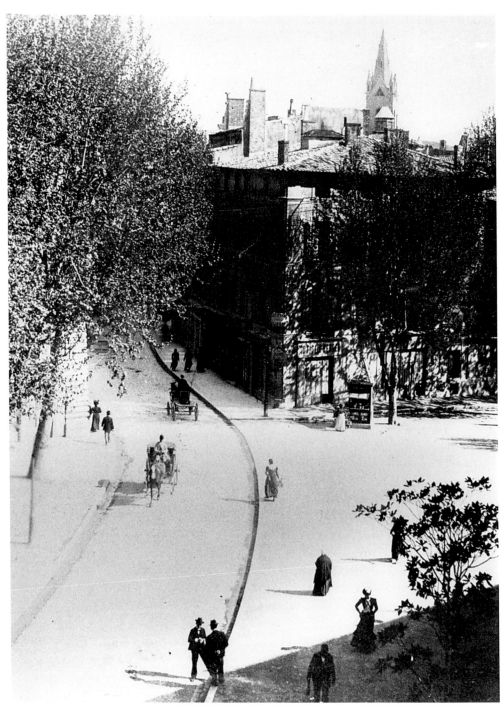

Nineteenth-century photograph of the Place du Palais de Justice, Aix

I

YOUTH

The town of Aix lies at the foot of Mont Sainte-Victoire in a plain sown with grain which is said to produce the best bread in the world, and is surrounded by hills planted with vines and olive trees. It is a dead town that retains no more than a melancholy pride in its ancient splendour. Here, in one of those pale months when the sunny cold of Provence is scented with the buds already opening on the branches of the almond trees, Paul Cézanne saw the light of day – on 19 January 1839, to be exact. The first promises of spring were what he himself was to bring to the old culture into which he was born, at a wintry time in its history.

The country is one which Poussin would have loved, with its groups of trees, the rational line of its hills, its horizons stirring with sea air; when the eye runs over it as a whole it is a classical landscape. Trets is its guardian Olympus. The chain of the Etoile, an ancient mountain range visible from the window of the Jas where Cézanne worked, stands out in sharp outline. The Arc Valley, quivering with poplars and willows, makes its leisurely descent, crisscrossed by white roads, through emerald vineyards, great yellow squares of wheat, and dusty almond orchards, to the lakes and salt marshes of Berre, beyond the pink ploughlands and slopes of Roquefavour. Here and there, a solitary cypress, a fig tree by a well, a sudden sturdy bay ennobles it with a thought or an austere smile. A pervasive Virgilian charm of mood, gracious, temperate and blue, contributes to its peacefulness and its spell.

But to the north of the town, the country becomes wild and, as it were, violent; above Le Tholonet the gorge of the Infernets opens to reveal a chaos of giant rocks, the plateaux of Vauvenargues extend in a desolation of stony scrub, the horizon becomes harsh, and the disturbing effect fades away only when, at the turning of a track, Mont Sainte-Victoire appears in its massive entirety, radiant as a blue altar.

It was at the foot of this altar, in the fields of Pourriers, *campi putridi*, that the fate of civilization was acted out long ago between the barbarian

hordes and the legions of Marius. Even today, in these fields fed with corpses from that vast encounter, the plough strikes upon stumps of swords, fragments of skeletons and weapons, rusted badges. Cézanne loved recalling all this.

I can see him at the Louvre, halted in front of *The Battle of the Cimbri and the Teutons*, the dull colours of Decamps' fevered canvas moving him to recall perhaps that onslaught of primitive peoples, or, with his nostalgia for Aix, the pitted crater and the dramatic slopes where Decamps set the battle scene, or even, more probably, comparing the older painter's values with his own way of seeing, his own dilemmas, the agonizing problem of expressing, with his direct and precise craft, the vividness of his historical imagination. This is what Zola called his romanticism – Zola, who had such a strong influence on Cézanne's whole youth and career, but was himself never moved by history.

I can see him again, in the Salle des Etats, turning to me abruptly with his keen, mischievous look.

'– Ah, the scoundrel! what dark, warm colours he uses . . . You know what Decamps said when he got to our Colline des Pauvres, when he actually stood in front of it? 'Why did I go messing about in the East? . . .' Yes, I share Emperaire's views. There's no reason why another sort of tune shouldn't be played in our own country, getting its effect from a different kind of light! . . . The sun shining through the dust, the horses' sweat, the smell of blood, all these things you write about, we painters have to drive them home with our colours. Don't let anybody tell me again that it's impossible. Come, look . . .'and he drew me over to *The Entry of the Crusaders into Constantinople*.

This taste for powerfully evocative scenes, which he struggled to suppress because of his horror of approximations and the absolute submission of his art to pure truthfulness, was doubtless in his blood.

At the time of his birth, Aix was in a deep sleep, dreaming of its days as the ancient capital of Provence and the reign of King René. The old houses of the members of the Parlement still lined the Cours, with its mossy fountains and avenues of young elms, carefully planted so that not a single shop window in the Allée des Nobles should sully the shade cast by the high balconies, the caryatids of the 'grand siècle', the full-bellied ironwork, the blazons of fleurs de lys. With its ring of convents, its ancient ramparts still intact, its countless gardens, its gilt façades designed by Puget, its ceilings decorated by Mignard, its doors with rich garlands carved by Torro, its Italian furniture and Flemish tapestries, its sleepy streets fragrant with strewn flowers during the processions mark-

ing the feast of Corpus Christi and brusquely awakened at carnival time by burlesque productions, gay dances and cavalcades – the good old town, Palais de Justice and all, lived its clerical and university life, if life it can be called, brightened by the street cries of the market on Thursdays, endlessly harping on memories of its ancestors, ignorantly disdainful of all new ideas, untroubled by that other revolution which was rumbling away in the direction of Paris.

In certain salons there might be an infrequent mention of the young Thiers, who had qualified at the Faculty of Law, for people remembered him walking along the Cours, all argument and no money, or of that Félicien David who sang to perfection, who became a Saint-Simonian and was pelted with stones when he tried to take a last look at his father's bakery before fleeing into the wilderness. Cézanne, when he returned in his old age to seek refuge for his heroic, tormented spirit among his own people, met with the same incomprehension and the same contempt. Sullen, his knapsack on his back, his hat over his eyes, hugging the walls, he finally reacted to the insulting glances he received by avoiding the Cours Mirabeau, even though his mother lived there – those classical façades which he loved and which recalled to him his childhood and his father, the father whom he so venerated.

I knew Cézanne's mother, but nothing of his father except for the gratitude he remembered him with. From that practical, sardonic old citizen of Aix, he derived that undercurrent of irony which escaped most of the people he met, but gave such a special flavour to some of the remarks he muttered through his moustache, along with a sharp but kindly wink of the eye. His father's Provençal good humour often tempered the son's poetic flights. He painted a magnificent portrait of his father, full of fervour, which for a long time dominated the huge, almost unfurnished, room, flanked by the four seasons (signed Ingres) above the sofa, at the end of the salon of the Jas de Bouffan.

'Father!' he grunted affectionately, when he drew me for the first time in front of the moving portrait.

Wearing his cap, in a familiar pose reading his newspaper, the good man sat between the four allegories. His ruddy face, firm skin, strong shoulders declared the person, hale in mind and body despite his years, whom the son had contemplated. He had painted him in thick paint, large and solid, as if he had wanted, with his colours, to lend more firmness to his filial tribute. He had set him down with brutal accuracy, as if he were afraid, in this work of affectionate devotion, of betraying his other loyalty, his passion for art, afraid that his trembling hand might in

confusion settle for the sentiment that is satisfied by a lesser emotion. It was thus, monolithic, his back a little hunched, but his face full and subtle, the very picture of sly authority, bent over his newspaper and holding it with his landowner's hands, that the old banker, when the windows were open, rejoiced in the heart of his domain – and the shade of chestnut trees, the smell of herds and corn, the ripple of ponds, the friendly rustle of branches all came to bless his well-earned repose with the homage of his fields.

Indeed, this large property with its acres of grass and wheat, its tall avenues, its stretches of water guarded by benevolent moss-covered lions, the informal majesty of its wide frontages decorated with medallions and nobly illuminated by large windows in the eighteenth-century style, its Genoese roofing and its farms out there under the mulberry trees, all this rustic richness, so often painted by the son, had been won by the father's hard work, his honest acumen, and his Roman sense of family and business. A hatter to begin with, he had rented, then bought, the Jas de Bouffan in order to let it out on market-days to the stock-farmers who brought their herds of sheep and cattle to town. Then when the cattle sales were slack, he lent money at high interest, clapping one man on the shoulder, giving good advice to another. Slowly but surely his field of activity grew. Upright and resourceful, he won the confidence of the locality, then of the region. One fine day he became a banker.

At that time Paul Cézanne was being educated at the little Pensionnat Saint-Joseph. It was only later that he went to the Collège Bourbon, now the Lycée. But already he had a healthy enthusiasm for escaping from the sleepy town streets and slipping off, to his mother's great alarm, to be with the horse-dealers, among the peasants and the cattle, sinking his little fingers into the woolly fleece of the sheep, rolling on the straw of stables and threshing-floor – or watching two blue-shirted peasants, with a bottle of *vin de Palette* between them, playing a game of cards, in which a week's earnings melted away in great sou pieces amid the swearing and joking.[1]

All his life he was influenced by the memory of those happy days, of those down-to-earth escapes to ordinary folk and the fullness of nature. Again and again he came back to his work on peasants and red-kerchiefed louts, on the massive blue of their smocks, on the coarse

1 In June 1899 he wrote to my father: '... the feelings your son has rekindled in me, your old schoolmate at the Pensionnat Saint-Joseph for we still feel within us the vibration of sensations reverberating from this good sun of Provence, our old youthful memories of these horizons, these extraordinary contours, which leave so many deep impressions on us ...

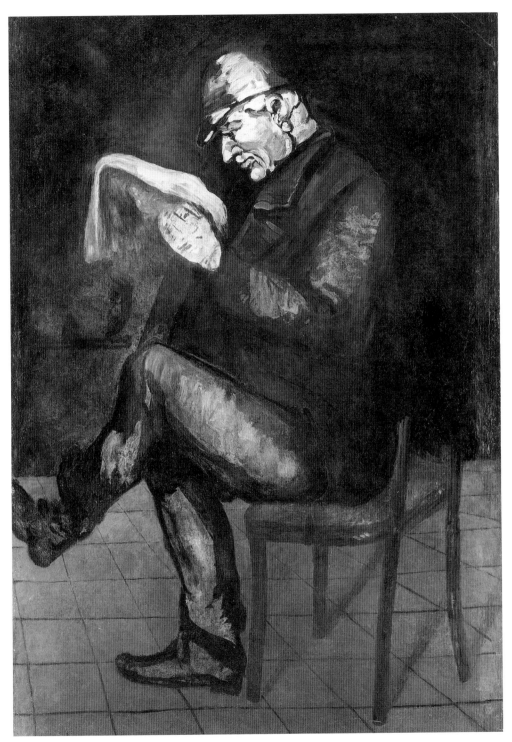

Portrait of the Artist's Father, c. 1865

gleam of the dark wine in their glasses. Set out on the simple biblical tablecloth of his still-lifes, the wine and bread take on a kind of festive Virgilian glow. Bucolic subjects fascinated him. At least twenty times I saw him copying Millet's reaper, or sower, in his sketchbooks.

One of his longest-held ambitions, finally realized after countless sketches and repeated studies, was to depict some ordinary workmen, some rough card players, seated on rustic chairs in front of the fireplace in one of the farms belonging to the Jas, with a bottle between them while a young girl – was it his youth in shining dress? – waited on them and watched. It is one of his most beautiful canvases, in which he came closest to his elusive 'solution'.[1] All the simple splendour of the Jas and the Virgilian spirit of the painter are woven together here forever.

When he had to agree towards the end of his life to the sale of the Jas – a family arrangement, approved by his sisters – I remember his uncertainty, his struggles and his despair. Above all, I remember his pathetic arrival one evening, his mute expression, the sobs that prevented him from speaking, the sudden tears that relieved him late on that day when, while he was painting and without letting him know, they had foolishly burnt the old pieces of furniture that had been religiously preserved in his father's room.

'—I would have taken them, you understand . . . They didn't even try to sell them, they found them a nuisance . . . Dust traps, worthless things . . . Now they've made a bonfire of them . . . A bonfire!'

In spite of himself he saw the scene anew.

'—And I, who looked after them like the apple of my eye . . . The armchair Papa slept in after lunch . . . The table he did his accounts on all his life . . . Yes, he had the foresight to provide an income for me . . . Tell me what would have become of me without that? . . . You see what they do with me . . . Yes, yes, as I tell Henri, your father, when you have a son who is an artist, you have to provide him with an income. We must love our fathers . . . Ah! I shall never be grateful enough to mine . . . I never showed him enough . . . And now they've burnt all that was left to me of him . . .'

'What about his portraits? At least you still have a portrait of him.'

'Ah! yes . . . his portrait . . .'

And he made a gesture of supreme indifference, with that wonderfully grand humility of his whenever one of his works was mentioned in his presence.

1 What's become of it? The *Card Players* in the Louvre, the one in the Pellerin collection and the one in the Bernheim-Jeune collection are only preparatory studies for it. The last time I saw it was at the Jas. It measured 3 metres and contained three almost life-sized figures.

That evening he did not want to leave us. He had supper in our house and then we spent the whole evening roaming the silent streets of his childhood. His mind was on the past.

'How this has all changed,' he kept saying.

But his prodigious memory animated the darkness with a thousand recollections – people and things that occurred to him by chance at the sight of a passerby, a shop sign, or a street corner. He quoted:

'*Objets inanimes, avez-vous donc une âme*
Qui s'attache à notre âme et la force d'aimer?'

But passing the Lycée affected him most.

'—The brutes . . . Look what they've gone and done to our old college . . . Our lives are at the mercy of the Borough Surveyors. Engineers ruin everything; it's a republic of flat straight lines. Is there a single straight line in nature, I ask you? They apply a ruler to everything, it's the same in the towns as in the country . . . Where is Aix, the old Aix I knew with Zola and Baille, the fine streets of the old suburb, with grass growing out of the pavement, and oil lamps? Yes, oil lighting, *li fanau*, instead of your crude electricity which destroys the mystery, whereas our old lamps encouraged it, glowed and lived within it, à la Rembrandt . . . We used to serenade the local girls . . . Just imagine, I played the cornet and Zola, who was better at it, the clarinet . . . What an appalling sound! . . . But the acacias over the wall shed a tear for us, the moon shone blue on the portal of Saint-Jean, and we were fifteen . . . We thought we were going to take the world by storm . . . Can you believe that at college Zola and I were looked on as prodigies? I could knock off a hundred Latin verses at a go . . . for two sous . . . By Jove I was smart when I was young! . . . but Zola didn't give a damn . . . he had his dreams, . . . a wilful savage . . . a weedy intellectual! . . . You know, the kind that street kids hate . . . On the slightest pretext they'd put him in Coventry . . . And in fact our friendship stemmed from that, from a thrashing which everyone in the playground, big and small, gave me because I took no notice, I disregarded the ban, I couldn't help talking to him anyway . . . a decent fellow . . . The next day he brought me a big basketful of apples. The Cézanne apples,' he said, with a mischievous wink, 'they date back a long way . . . But this rotten Lycée hasn't kept a trace of those years.'

Indeed, instead of the dreary buildings of the present Lycée, the provincial college used to stand among meadows, its gardens and ivy backing on to the ancient city walls along the Cheminée du Roi René. Elms and

39

venerable pines – those great pines with knotted branches which Cézanne was later to introduce into the foreground of his landscapes – shaded the quadrangles where the institutional plane-trees stand now. The vaulted halls, the classrooms with their cracked walls, opened on to lawns and clumps of bushes which, in the spring, were full of sunny sounds, a constant humming of wasps, rustling of leaves, twittering of birds. Its wonderful pool, shady and green under the mossy oaks, echoed at night with the clamour of frogs in its reeds, and from the dormitory windows one could look out, in the moonlight, over the gentle landscape and soft meadows sloping down to the willows of the Arc. The house had a paternal atmosphere . . . It was an old convent, converted to a school. It was even said that the chapel was the work of Puget in his old age. It was to this place, when young Cézanne left the Pensionnat Saint-Joseph, which was considered inadequate for a banker's son who was soon to turn thirteen, that the wealthy hatter and owner of the Jas de Bouffan sent his heir.

According to those of his friends at that time that I have been able to question, Cézanne was an excellent pupil, shy, dreamy, a bit reserved, who got on admirably in classics; one called him 'un écorché' (supersensitive), and another stressed that he 'was much more promising at drawing than he has turned out since.' He also wrote French verse, mostly inspired by de Musset, and as for Latin verse, one only had to suggest a subject and his pen galloped across the paper for a solid hour without pausing. His memory was fabulous.

To his dying day, he retained this wonderful memory: things seen and heard, things of the mind as well as the heart. I remember how amazed I was when, meeting my father again after not seeing him for thirty years, Cézanne reminded him of the street corner where they had parted and the unimportant words they had exchanged, the woman in a grey blouse who had watched them from a window where a parrot was chattering and the multicoloured curtain which could be made out on the wall behind her.

In his later days, when working left him stiff, exhausted and in pain, he read very little. Yet how often, in front of some view in the country or in Paris, or standing before a work in progress in the studio, indicating the syllables with a raised brush, have I heard him reciting twenty lines or so from Baudelaire[1] or Virgil, Lucretius or Boileau? Going round the Louvre, he knew to the nearest year when and where a picture had been painted and what church or gallery had a copy. He had a wonderful knowledge of the European museums. How was it possible? He

1 He knew *Les Fleurs du mal* by heart.

who had never visited them, and scarcely travelled abroad? I believe that reading or seeing something only once was enough for him to remember it for ever. He looked and read very slowly, almost painfully; but the bits and pieces he had picked up or read remained engraved, buried, in his mind, and nothing could uproot them from then on.

His memory and his awkward touchiness – those were what struck his college companions. He was an excitable child.[1] Already in his budding genius, he suffered from over-dramatizing, a sort of passionate hallucination which made him, in spite of himself, ascribe to everyone who approached him an interior life like his own, and which tormented his imagination in seeking motives they might have for disguising, as he thought, their enthusiasms or their rage. Hence he felt like a simpleton among other people. He attributed to them devious plots to undermine him and his art. 'They want to get their hooks into me,' he would say . . . He had sudden outbursts of anger. For example, you had to be careful not to touch him, even inadvertently; he bristled right away. One day in my presence, someone who was rash enough to clap him familiarly on the shoulder received such a shove that he was thrown off balance. A misanthropy, all too often justified, which made him choke and go red in the face, sometimes to the point of being ill, lent a rough edge to that native bashfulness which protects exceptional people from the advances of fools.

If one has known Cézanne, one can follow in Emile Zola's *Correspondance* the sequence of one of these sudden attacks of distrust; in his youthful letters to Baille there is a groundless row between him and Baille which Zola ends by clearing up. 'You know that with my character as it is,' Cézanne admits, 'I hardly know what I'm doing, so if I've done him a few wrongs, well, let him forgive me . . .' In these words we have it all, the touchy heart full of tender feelings, the thin-skinned sensitivity avid to set things right.

This friendship between Zola, Baille and himself was the great intoxication, the great eye-opener of his adolescence. In the opening chapters of *L'Oeuvre*, Zola tries to convey the feel of it.[2] He shows them from the age of fourteen, isolated, enraptured, in the grip of a fever of literature and art:

1 '. . . Painfully shy,' Zola wrote of him later, 'and hiding it under a swaggering rudeness.'

2 Afterwards, the book takes a different turn. To suit the novel, Charles Lantier behaves and talks according to the logic inherited from the Rougon-Macquart family, and no longer according to the portrait, hitherto faithful, of the friend on whom Zola had based his character. Cézanne himself, Philippe Solari, Numa Coste, Huot, all of them characters transposed from reality into the novel, and involved in the sometimes true, sometimes imaginary life of Lantier, have always supported me in this view. I shall return to that later.

'They felt their own heart beating in him [Musset], a more human world opened up, which captured them by its compassion, by the eternal cry of suffering which, from then on, they were to hear emanating from everything. Furthermore, they were not discriminating, they shared the greediness of youth, and had a furious appetite for reading, gulping down the good and the bad, so intent on admiration that appalling works often induced in them the same rapture as pure masterpieces.'

In that period, I think, Cézanne's tastes were more refined. He was already in the thrall of Virgil and Alfred de Vigny, the great contemplative poets. He chose Hercules as the subject of a poem. It was 'old Cézanne' who led the group.

'You who guided my faltering steps on Parnassus . . .', Zola wrote to him later. According to his letters, Zola affected ignorance of Virgil and Latin. Significantly, it was the passionate writers, Michelet, George Sand, who made him 'tremble with excitement' and *Jacques** whose pages reduced him to tears.

Perhaps Cézanne's excitable, disorderly imagination came from his mother, who, I have been told, was of Creole descent. From his father and his forebears, who had come to France from Italy in the eighteenth century, he may have inherited the composure, the strong Latin instinct which, from his adolescence, inclined him towards the form of realistic and classical art which he spent his life trying to achieve. Zola was to reproach him in a friendly way for his exalted moods, the romantic disease which much later lacerated his tormented sensitivity; but I believe that Zola himself, in those ardent days of their youth, can be held largely responsible for that. But by way of compensation he bestowed on 'his brother' Cézanne that most precious gift of all, belief in himself, faith in his genius and his art; he made this naturally hesitant spirit drink that strong wine, that unreplaceable cordial, true enthusiasm based on loyal friendship. Like all great men, Cézanne considered friendship the crown of all virtues, and till the day he died he recalled tenderly that which Zola and he had sworn in the college courtyards and the roads around Aix.

What a life of simple-minded heroism they led at that time! They prepared themselves passionately, innocently, for the high destinies to which they felt called. They despised cafés, hated the streets, professed a horror of money and all prejudices. They shunned the city centre and 'declaimed poetry in pouring rain, without seeking cover,' as Zola tells us. 'They had a plan to camp beside the Viorne [the Arc] and live there in the wild, with five or six books, no more, sufficient to their needs, and

*All translator's notes will be found on p. 233

enjoy constant bathing in the river. Girls were not permitted, for they used their shyness and awkwardness to claim superiority.'

They were called the three inseparables. Baptistin Baille, who later became a Professor at the Polytechnic, was more reticent; in the trio, he stood for moderation, sturdy common sense, the more practical side of mathematics. It was to him, perhaps indirectly, that Zola owed his short-lived interest in natural philosophy, the industrious pursuit of science, which directed his immense but confused and unsophisticated genius towards a literature of greater precision, and diverted him from his predilection for romanticism towards what he was to call 'the experimental novel'.

Did Baille too have an influence on Cézanne? I doubt it. I even wonder if that uncompromising dislike of engineers and 'the straight line' frequently expressed by the old master may not have derived – for he never forgot a thing – from some distant, violent exchanges suddenly sparked off in his memory by a turn in the road or the smell of a bush.

For when, in old age, he immersed himself in the lanes around Aix, his paintbox always slung over his shoulder, celebrating that whole landscape in his canvases with such wonderful humility, he was retreading the tracks he had explored in all directions as a youth with his haversack and his two inseparable companions. Especially with Zola. They would set off on a Thursday, Cézanne even then with his sketchbook, his friend with some sort of book in his bag. They were intoxicated by the light, the poems and the open air. The plain and the hills, the river and the mountain, Hugo, Lamartine, Musset, the red boulders, the rocky horizons, the bluish shimmer of the hillocks and the trees, all the wholesomeness of the earth, all the humanity of the verses, on the cracked roads where they burned their shoes, at blazing noon in lethargic fields or at dusk as the Virgilian shadows lengthened, nature and life would suffuse their very souls, would knead them into a dough of sun and excitement, would give a shape to their fancy and a rhythm to their fate, in the slow fraternal music of words and syllables, in the friendly warmth of sunlight.

Sometimes, when the holidays were in full swing, they went off for several days on a proper expedition, 'covering the whole country'. Taking rough provisions, along with sketching albums and books, in a knapsack that bumped against the small of their backs and had a strap that cut enjoyably into their sides like a saw, they slept at night on some threshing-floor amid the star-scented corn, had their evening meal in some ruined cottage where they would fall asleep on a bed of broom and

thyme after the last mouthful, their heads humming with the country-side and poetry.

From every point Sainte-Victoire dominated the landscape, in the morning as blue as a virgin's prayer, at noon ablaze, at sunset flushed after drinking so much light, under a cap of clouds or a crown of sun, spreading on its slopes at night an altar-cloth fragrant with incense, or erecting at dawn the stone horses of an Assyrian bas-relief – everywhere, at the horizon of every plain, at the end of every road, from one hill to another, the sight of Sainte-Victoire entered Cézanne's fresh eyes. Sainte-Victoire, and the dam of Le Tholonet, and the hills of Saint-Marc, and all those 'motifs' that were to be his life-long passion, the red slopes and the balconies of rock overhanging the quarries of Les Pauvres, the soft outlines of the Pilon du Roi seen across the reedbeds of Gardanne, the pine woods of Luynes, the farmhouses of Puyricard, the château of Galice, all the farmyards, orchards and meadows of the Jas de Bouffan where, beyond the noble chestnuts of the century-old walk, the soil was getting bare and the harvest shone palely.

White with dust, the three truants careered down the scorched village streets, drank a glass of boiled wine with the villagers of Palette, hung over the wheel of the oil mill of Les Pinchinats, picked almonds in the orchards of Venelles, sometimes pushed on as far as Berre, Saint-Chamas or Martigues to see the fishermen pulling their nets from the pond. They were mad with sun and sap, unconsciously haunted by noble country deeds. They inhaled the wholesomeness of work with the blue air of the fields. Their souls held no more than the simplicities of white bread and pure water. Like the shepherds of the Nativity they drank the gifts of nature only from cups made of boxwood.

But their supreme joy and ultimate bliss, their almost sacred rite, was bathing in the Arc, reading aloud while still wet, having discussions in their bathing-pants under the willows. The river belonged to them. From the end of spring they seized possession of it, made it their domain, splashed and washed in it on their days off from dawn to dusk, grubbing among the weeds, following the underwater life in pools of light and shadow, discovering in the ephemeral world of insects and drops of water the universal drama of the infinitely great in the vanishing small. Often an epithet, a shift of sunlight or of thought, a paradoxical remark would make them grab one another by the hair, roll on the sand and pick themselves up with fits of laughter and hug each other. In Bohemian style they cooked their cutlets on sizzling vine branches and cooled their bottle in a spring. This was true camping. This was living.

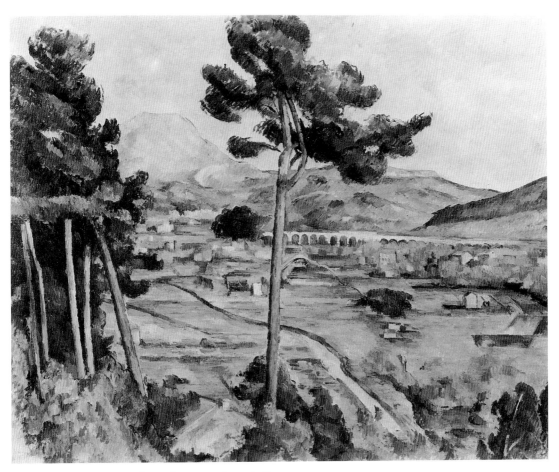

Mont Sainte-Victoire with Viaduct, seen from Bellevue, 1882–86

Never did fevered artistic minds develop more naturally. Their imaginations became steeped in truth. All their lives, even at the worst moments, they would remember that pagan glow or that blessed pain. How understandable is the remark Cézanne made to a friend much later: 'Painting from nature is not copying the object, it is realizing sensations.'

Those days spent out of doors gave the two friends enough sensations to keep them going for the rest of their lives. They were saturated with sensory experience to the point where the country became a part of them. From nature! Cézanne was never to paint successfully any other way. He was already making pencil sketches and trying his hand at watercolours. His father had given him his first box of colours, which had turned up in a lot of old ironmongery. And the future companion of the Impressionists, who was to become at one point the wildest of colourists, was applying himself at this time to setting down in delicate tones the profile of a hillock, a stretch of running water, a tree in a breeze, a cloud against the sky. I have seen in his brother-in-law's house one of these early canvases, of a little donkey, naively drawn with an adorable awkwardness, tender and grey, yet evincing some sort of vague pantheism, already a whisper, a stammering, of astonishing lyricism.

He went to the museum. The example of Granet, a poor bricklayer of Aix discovered and promoted by Ingres, fired his imagination. Of the few of his canvases he could see, with their painstaking honesty, their conviction, the friendly unassuming tone behind their tight academic style, he preferred the more direct studies Granet had brought back from Rome. In some of these small pictures there is a foretaste of Corot, as Cézanne pointed out to me one day. Indeed, in the background of the vivid portrait (the pride of the Aix Museum) that Ingres painted of his pupil, in which Granet, with his imperious eyes and locks like black marble, stands out so magnificently against a stormy sky threatening Rome, Cézanne found a pine tree and a tall building where Ingres, assuming the character and carrying out to perfection the fumbling technique of the painter he was immortalizing, had in a bound for once attained the level of Corot.

'Friendship,' he concluded, 'has its rewards ... And as for Corot, what a portrait he did of Daumier! Both their hearts are beating in it ... While, just look how Ingres, yes, in spite of himself, has flattered and transfigured his model. Compare it with his other portraits, stuffed shirts just like himself.'

Did Cézanne do a portrait of his friend? He began one, during his first

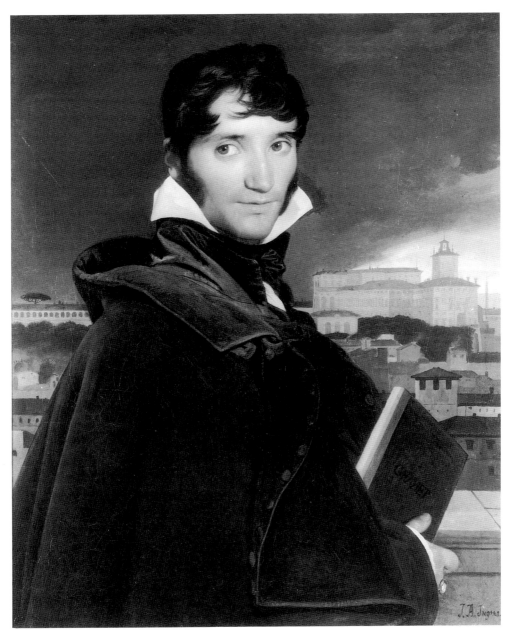

Ingres, *Portrait of Granet*, 1807

years in Paris, but too soon; he threw himself into it, scraped it away, began it again, and finally ripped it apart. The more his affections were involved, the more inhibited he was and the more his technique failed to measure up to his aspirations. Also in that period he was still trying to understand himself . . . He was to try all his life.

Another portrait he often studied in the Aix Museum, which must have made an impression on him in his youth, was Puget's pensive self-portrait as an old, disenchanted man in a sad reverie, with his palette in his hand.

'Hm!' he'd say, 'we're a long way from the "melancholy emperor", but look at this green in the tints of the cheek . . . Rubens, eh? . . . Like his watercolour of the centaur at Marseilles, pure Delacroix! – that *Education of Achilles* which I prefer to his sculpture, yes! . . . with its yoke of oxen in a fold of the landscape, its gusto, the inspired heroism of the child, the dramatic colour, the violence of the mistral upsetting and at the same time strengthening the colours . . . yes, yes. As I often say, Puget has some of the mistral in him.'

And then he stopped short at the next picture, the *Card Players* attributed to Lenain.

'That's how I'd like to paint! . . .'

He often made me look at this picture, which shows several soldiers in a guard room, an old man stowing away his purse, and another, young and blond, wearing a sword and standing in an affected pose, at the end of a card party over a bottle.

'That's how I'd like to paint! . . .'

Was there a naive irony in these words of the old painter standing in front of a canvas which to me seemed mediocre; he who had himself also placed card players round a table in a bright farmhouse kitchen, but so differently – massive, solid and alive, in such vivid, strongly felt and penetrating colours compared with these smoky tints? Perhaps we should see in this only a touching remembrance, a youthful excitement devoutly kept alive and possibly, connected with Thursdays* at the Jas, the inspiration for a similar subject. In Cézanne there was such a mixture of veracity and banter, of sincere excitement and playful scepticism, that it would be difficult to be sure. Oh, he was so Provençal, the old master! And well he knew it . . .

'I'll tell you what,' he would say, 'the phrase *forcés pas* [nothing excessive] of our forebears was simply a free translation of *rien de trop* [not too much of anything], the words carved on the pediment at Delphi.'

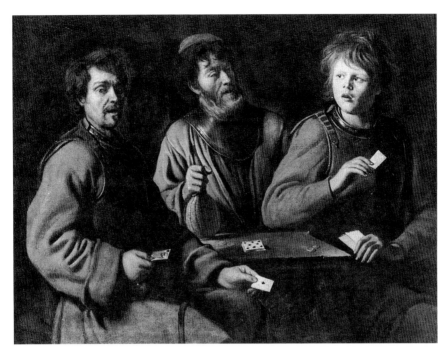

Card Players by the Lenain brothers, 1635–40

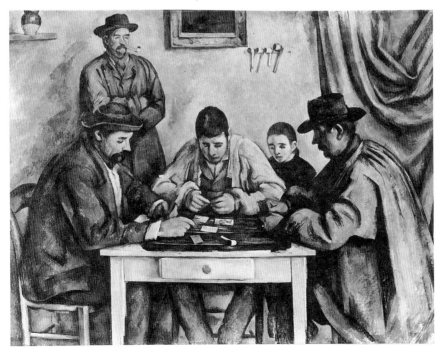

Card Players by Cézanne, 1890–92

And then he would smile to himself, so full of whims, tormented by a sort of romantic streak which his lucid reason and Latin ability to see things clearly never succeeded in controlling. Yes, the most delicate sensibility in combat with the most theoretical mind – that's how I would be tempted to define the drama of his life. He was indeed at times the 'mad visionary' described by Zola as being 'driven to the exaltation of the unreal by the torture of reality'.

And this agony began way back. Even as a boy he complained of it; again it's Zola who emphasizes this, and I like to quote him since he was an eye-witness, more enthusiastic perhaps than subtle. His dedication to *Mon Salon* attests to it and *L'Oeuvre* was written during a visit Cézanne made to Médan, with Paul Alexis. As I say, he had been a witness to Cézanne's early experiences – 'even as a boy it annoyed him when he was attracted by a picturesque old street, he was infuriated by the romantic canker which nevertheless kept coming back; maybe it was his affliction, this false view of things which he felt sometimes as a bar across his skull . . .'

His whole life was a struggle against this affliction; all his art, his austere observation, his pious realism, his loving submission were only remedies for it. His reason applied itself passionately to the heroic task of finding something sanctified in every subject, and it was this unwelcome but tenacious romanticism which inflated with Michelangelesque power the bodies of his bathers as well as the oppressive fleshiness of his female groups, which elongated certain nudes à la Greco, reducing their heads, inflaming their hips and thighs with a mad blue or a wild green, and which fed its gloomy sap into his bouquets of artificial flowers. It keeps bubbling up in a thousand scenes of revelry, weddings on riverbanks, feasts under the trees, such as one can see in the Pellerin Collection. It flared up one exciting week when the poet Gilbert de Voisins suggested that the old master of Aix should use his own fantasy to illustrate Gustave Flaubert's *The Temptation of Saint Anthony*. Two drawings for it were begun. And again it was his romanticism, even at the end when he thought he had entirely recovered from it, which made him pile up, in blue still-lifes, those Verlainean skulls on a rich cloth. Earlier, on a warm-toned, dark canvas, covered with impasto and as moving as a Rembrandt, he painted on a rough napkin, facing a milk jug, a skull which emerged from the depths of some cemetery vault, or some bottomless void.

On the last mornings of his life, he clarified this idea of death in a heap of skulls, where the eye-sockets gave out a sense of blue. I can still hear

The Temptation of St Anthony (drawing for Flaubert's story), 1873–75

him reciting to me one evening as we walked along the Arc the quatrain by Verlaine:

> *Car dans ce monde léthargique*
> *Toujours en proie au vieux remords*
> *Le seul rire encore logique*
> *Est celui des têtes de morts.*

I can hear him, in his studio in the rue Boulegon, intoning in the manner of a scholar or a priest Baudelaire's 'La Charogne', or asking me to read to him 'Un Pouacre' from *Jadis et naguère**.

'Come on, read 'Un Pouacre' to your gouty old friend,' for with those close to him he liked to show off his erudition, and explained that 'pouacre, nasty, came from *podragum*, gouty'.

One day he decided to gather all his ideas on this 'motif' of the skull that haunted him. Using a vertical format, he painted his *Boy with a skull*. Against a rich drapery with floral patterns (the one he used in his still-lifes), he posed a young man, dressed in blue, sitting at a white wooden table with a skull in front of him. One could not achieve a more direct effect of pathos, or a more touching reality. All his romanticism is there, but this time connected and subjugated to his genuinely classical style. Poetry and truth; it is the poetry of precision, the beauty of all great works . . . He loved this painting. It was one of the few he would sometimes mention after he had stopped working on it.

In this peasant boy (it was the farmer's son who sat for him) contemplating this mysterious object of bone, in the ruddy naive face, so unaware of the existence of death, is there something of his own youth, of those distant reveries at the time he left college? As soon as he had passed his *baccalaureat*, his father made him enrol at the Faculty of Aix as a law student. On and off he attended lectures, but mainly he wrote poetry, verses 'of dark sadness'. When he was not setting the legal code into rhyming couplets, he would scribble sentimental metaphors about the swift passing of time, banal images but with a sudden sharp phrase here and there, a real cry of pain, a slang abbreviation for feeling. He felt isolated. His creativity agitated him. His intensive reading no longer overcame his hunger for love and knowledge. A few little platonic affairs – a hat shop assistant followed from a distance under the trees of the Minimes, then gently accosted on the path through the yards of Saint-Roch with words that frightened the poor little thing, so surprisingly and awkwardly passionate was this tall bearded boy with small burning eyes and a Calabrian felt hat – two or three provincial escapades to which he abandoned himself had a discouraging effect and confirmed

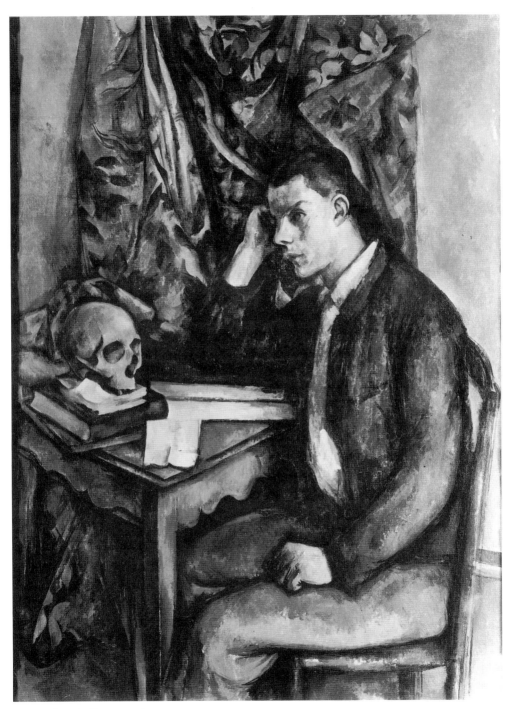

Boy with a Skull, 1896–98

him in his taste for Michelet's *L'Amour*, which he had devoured several times on Zola's recommendation. Zola was in Paris, Baille was at the Marseilles lycée studying for the Ecole Polytechnique. The vapid students he mixed with, his old school companions, had no spark, wanted only to be playing cards or 'quaffing a beer'. He saw himself as different, solitary, marked with a sign. He was afraid . . . And then it came.

The consolation and the discouragement, the passion of his life, its tyranny and its ecstasy, the unique, inevitable thing for which he had been born and for which he would die – Painting came. He surrendered himself to it with his shy child's soul, his fresh eye, the innocent vitality, power and exaltation of his faith. Everything else went by the board. He wanted to be alone with his painting. His friend Baille, who appeared at this moment to spend a few days' holiday in Aix, found him dry, mute, unforthcoming in his company. He did not understand this anguished happiness, this new aspect of his friend, any more than Cézanne could understand the mild pleasure of having a talk over a pipe, casual chat, time spent among friends. He fled anything that might distract him from his burgeoning art. The flame of youthful imagination sparked into the ardent flame of work. He wanted to spread this whole new world of colour and line which seared his brain onto canvases, walls, cardboard, paper, whether with a pencil, brush or charcoal. And there, in front of him, on spoiled sheets of paper or muddled canvases, all those visions that were so clear behind closed eyes proved to be nothing more than a shapeless confusion, a soggy mess with no figures or radiance, or, worst of all, an occasional image of appalling banality. He went at it furiously. With clenched fists, he wept in front of his mutilated dream, besmirched with muddy colours. He felt powerless. He spent whole days, in rain, mistral and sun, grimly wandering the roads, fleeing from his mistress – for he adored it, this pitiless painting, as a lover adores his tormentor. He retrod all the paths of his childhood, climbed up footpaths, roved the whole countryside again . . . Then, faced with a setting sun, an empurpled landslide of rocks, a soothing tree, a new look from a spring, he was seized by a kind of shame. Hope came back to him. He ran home and locked himself in. With trembling fingers, with a respect, an adoration for every living thing, he began his work again. Modest, fervent, pious, he applied himself. It was a religion. He had reasoned with himself on the way home. You must learn. You must. For this wonderfully dramatic creature, convulsed with sobs, clumsy with ecstasy, did not understand, could not understand, why his hand should hesitate when his brain could create, when his eyes could see and would themselves, it

seemed to him, paint (if only they were able) everything they touched with such certainty and love. Why should the subject and his method rebel? 'The form doesn't follow the idea!' he wailed. He hurled his brushes at the ceiling. He wept . . .

He tried a teacher. No. A professor. A friend of his father's, a worthy and meticulous painting instructor named Gibert*, who, as it happened, could do anything he wanted with his hands. He could express an idea, he had style and a formula for everything. But the sad thing was that he had nothing to say. One of those big fish in a little pond who judge without appeal anything outside their knowledge, one of those who, in Aix, at the 'Friends of the Arts' or over a beer at the Café Raphael, still ventured to declare: 'Delacroix? . . . A load of rubbish.' One evening in my company Cézanne heard this comment. I can still see his suppressed rage, the way his eyes suddenly went bloodshot and the savage gesture with which he put on his hat to leave.

The teacher set his enthusiastic pupil academic exercises, made him copy plaster casts, initiated him step by step in all the little tricks of the trade. It was doomed to failure. Cézanne had already done the course at the local art school, had even won the second prize in drawing, in competition with his friend Villevieille, whom he was to meet again the following year in Paris. But Gibert was no more use to him than his prize. It wasn't that he scorned hard work or turned up his nose, as was stupidly put about, at study and drawing. To the last day of his life, every morning, as a priest reads his breviary, he spent an hour drawing and painting Michelangelo's anatomical figure from every angle, and I remember with what respect he frequently referred to the example of old Ingres, when he was more than sixty years old, going under his umbrella to the Louvre and saying, 'I'm on my way to learn how to draw . . .'

But art teachers teach only what they know, and they know nothing. Tricks, systems – art has nothing to do with them, nor do the true masters. Cézanne, and it is one of the misfortunes of the age, had no master. He had to learn his way on his own. He gave his life to it. He had to rediscover all by himself those collective, first-hand traditional lessons, which had passed from one studio to another from the time of Siena and Florence, of the Venetians, up to David. He was a martyr to his quest.

'And to think,' he said to me one day, 'that all my experience is fruitless . . . I am dying without any pupils . . . I am nearly there, I have regained the main stream. . . . There is no one to carry on my work. Ah, the things I could have done if I had had a master! People will never realize how much Manet owes to Couture . . .'

His own pedagogue, instead of sending him to Paris, directing him to the Louvre, and at least, since he was 'as ignorant as a school master', refraining from inhibiting the development of his gifts, kept him in Aix, and, in all seriousness, considered him a bit abnormal. He had a talk with Cézanne's father about it.

'Painting is after all a matter of pleasure! . . . Your son has a nice touch with a pencil, that will be a distraction for him, as he has a fine future before him if he works hard at the law, and one day, either as a solicitor or barrister – who knows? – he will run his father's bank, eh?'

What could have got him in this state? They worked it out. All those letters Paul was receiving from that little scribbler in Paris, that pillar of the taverns who squandered his mother's last few sous with vicious people and was no doubt loaded with disease and bad advice. That was the source of the infection; it all stemmed from Zola. The story can be followed in the letters that passed between Zola, Cézanne and Baille. They are perfectly ordinary, but all the more poignant when one knows what fate was at work.

When Cézanne, suffocating in Aix, begged his father to send him to Paris, the old banker was unyielding. He did not believe in his son's painting. He feared what might happen to so upright and honest a young man amid the dangerous streets, companions and encounters of the large city. He wanted to make of his son a serious successor to his flourishing bank. Besides, these ideas about art were disturbing him, as his mother could see even when she tried to take his side, and would end up attacking his health and ruining his body, just as they were already secretly undermining his fine intelligence. It was a struggle all the more painful because father and son adored each other and each in his affection, the bourgeois rooted in his virtue, the artist guided by his instinct, felt he had reason on his side and could not yield. Give up painting? It would kill Cézanne. Naturally kind-hearted, he would have liked so much to erase the constant worry that he saw in his family's eyes. Mealtimes became gloomy. He sank into dejection. His work was affected. He neglected everything. He was falling ill. Paris, out there, seemed to him like salvation, security, fulfilment. Yes, true enough, it was the venue of every orgy, but his own orgies were only hard work, study and freedom. He would see the Louvre, Rembrandt, Titian, Rubens, that fountain with nymphs by Jean Goujon described in a letter received from Zola just that morning. He would learn by other means than the *Magasin Pittoresque* how to represent people; for one of his passions was to leaf through the illustrated papers by lamplight in the evening –

news and even fashion magazines – looking for women moving under trees, people in the streets, and from these urban, rural or domestic scenes, these activities of every sort, to re-create, to compose in his reveries, immense canvases that could never be realized, but which gnawed him with longing from head to toe.

He even tried to work out some of these fantasies by doing coloured versions of groups of young women, with slender waists or wearing crinolines, which he took virtually as they were from the fashion publications. Much later, in a canvas he did of his two sisters walking in a park, something remained of this 'style' – was it deliberate? The posture, the clothes of these two women, a little flag in the sky, a vase placed among the leaves, the ironic examination of naive elegance, the whole atmosphere of the picture is visibly inspired by the imaginings and dreams of this period. Printed images always amused him.

However, his hour had struck. His father had engaged a replacement for him. The law was making no headway. A decision had to be taken. This strained situation, painful to all, had to cease. 'You still want to go to Paris . . . You say that's the only place where people work . . . You want to study fine art . . . Painting doesn't keep a man fed . . . All right, try roughing it for a little while . . . Maybe when you have to tighten your belt a hole or two you'll return to a better frame of mind, and so, this way at least, you won't be able to make too serious a mess . . . Off you go . . .'

He left with an allowance of 125 francs a month to cover food, lodging, clothing, paints and living, but he was brimming with energy, ideas, health and faith. Emotion overwhelmed him. Zola and the Louvre were awaiting him. It was 1861, he was twenty-two years old. He was happy.

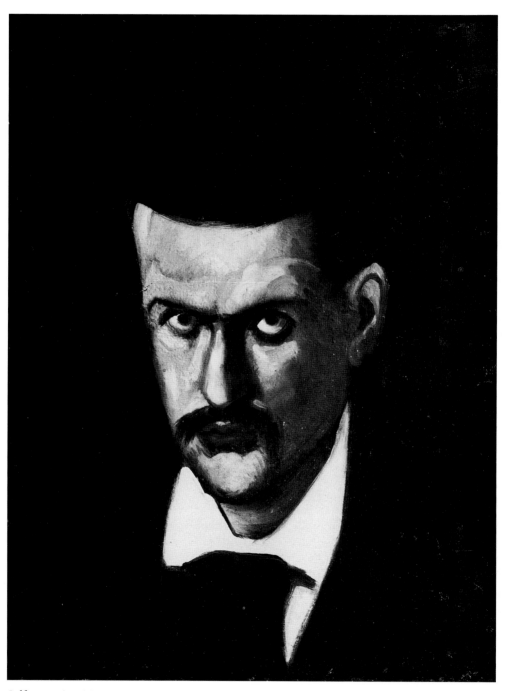

Self-portrait, 1861

II

PARIS

Cézanne's whole life was nothing but an alternation of boundless hopes and deep discouragements, rapturous fervours followed by black depressions. Every morning when he rose he set out to conquer the world, expecting his art to match up to his ardour and his determination; when he went to bed at night he despaired of life and cursed himself for having painted. His only consolation was his work, and when it 'went badly' he suffered a martyr's pains. He foundered in a slough of despondency. One evening when somebody found him in this state and asked what caused it, he replied, adapting a verse of de Vigny's:

> *Seigneur, vous m'aviez fait puissant et solitaire,*
> *Laissez-moi m'endormir du sommeil de la terre.*

His arrival, his mode of existence, and his first experiences in Paris were, like everything in his life, in turn delightful and sordid, overflowing with certainty and clouded by despair. He suffered from perfectionism, from the torment of singlemindedness.

All at once his way of life was highly regulated, devoted entirely to his work. He had only one wretched room in a furnished house in the rue des Feuillantines, but every morning he went to the Académie Suisse; he lunched briefly, he was always very sober, and enjoyed only at long intervals a more ample and decent meal, a proper blow-out; in the afternoon he returned to drawing, either in the company of his friend from Aix, Villevieille, who had gone to Paris before him and had a studio, or at the Louvre. After supper he went to bed early. Apart from Villevieille and Zola, he hardly saw anybody. He was working.

He was never satisfied with himself, nor with what he was painting. He resorted to interminable theoretical discussions with himself, which he enjoyed and from which he couldn't be distracted. At the Suisse you were fairly free. You paid your 'lump', the model was there, everybody sketched, dabbled or constructed at will. Friends were either wildly complimentary or burst out laughing. But other people never had much

hold over Cézanne. Zola wrote to Baille at this period, 'He is made of one piece, stiff and hard to handle; nothing will bend him; nothing will make him give up a point.'

It was at the Académie Suisse that he knew Emperaire, another Aixois, a dwarf with the head of a splendid Van Dyck cavalier, a burning spirit, nerves of steel, an iron pride in a misshapen body, a flame of genius in a crooked hearth, a cross between Don Quixote and Prometheus. Like Cézanne, about whom he often spoke to me and whose remarks he quoted, he came home to die in Aix, very old but still believing in the beauty of the world, in his genius, in his art; he was seventy and half-starved, but he still suspended himself from a trapeze in his garret for an hour every day in his fierce determination to 'stretch' himself and to keep alive. He left behind some very beautiful drawings in red chalk, and with the proprietor of a dive in the passage Agard an Amazon in the style of Monticelli, along with two still-lifes, one of which, of game, a painting of a partridge and a duck by a large bowl of blood, was particularly haunting and tragic. Cézanne liked these enough to go sometimes and eat the terrible ratatouille at the restaurant where they hung so that he could look at them at leisure. He would have liked to buy them but was not bold enough, he confided to me on the day when, the shop having finally gone bankrupt, the property was sold before the old master became aware of it.

He painted an astonishing portrait of Emperaire, the dwarf's heavy head standing out against the red flowers of a patterned chair cover; from the high armchair his little legs cannot reach the floor but are propped on a foot-warmer. Wrapped in his greatcoat, the thin man has just come from his bath. Emaciated, grotesque, exasperated and weighed down by life, pathetic, with long drooping hands, he raises his noble, sad face as if it were held in some brace of tragic will; and above his head, like an ironic proclamation, a friendly promise of fame, Cézanne inscribed the name in large capital letters: Achille Emperaire.

Cézanne spoke of him often and had an inexhaustible store of anecdotes about him; he considered him 'very strong'. One Thursday Cézanne and I ran into him at the Aix Museum and we walked round the galleries together. Nothing was more touching than to see the way Cézanne addressed the little fellow, lavishing affectionate attentions on him, readily espousing the imaginings of his dotage, his illusions of a dwarf's insights, and afforded him a great moment of joy by supporting his dream of unknown mastery and of fame following on the heels of death.

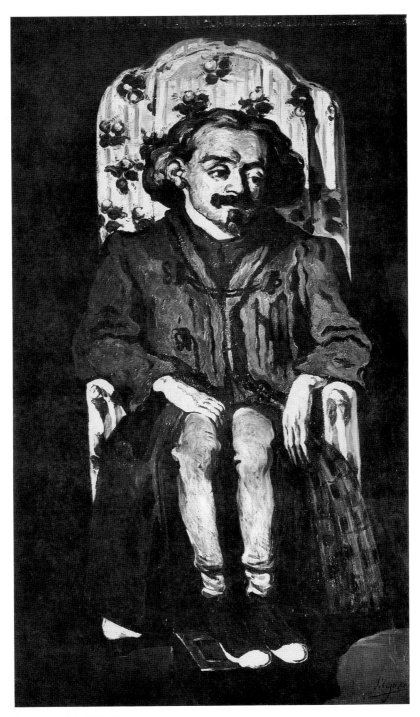

Portrait of Achille Emperaire, 1867–70

'There's a bit of Frenhofer* in him,' he whispered in my ear.

Emperaire was beaming.

I would not swear to this, but I believe that at the Académie Suisse, being older and at that time more knowledgeable, Emperaire had a certain influence, not on Cézanne's art, but on his theories. In any case I often heard him developing views on the Venetians, and particularly on Rubens, which were closely related to those of Cézanne and couched in almost identical terms. On the other hand, and this must have annoyed Cézanne, he loathed Delacroix, whom he placed below Tintoretto, but he had things to say about the natural nobility of the great nudes by Titian and Giorgione, the princely ease of Veronese, the Ronsard-like quality of Rubens, which must surely have delighted the old master of the Jas de Bouffan. Did they go round the Louvre together after they finished their day at the Académie Suisse? Cézanne in his hunger for painting had eyes for everything – churches, museums, exhibitions, shows. He dragged Zola to them, thus fostering his artistic education, as Zola recalled a few years later when writing his articles on Manet and the Salons. He loved trotting round Paris this way, standing on the bridges, walking down the Champs-Elysées, observing the Place de la Concorde. He read Flaubert, Taine, Stendhal, kept up with Sainte-Beuve's *Lundis**. As yet Courbet was unknown to him; the name and legend haunted him, but he had yet to see a picture by the artist about whom he was to say later: 'He is an objective painter. He sees the image fully formed in his eye . . .' But he dreamt of Courbet at that time as a gigantic revolutionary, a sort of outsize Renaissance character.

The transports and the passionate improvisations, the brilliant theorizing that he lent himself to with the spirited Emperaire were tempered by Villevieille's application, his more bourgeois attitudes and his good sense. The latter had married a charming, 'rosy, plump and lively' young girl, and the peaceful happiness of their respectable household sometimes inclined Cézanne to daydream about the joys of domesticity. He was happy in this setting, and retained fond memories of it . . . When his mother died forty years later, it was Villevieille whom he summoned to make a drawing of her on her deathbed, acting one one of those curious impulses out of the past, which made him want to reconcile his feelings with certain regrets, vague intuitions, and what he called the support of moral principles.

Between Emperaire, a bit overexcitable, a bit daft and romantic, and the soothing Villevieille, Zola exercised his calm assurance, his unswerving will-power, his robust spirit, but Cézanne was now a little

afraid of him. Among painters it was said, and not without reason, that Courbet's close friendship with Proudhon had had a bad effect on his recent work. An artist must not have social aims. His work, provided that it was in a good tradition, looked after itself. The painter's own pre-occupations, shaped by meditation and experience, always seemed to be sufficient. It was not popular subject-matter that instructed the public, but truth, order, the noble handling of colours and lines which, when harmonized, conveyed morality and justice. . . . Cézanne distrusted the literary side of Zola. He began to see a little less of him. He had just failed the examination for admission to the Ecole des Beaux-Arts. His fits of depression became more frequent. And just as he had dreamt in Aix of Paris, he dreamt in Paris of Aix.

He told himself that the air of Provence would give him back his strength. He wanted to work from nature again. It seemed to him now that the pines, the firm rocks, the definite planes of the hills in the Arc Valley, and the red earth of Le Tholonet would sustain him. He made a few attempts in the outskirts of Paris – with his friend Guillaumin he painted in the old park of Issy-les-Moulineaux, then in Marcoussis – but these groups of delicate trees, these lush riverbanks and tender growths did not suit his inflamed vision. He dreamt only of forcefulness and vi-olence. The bluish phantom of Mont Sainte-Victoire floated at the edge of his consciousness and was always there with him at the horizon of every landscape. In the torment of perfectionism that had afflicted him from the start, he always imagined that a change of location, of canvas, of motifs, would assist his efforts. Zola saw this clearly. 'It was always the same,' he says of Lantier, describing Cézanne in this period, 'his need to create outstripped his hands; he never worked at a canvas with-out thinking of the one to follow. His only concern was to get rid of the work in hand, which was killing him: no doubt it would be worthless again, it was made up of fatal compromises, trickery, everything that an artist's conscience should make him abandon; but the next one, ah! he saw the next one as splendid, heroic, unassailable, indestructible.'

And what he saw as heroic and indestructible was his Aix country-side, the regeneration of the brown landscape through a blaze of south-ern light, the soil and the sea, the sky appearing in his pictures with their authentic poetry; was grand nudes moving in open fields, rough as trees but human as a poem by Virgil; was an impasto of colours supported by a passionate freedom of line; was his future genius, as yet clogged with too much subject-matter perhaps, with the dirt of a palette which the mistral would sweep clean, with the rains of Paris clouding his vision

which, he was sure, would be scoured away by the first touch of sunlight on the lake and the olive trees, once past Avignon. He must get away . . .

Zola thought of a trick to make him stay. He asked him to paint his portrait. Cézanne leapt at the idea and set to work. At first everything went well. The sketch was marvellous. He was sustained by feverish enthusiasm, a glow of response. Then the sittings began to flag, became less frequent. The subject was really too much for him. He had undertaken a work beyond his ability. He recognized it. What he needed was to work, work! He could scarcely put two words together, and the final goal of art, he felt bound to proclaim, was the figure. Before embarking on the terrible problem of extracting an expression from the lines of a face, he needed to have accomplished the easier task of capturing the gestures of a tree, the look of a spring, the profile of a rock. Down there, round the farmhouses of Aix, on the threshing yards and harvest fields, the sun was burning in all its magnificence, spreading its great sleepy face as far as the blue shadows of the clear-cut hills. . . . One day Zola arrived for a sitting and found packed bags and an empty easel.

'What about my portrait?'

'I've ripped it up.'

That was in September 1862. It was scarcely more than a year since Cézanne had arrived in Paris. That evening he was on his way to Aix.

He spent a year there. After an autumn of work, and the joy of being back in the country among Provençal people and things, the chestnut trees of Jas, the peaceful streets and the fountains of Aix, his wavering returned. He was assailed by doubts. This time his dejection was so profound that he seems for a period to have given up painting. He didn't take up the law again, but did some kind of work in his father's bank. Was this in order not to provoke his family any more, to try to placate them after his setback at the Beaux-Arts? Was it a final bitter pill, a giving-in to pessimism? Once when I dared to broach this subject in a rash moment, he gave me such a fierce look that I was never tempted to bring it up again. It is easy to imagine him, wounded in this way in the prime of life, dragging himself about, champing at his bit under the plane-trees of the Cours Mirabeau. He couldn't keep it up. The mocking lines of verse he scrawled above a column of figures in the ledger sum up the tragedy and yearnings of his life at that time:

Cézanne le banquier ne voit pas sans frémir
Derrière son comptoir naître un peintre à venir.

In order to extricate himself from all this bookkeeping which was clouding his brain he cleaned up his box, bought some paints, and refurbished his sketching easel. He roamed round the town again. He deserted the office and spent his days sprawled on the grass under the cypresses in the grounds of the Jas. One morning we went off into the country. He was under the spell again. It was spring and hope was in the air.

In most Provençal manor houses, there is a large circular couch tucked away in a shady corner at the back of the salon where, on a heavy summer day, one can have a delightful siesta after lunch. The Jas de Bouffan, like every self-respecting country house, had one of these, and Cézanne had the exhilarating idea of decorating it. On the high wall above it he painted four young, lithe, primitive, dancing girls; Autumn, running with her basket and her burden of fruit, Summer with her arms laden with flowers, Winter crouching by a fire and reminiscent of some naive but wonderful work of Puvis de Chavannes brought to life. With a touch of childish playfulness, of student wit, he added the name of Ingres in tall provocative letters to this *Four Seasons*, which brought to mind rather some clumsy fresco by an unusual fifteenth-century artist working for Epinal*, the more so as there were already a sober life and a charming seriousness about these fantastic figures. The great Cézanne of the still-lifes can be perceived in the flowers, the sheaves of corn, the baskets of fruit; a noble decorative sense bathes the whole composition.

Unfortunately no landscape studies or sketches of this period have survived. They would provide a fascinating fund of information. I have learnt from Solari and Emperaire that he loaded his canvases with colour at that time, building up the paint broadly with a palette-knife, in effect darkening his tones, perhaps in spite of himself.

It was the moment when, unbeknown to one another, Monticelli in Paris, Gresy, Guigou, Aiguier, Loubon, Engalière in Aix, Toulon and Marseille, were following the same path and constituting a Provençal School the length of the coast and the valley of the Durance. Cézanne, who expressed Provence better than all of them, was – like Monticelli – a universal painter. In Provence, it was the world that he saw and painted, beyond Sainte-Victoire and the countryside of Aix was the horizon of the earth. Confined in his dead city, he could have been an Aubanel or a Mistral of painting. But higher things awaited him. In confronting the landscape of his birth with the landscape of his life, he realized with greater precision the essential lyricism of his country; in extracting its

Four Seasons, 1860–62

humanity, he extracted its very soul dissolved into the soul of the universe. As soon as he felt strong, reinvigorated by contact with his native soil and by ideas from his meditation and reading, retirement to the country was no longer enough for him. In 1863 he went back to Paris.

We now come, I believe, to the happiest period of his life. It was the moment when he was least preyed upon and harrowed by doubt, most uplifted by faith. Pissarro opened his eyes to Courbet, Guillemet introduced him to Manet. He felt free to be himself. He painted violently, according to Mottez, one of his Beaux-Arts teachers; he painted, as if in fiery poems, that whole series of feasts, orgies, vaguely naturalistic mythological subjects which link him with the Venetians. He was twenty-five years old, wonderfully healthy, warm of heart and blood, with an abundance of ideas which caught him up in a stream of subjects, lines, colours, of which he was bold enough to consider himself master. Nothing stopped him. Even his technique seemed to obey him. His mind was working at such a pitch that one day he yelled to Huot in the middle of the Salon Carré: 'The Louvre should be burned down.' On a page of his sketchbook he wrote in pencil these lines from *Emile**: 'The body must be vigorous enough to serve the spirit: a good servant must be robust. The feebler the body, the more it demands; the stronger it is, the more it obeys. A weak body enfeebles the soul.' And below, in his large handwriting, underlined: 'I am robust. I have a strong spirit.' On the wall of his studio he inscribed in charcoal: 'Happiness consists in working.'

This studio was only an attic with dazzling windows. 'The young plein-air painters,' wrote Zola, 'all had to rent studios that the academic painters didn't want, those which were visited by the vital flame of the sun's rays.' Cézanne was no exception. He lived near the Bastille in his sort of greenhouse, in a sheet of light, practically penniless but in joyful overflowing of all his senses, a plenitude of all being in which his genius expanded in spirited sketches, canvases full of wild ideas, gorged with sensations, strained to cracking-point under the heavy layers of radiant colour. He painted everything that came to his hands or his eyes.

'Isn't a bunch of carrots,' he cried out, 'yes, a bunch of carrots, observed directly, painted simply in the personal way one sees it, worth more than the Ecole's everlasting slices of buttered bread, that tobacco-juice painting, slavishly done by the book? The day is coming when a single original carrot will give birth to a revolution.'

Philippe Solari has told me that he heard exactly these words, which

The Feast (The Orgy), 1870

appear in *L'Oeuvre*, more than twenty times from Cézanne's own lips.[1] They lived virtually together. Camille Pissarro and especially Solari were his two new friends. About the same time he got to know Renoir. All his life he remained bound to Solari, a delightful Bohemian sculptor whose sketch models he adored. To my knowledge he was the only one of Cézanne's friends who never experienced his fierceness and his sudden seizures of misanthropy. Solari was so gentle, such a tactful friend. And one had to hear the old Cézanne murmuring with a wink: 'Philippe! . . .' All his loving irony, all his richness of heart was in his voice. Perhaps it was his distant years in Paris coming back to him.

As a prizewinner of the Ecole des Beaux-Arts at Aix, Philippe had been sent to Paris at the town's expense to prepare himself there for the Prix de Rome and, with his lively and intense nature, soon became one of the merry band of revolutionaries. He lost no time eating his way through his small monthly allowance, at which point the two friends cooked their meals together, smoked the same plug of tobacco in the same pipe, and lived on a common budget. One exceptionally hard week, as Solari told me, having only one presentable coat between them, they took it in turns to go out for some fresh air while the other remained in bed. They thoroughly enjoyed taking strolls in the Luxembourg Gardens and sleeping there on benches in waste ground: for them it was like a riotous day out. Another treat, all one winter, was a demijohn of oil, sent from the Jas, into which you dipped sops of bread so scrumptious that you went on licking your fingers up to the elbow. That was the winter when Zola brought Manet one day to visit the shop transformed into a studio where Solari was working on his Salon entry.

Its subject was a tall Negro fighting back some dogs, the same man who posed for Cézanne's famous *Negro in Blue Trousers* which Monet owned. Manet, Cézanne and Zola walked round the gigantic model. '—The War of Independence,' said the delighted Solari. They began to shiver. He lit a fire. Then a terrible thing happened. The armature of the statue, made of old chair legs and broom handles, cracked under the heat. The Negro caved in . . . Solari had to send him to the Salon still

1 Apart from the evidence of Solari, to which one must add what I have gathered from Huot and Numa Coste personally, one has only to go through the letters of Zola's youth to be certain that the influence in the 'path' of naturalism was received by the novelist from the painter. All Zola's early letters from this period overflow with 'idealism' – the word is repeated several times – as much in a moral as in a literary sense. It is Ary Scheffer whom he proposes to his friend as a model. He had a vigorous hatred, in his own words, of realism. One could multiply instances. Dante and Shakespeare, George Sand and Michelet, the Michelet of *L'Amour*, are his great enthusiasms. See especially his outline to Baille for a volume on the poets and the plan for an immense epic that he wants to write himself. It was not until 1864, in his theory of the Screen (letter to Valabrègue) that he declares himself for the first time a realist. Cézanne had always been one. It was the base of his temperament. His romanticism derived in large part from Zola.

being bitten by the dogs, but lying down. It was a great success. Albert Wolff praised it in *Le Figaro*. A guano dealer bought the woolly-haired Independent, painted him over with black varnish, and made him, ye Muses!, his trademark. As Zola tells the anecdote in *L'Oeuvre*, the Negro becomes a bacchante.

'These realists,' concluded Cézanne when, in front of Solari at Le Tholonet, he told me this story between fits of laughter, 'they're always up to tricks like that . . . eh, Mahoudeau?'*

Because he was shy and awkward, Cézanne saw very little of Manet. From a distance he felt a certain veneration for him, even though he sometimes criticized him for being too easily satisfied with nice 'studies', for having put museums before nature, and for being basically 'short on colour'. But the *Olympia* completely won him over. One day he brought me a large photograph of it.

'Here you are, put this somewhere, on your work table. You must always have this before your eyes . . . It's a new order of painting. Our Renaissance starts here . . . There's a pictorial truth in things. This rose and this white lead us to it by a path hitherto unknown to our sensibility . . . You'll see.'

He also spoke with great emotion of *La Sortie de l'Opéra* which he had admired one day when he was in Manet's studio with Solari.

'The heroism of modern life,' he said, 'as Baudelaire called it . . . Manet caught a glimpse of it. But,' he added, 'it isn't quite that. I saw it more broadly.'

What did he mean by that? Once back in Paris, he took up his restless pursuits again. He had become intimate with Camille Pissarro, 'the humble and colossal Pissarro', as he was to call him later. The latter helped him to look at things in a more direct way, closer to nature and more down to earth. He led him away from his mythical, poetic themes to orchards and ploughed fields, to the villages of the Ile de France. He discussed Courbet with him from a naturalistic point of view – getting past the romanticism to something more deeply rooted in Cézanne's nature, the realism in his Latin heredity. They experienced together, at the Salon des Refusés, the revelation of the *Déjeuner sur l'herbe*. It went to their heads. They went to the suburbs, along the Marne, to paint 'from nature' and sometimes even set up their easels right in the middle of Paris. But Cézanne came home from these sessions overwhelmed and even more frustrated. Contact with the great outdoors and wide horizons did not satisfy him. On the contrary. The inner conflict began all over again.

Looking at his decorative sketches with their impassioned figures, their heavy dream-like foliage, 'the naked and flushed breasts of his dreams' in frenzied alcoves, he was overcome by an uncertainty that one should invent anything at all: one should paint, Pissarro was telling him, only what could be touched by hand or seen with the eye. And when he stood by the sluggish river, his easel set up under real branches, his feet planted on lumpy ground or in grass, he longed for grand composition, he was haunted by the memory of the masters, the triumphs, the big scenes in the Louvre. And he, who was laboriously trying to translate straightforward nature, to record it in his own way, felt compelled to dominate it, to transfigure it, to impose on it a tragic or a brooding mood, or plunge it in blazing sunlight, and turn the whole thing into a kind of paganism which would span the centuries to join hands with the great period of the nude when man had created his own Olympus. At such times he would rush to his studio, fleeing from the overbearing earth, sky and water, which threatened to crush him, obliterate him, too stiff and unyielding to mould into the apotheoses of his imagination. He wanted to give them flesh and blood. He fought against the unprofitable air, the allurements of flesh. He closed his ears to the moist voices of the rain, the wind's caress, the call of the sun in the leaves. He barricaded himself, alone with his models. Sometimes a friend. His brain was on fire. Those who saw him at that time described him to me as strange, haunted, half beast, half god in pain. He changed models every week. He was so thwarted by his inability to satisfy himself that, 'priding himself on being incapable of inventing anything, he worked without any references apart from nature.' He produced atrocious sketches, studies, paintings.

In the attic at the Jas de Bouffan I have seen a canvas full of holes, slashed with a knife, grimy with dust, which had landed up there somehow or other and which was burnt, it seems, along with thirty others, even in Cézanne's lifetime without his deigning to bother with them. This particular one, wild, cracked, battered, glowing, when I had wiped away the layer of dust that soiled it, revealed to me, crouching on a cloud shaped like a swan, a creature bulging with flesh, with a straining belly, swollen breasts, her face shining, glorious and hideous beneath a tumble of reddish-brown hair, her hands caked with blood, an enormous necklace of gold chain across her thighs, and her body struck, like Danaë's, by a shower of light and gold coins. Around her, in broad daylight, a hideous, distorted, baying pack of fully clothed men, priests, generals, oldsters, a child, workers and judges, faces in Daumier's style

Manet, *Olympia*, 1865

but bloated and red as if smeared with blood, a riot of bodies cut across by a Dantesque rainbow of strange hues which rolled round them like a snake, a whirlpool of shrivelled arms – and under a star in a black corner of the sky, a white apparition covering its eyes.

'Just the thing for Mirbeau* – eh?' said Cézanne, who caught me deep in thought before this scene, and with a kick he sent it rolling to the back of the loft.

Not all his visions of this period had that alarming biblical character. There are some lovely little pictures that bear comparison with Monet's *Femmes dans un parc* and *Goûters sur l'herbe*, but denser, pithier, more variegated, in which, at the foot of bright boulders, in the green shadow of forests, he has grouped dishevelled figures, flowery hats, crinolines, at gentle festivities in which the merest touch of pagan melancholy dignifies the pearly laughter and the kisses falling like leaves. The wine in the carafes, the pork pies and bread, the bloom on the fruit, the inviting napkins hint at the arrival of a successor to Chardin. Slowly the figures disappear. A different, more elusive charm, a sort of rustic mysticism opens up the glade, thickens the greenery. Everything takes root. The fragrance of the earth impregnates the air, which turns blue. Nature steps in, more and more it alone attracts the young painter, excites and absorbs him. He is still modelling it, he is learning to modulate it.

In 1866 he went off to spend many months in the country, returning to Paris only at long intervals.

He was overjoyed when Zola dedicated *Mon Salon* to him, a pamphlet bringing together the articles published in *L'Evénement* which had caused such a stir and then suddenly been discontinued. He knew it was his contribution to their discussions which in large part inspired all those lines that sparkled with courage and truth. He loved a fight. He spread alarm. The jury had not yet admitted him and were only to do so once when Guillemet took them by surprise and made them accept his portrait for the Salon of 1882. He was banished. So much the better. He gloried in it. The very streets breathed battle. For him, the air around the Palais de l'Industrie smelled of gunpowder. This year they had just turned down, along with his own entry, what was perhaps Edouard Manet's strongest work, worthy of the Louvre, *Le Joueur de fifre*. But Courbet exhibited his *Femme au perroquet* and *Remise de chevreuils*. There was talk of giving him the Gold Medal. The rising generation found these canvases less powerful and above all less serious than *La Baigneuse* or *La Curée*, a far cry from *The Burial at Ornans*. Millet, whom they admired for his weight and substance, was becoming indeci-

sive and soft. There was no longer that breath of the earth which filled the horizons of his earlier landscapes. Théodore Rousseau had less breadth, was becoming fussy. But Claude Monet was showing his *Camille*, and all the young painters rallied around him, were excited by him, setting him up against the enemy, Roybet, who, with his *Un fou sous Henri III*, sought to create a sensation. Cézanne fought in the front ranks. He came hurrying from the country, bearded, his hair uncut, his nose like an eagle's beak, wearing his red waistcoat, full of fervour, trailing a fresh whiff of leaves and springs, as he appears in a portrait of that period; affirmative, dogmatic and, once it was no longer himself involved, as convinced of the genius of others as he was unsure of his own. At sixty he still took off his hat whenever anyone spoke in his presence of Claude Monet.[1]

'The best eye any painter ever had,' he would say.

How enraptured he must have been when, at the age of twenty-seven, with his fire, his rebelliousness, his beliefs, he led a group of his friends to the tall canvas on which a fellow of his own age had created the green and black *Camille*, the dazzling young woman in her striped dress. He was infected with a healthy dose of emulation. The more one admired the better one worked, the more faith one had in oneself. He understood his limitations, but at the same time he also understood the immense possibilities that were growing in him. Once again he went off to confront the oudoor world, the changing seasons. He contended with nature. His untrammelled vitality, his seething genius needed no other discipline but nature. He would come back to it tirelessly, he always came back to it. 'Everything, above all in art,' he was to write towards the end of his life, 'is theory developed and applied in contact with nature.' And to a young painter whose first steps he had hopes of guiding, he wrote, 'Couture used to say to his students: 'Keep good company,' or : 'Go to the Louvre.' But after seeing the great masters who have come to rest there, one must hurry away and let nature revive the instincts, the feelings of art that exist in us.' In giving this advice, he was summing up his own past experience. He knew how intimidating it was to face reality and how daunted he had been by nature in his early career. 'An anxious modesty made him feel small in front of it.' He was so intent at that point on absolute solutions that, despairing of ever attaching to the elusive and perfect contour of objects an outline of exactly the right shade, he gave it all up. His qualms, his doubts, his anger returned.

1 Towards the end of his life he wrote in a letter to the young painter Camoin, who was going to spend a season at Giverny: 'I hope that the artistic influence which the master [Claude Monet] cannot fail to exercise on those who are directly or indirectly in touch with him will make itself felt to the strictly necessary degree it can and should on an artist who is young and ready to work hard!'

In 1867 he came back to Paris. The streets reawakened his excitement. As happened every time he had a change of atmosphere, of thought, of subjects and canvases, he was sustained by a muffled certainty. He was full of optimism. He dreamt of 'enormous pictures'. He attacked canvases of four to five metres. None of them satisfied him. He thought of doing a mural. He roamed around stations, churches, markets. Nothing put him off. He would have loved, as Solari told me much later, to work out of doors and decorate façades, like a Venetian, and mingling with bricklayers, plumbers, labourers, he would have painted them in action on their scaffoldings, celebrating on the dazzling wall the glory of work and life.

The combinations of violence and timidity, humility and pride, doubt and dogmatic affirmation, which shook his life now erupted into his art. It seems that he carried some canvases to extremes, plastering them with paint, chiselling them, daubing them with a rainbow of colours seemingly carved from gems, in the style of Monticelli. This was the period of the 'blunderbuss'. It was said that he fired at the canvas at close range, discharging colour from a loaded blunderbuss. The same people also claimed to know that Wagner, intoxicated by perfume, wrote his scores by spraying ink at random on his staves. At other times, however, when Cézanne wasn't painting with the blunderbuss, he applied himself, like a good child, groping his way, dreaming vaguely of the academies, of the Salon. But under his fingers the line would soon break out, the drawing would burst into multicoloured pistils. Large female figures would blossom in every corner of his studio.

For suddenly and often, until the day he died, a burst of energy, a hectic craving would set his body on fire. As formidable as his love of painting, a pagan passion, a frenzy of the flesh beat in his blood, fevered his temples. Everything alive seemed to him splendid. The black fire of his genius was concentrated in his desire to glorify the world with a supernatural sensuality. He experienced in flashes the dramatic ecstasies of Tintoretto. Although he was so sound, so robust, so virtuous, there ran in his veins a fire which, in the mysterious depths of his being, would stir something, perhaps, of Géricault's or de Musset's uncontrolled abandon. But he kept it in check. Nude flesh made him giddy, he wanted to leap at his models; as soon as they came in he wanted to throw them, half-undressed, onto a mattress. He was excessive in everything. 'I'm a man of extremes,' he said, 'like Barbey.'* A consolation, a new torment remained for him. He had found another way to adore those nudes whom he chased from his studio, he bedded them in his paintings,

Poussin, *Triumph of Flora*, c. 1630

tussled with them, lashed them with great coloured caresses, despairing to the point of tears at being unable to put them to sleep in scarlet enough rags, to stroke them with subtle enough glazes.

Until his death, and beginning at this period, when he made his first sketch inspired by Rubens, he worked constantly on an enormous canvas, abandoned and taken up again twenty times over, torn, burnt, destroyed, restarted, the final version of which is in the Pellerin collection*. At one time I saw a splendid, almost finished, version of it at the top of the staircase at the Jas de Bouffan. It stayed there for three months, then Cézanne turned it to the wall, then it disappeared. He didn't want one to mention it to him, even when it glowed in full sunlight and one had to pass it in order to reach his studio under the roof. What became of it? The subject which haunted him was a bathing scene, women under trees in a meadow. He made at least thirty little studies of it, two or three of them extremely delicate and finished, a multitude of drawings, watercolours, albums of sketches that never left the drawer of the commode in his bedroom or the table in his studio.

'This will be my picture,' he would say occasionally, 'the one I shall leave behind . . . But the centre? I can't find the centre . . . Tell me, what shall I group it all around? Ah, Poussin's arabesque! He knew all about that. In the London *Bacchanal*, in the Louvre *Flora*, where does the line of the figures and the landscape begin, where does it finish . . . It's all one. There is no centre. Personally, I would like something like a hole, a ray of light, an invisible sun to keep an eye on my figures, to bathe them, caress them, intensify them . . . in the middle.'

And he would tear up a sketch.

'That's not it . . . And then, the business of arranging all those poses, out of doors . . . I have tried, when the soldiers are bathing, going along the Arc and observing the contrasts, the colours of flesh against the greens . . . But that's something else, that doesn't help me, that can't help me with my good women . . . But wait, good heavens! what a mannish look this one has . . . They're still in my eye, those recruits.'

And shaking his fist at the delicately blue-tinted figures in his sketch, and perhaps beyond their shimmering presence to womankind in general: 'Oh, the bitches! the bitches!'

The large *Bathers* in the Pellerin collection was never finished. It is animated by fifteen radiant nudes. Beneath tall trees with smooth, slender trunks, meeting in the sky and forming a pointed swaying arch as of a vegetable cathedral, which opens onto a fresh Ile de France landscape, these women are preparing to bathe on the bank of a slowly moving

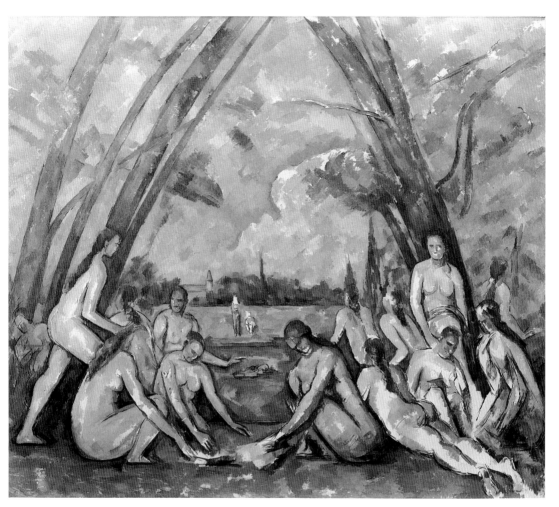

The Large Bathers, 1898–1905

river. One of them is already letting herself be carried along by the stream, her hair floating, her head laid back. Others hurry forward. They form two groups, eight in one, six in the other, unified by the whiteness of a cloth with which three of them are playing on the bank, by the one who is swimming in the exact centre of the composition, and farther on, in a field in front of a château, by a man who is observing them. Is that the eye of the sun Cézanne was talking about and which he decided to make human, to render less symbolic but more lively? In any case, it is the man who forms the centre, he and the arch of tree-trunks, the pointed stained glass window of the branches, and the cloth in the foreground. The water is deep, the grass gleams. The limpid French landscape is as pure as a verse of Racine. It is a bright summer afternoon ... At first the women seem to be out of proportion, massive, square, the two running are like a carving on an Egyptian relief. But then one goes closer, one studies them for a long time. They are elegant, elongated, divine, sisters of Jean Goujon's nymphs, subtle daughters of the naive *Seasons* at the Jas. One of them is retreating with the gesture of a dazed girl being chased; her legs are not visible, but one can see her hand, clenched like that of a Cambodian dancer, and one feels her leaping, pubescent and enraptured, through the green stalks that brush against her. Another, calm, olympian, is leaning against a tree and daydreaming, her gaze far away. Another is stretched out, contented, at peace, well placed to watch her friends in the water as she leans on her elbows in the grass; and her full breasts, her hard, massive thighs, her brown hair are bathed in the light and shiver, soaked by a blue breeze like a dream spread over silky flesh. The two who have been watching the swimmer and have decided to join her are already quivering as the water touches them. On the left, in the same group, the tallest, with the great stride of a warrior, disperses the others. She soars. She is strength, youth, health. Slightly bent, she is parallel to the luxuriant shoot of a tree, she is herself like a walking tree, a human plant, ready for love. And behind her, the forsaken one who has fallen asleep sighs at the treachery and the charm of the grass where a fragrant heat is flowing. But the two most beautiful, in my opinion, are those who are crouching, magnificent and royal, holding out a cloth to their kneeling sister, and forming with their outstretched arms a Mallarmé-like curve, which is underlined with a stronger sweep, a fuller fervour, by the fleshy curve of their hips, the blond hair of the one who has a tiny head on a goddess's body, the strong shoulder of the other whose face is pensive under her weight of hair. There is a grace, a joy, a pride about them all ... It is

moving that so much doubt, torment, rage should have been resolved into such tenderness, kindness and peace. There is no trace of Cézanne's agonizings or burning tears in these Virgilian games, this innocent festival, this dance of vegetation. Nothing is expressed in this Eden of pagan streams, harmonious bodies, tender trees and blue nudity but power and balance. From afar, from deep down, a great bewildering gust may seem to emanate from a tragic orgy, and you scorch your face; then you ascend, and there's no other mystery there than that of happiness and perfect health.

But nothing, not even these sensual flare-ups, this carnal stupefaction at the sight of woman, this love of love itself, prevailed for any length of time over Cézanne's only true passion. In truth, he worshipped only painting. Like Flaubert, never satisfied with the finished page in front of him and oblivious to anything else, a pure will, a sort of sanctity, kept him cloistered in front of his canvas, isolated him from everything else. Even when he was away from his studio, nothing existed for him except the work in progress. All his thoughts and sensations drew him back to it. It was a state of feeling which can be compared only to that undefined reverie which envelops lovers wherever they are. Nothing interested him but his art or the point of view of his art. Everywhere, in the street, at meals, in a café, he would stop talking or listening, half-close his eyes, observe, take note of a shadow, follow a gesture, a line, a trait, check a contrast, take everything in, seize it in his memory, compare it to his work of the night before, chew it over with a view to tomorrow's work. He lived in his work. He could not bear any attack on it. That was the source of all his agonizing, which people took to be a mania. Towards the end of his life he regretted not being a monk like Fra Angelico, so that, with his way of life regulated once and for all, interrupted only by frugal meals and the beautiful repose of the mass, free of preoccupations and cares, he could paint from dawn to evening, meditate in his cell, never being distracted from his meditation or deflected from his work. A whole unsociable side of his character persisted in his constant fear of insensible people who had nothing to do and therefore wasted other people's time. He avoided them like the plague, after having given in several times to their distracting sympathies with his own expansive directness. He was very considerate, and it was extremely painful for him to upset anyone, even a stranger. When someone came to see him, he was at first wildly angry at the idea of the time he was going to waste, but then his natural goodness asserted itself. He took hold of himself, and with charming diffidence welcomed the very person on whom he

had not been quick enough to slam the door. For this proud-spirited man was essentially humble. People seemed to him prodigiously complicated, and working out, once they had gone, how they ticked, deciphering their thoughts and their aim, meant minutes lost to him from work, from painting. He shut himself in, wanted to see no one. And this was not just the misanthropic madness of an old man. He was like that even in his youth. He went to ground for weeks and wouldn't let a living soul into his studio, avoiding any new friendships. This is made evident in a reply from Emile Zola, in May 1870, to a letter from Théodore Duret, one of Cézanne's first buyers, who wanted to initiate friendly relations with him.

Slowly, in his heart, everything that was not strictly concerned with painting receded. All his humanity – his attachments, his country, his family, friendship – became lost in his religion, and had no more meaning for him than for a Spinoza or a Francis of Assisi. One has to think of him, I believe, and particularly at this period in his life, as being competely removed from ordinary conditions. He sublimated himself in painting as a monk does in God. It was his mysticism, it isolated him. His earthly interests, his civic duties, his natural feelings all fell away in the face of painting. I can give a couple of examples of this.

One evening at the Jas, some farmyard hayricks were burning. Fascinated by the coloured play of the flames, he was lost in contemplation, noting the shades, discovering some enigma of colour or shadow. The firemen arrived.

'Wait!' he shouted.

They thought he was mad and persisted. He grabbed a rifle.

'I'll shoot the first man to put out the fire.'

And until everything was reduced to ashes he revelled in the fire's spell, studying its reflections and its dance.

Much later, in 1897, on the day of his mother's funeral, he went off as usual 'to the motif'. This was his best way of praying and communicating with her in death.

War broke out. He might have been conscripted like Bizet, an equally great artist, or volunteered like Camille Saint-Saëns or Henri Regnault. Flaubert, whom he resembles in so many other ways, rose up like an old lion at the sight of his wounded country, bellowed away in his admirable letters to George Sand, left work on his *Temptation of Saint Anthony* to organize a company of snipers around captured Rouen. Cézanne, a more intense votary of his art than the others, a mystic in his

work, a monk in his painting, saw nothing, heard nothing of the cries of his threatened country. Oblivious as Archimedes, who was found on the beach solving a problem amid the clamour after the capture of his city, Cézanne would have gone on painting with bullets flying all around him. He left Paris. I don't want to disguise or omit anything I know of his life. It was said that the police were searching for him in Aix. He had disappeared with his mother to L'Estaque. He was painting by the sea.

Cézanne carrying his painting materials in Auvers, *c.* 1874

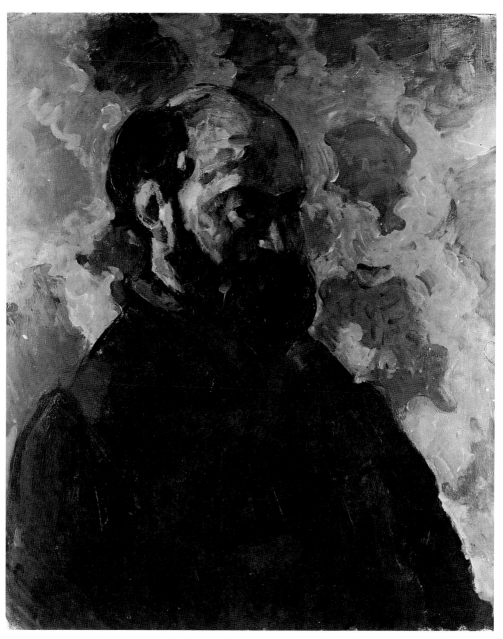

Self-portrait, c. 1872–73

III

PROVENCE

The stray bullet that landed Regnault in a ditch, the end of the war, to which we owe Saint-Saëns' *Marche héroïque* and Bizet's overture *Patrie* – did they have any effect on Cézanne? Did he feel remorse? Did he take pleasure in having saved himself entirely for his art and in placing the humble glory of his métier at the service of the enormous traditional glory of French painting, which no defeat of arms could ever wipe out? Did he think of himself as a worker in the salvation of his country? In that poor village of fishermen, where there were not enough hands for the boats, what were his thoughts?

He is always there to be read in his art. One can only judge by results. His canvases became deeper. More solid and more airy at the same time. His art assumed a gravity, a fluid austerity, which may also be attributed to his rediscovery of Provence and the intensified horizons of the sea. He shook himself free from all influence. Courbet no longer weighed him down. He was himself.

He had just turned thirty-two. He was physically at his peak. Circumstances forced him to reconsider everything that he had disdained or overlooked up to then. He was aware that, in the eyes of most people, he had just committed a serious act, a crime. Yet he knew that it was in no way a matter of cowardice. Perhaps he dared to convince himself that genius has its own laws and is not subject to ordinary discipline. Can one live without discipline? Yes, genius has its own. But what is it? In the case of an excessively passionate temperament, a mind like his, everything becomes concrete and material. All that he gained in the way of self-awareness, every step towards self-control, was reflected and expressed objectively in his art. Basically he too was one of those men who believed most actively in 'the reality of the ideal'. But did he believe, had he ever believed, in his genius? His doubts began to revive. Once before, in an attic in Paris, during just such a crisis, despair and renunciation might have overwhelmed him. I have seen him in the same

condition much later, when he was approaching old age and arrived in Aix full of disgust, determined never to touch a brush again, to let himself die, dried up, done for, without faith, even in painting itself.

But in 1871 he had the sea. The salt air was bracing. He chatted with old fishermen who had no news of their sons, possibly dead or prisoners in Germany. He became aware of human suffering. A blast of the mistral filled his sails. He pulled himself together. From these simple people he received a support which he could not even have imagined. He learned what, to the artist's true eyes, might still be merciful in the bitterness of the setting sun or the hesitant hope of dawn at sea. And then, at thirty, even if one is racked with regrets, the aridity doesn't last. Energy arises from the doubts themselves. A man of theory like Cézanne quickly invented a system for shielding his inflamed sensibility. Later on he would suffer new pains, but his internal agitation found solace there. Art is nourished by faith, whereas reflection leads to doubt. Cézanne had sudden illuminations which he was unable to sustain and, thus overstretched, he never attained repose. He nearly attained it in l'Estaque. That's what he believed. That's what he told himself.

Paris had been oppressive, wasteful, obtrusive. He had to rely on nature. The nature of his homeland, which was consonant with his blood. It was only here, in Provence, that he would rid himself of the romanticism that was a distraction to him. He painted in the presence of the classical sea. Those waves had brought civilization to the ancient Celtic forests: order, measure, wisdom. Those roads he walked with his easel on his back he owed to the great practicality of Rome. It was no good dreaming with brush in hand, he had to learn reality like Virgil. He too, the Platonic positivist among the war veterans, had polished his first eclogues during a national upheaval. The countryside restored his equilibrium. Nothing is beautiful if not true. During all those frenetic years of the Second Empire, France had been in a state of hectic illusion. It had jeered at Flaubert, Courbet, Renan. It had condemned Baudelaire. It had snubbed Taine and Claude Bernard. In its frivolity, its licentious taste, it detested those with clear and sharp vision. That was the road to perdition. While hissing Wagner, they were applauding *La Femme à barbe*. While looking on Manet as mad, they were infatuated with Thérésa* and with Emile Ollivier*. Everything crumbled in artifice and lies, everything was degraded. There was no time to waste, action was needed. Why shouldn't he, like Zola, dedicate himself, within his own field, to the immense task of rebuilding France especially

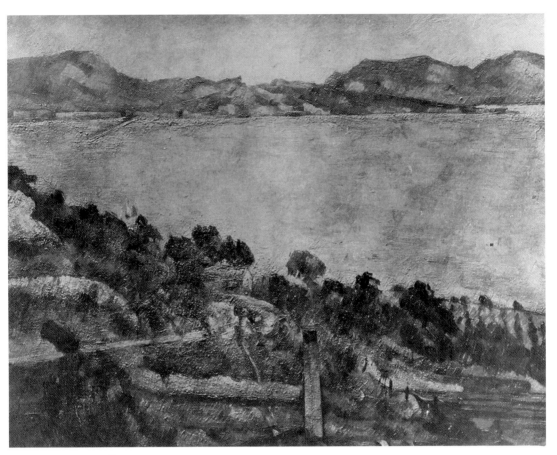

The Gulf at Marseilles, 1883–85

since, in the general panic, affected in spite of himself by the error surrounding him, he had unwittingly deserted his post. Now he could see clearly. He would spend all his life making up for it. One had to be true. Truth was everything, in politics, in morality, science, art. He had only one weapon, his brush. He would apply himself to work. He would bring back truth in painting. He had felt this in a confused way; now he was sure. This was his mission, his delight, his wish. It was his Calvary. He would abandon the large, false subjects. He would never move a step away from nature . . .

Did he tell himself all this in the full light of his integrity and intelligence? Or did he work it out in his unconscious, amidst the contrary impulses of his harsh, feverish temperament and of his sensitiveness brought under control? We shall never know. What is certain is that during the last years of his life, he spoke in this sense; he assured me in fragments of conversation on a number of occasions that he had these ideas from the time of an upheaval, an inner conflict which he did not define. I suspect that is happened after his flight to l'Estaque. Everything points to this.[1]

Like his art, his life changed after the war. He fell in love. He had a son. He married.* He brought order to his life, as to his art. And towards the end, in his need of order, of traditional support, he even went as far as the regular practice of his religious duties. He placed all his hopes of social recovery on the head of his son, whom he cherished to the point of adoration. But nothing diverted him from painting. All this growth of self-awareness, this development of impassioned wisdom, went on, as he said, in his 'heart of hearts'. He went on painting.

He painted the sea, its density, its humid light, its infusion of the sky. He hung it from the horizon, massive and blue, as it appears sometimes from the heights of l'Estaque when one suddenly emerges from between walls of rocks and faces it. He suspended it in the stone frame of those rocks like a great upturned mirror. The hills of Marseille-Veyre quivered out there 'white with the heat and soft'. The islands floated, outlined in the bluish dazzle. Each wave seemed to harden into a blue crystal. He painted the scene flat, bitter, deserted . . . And at other times the landscape became wild, no longer anything more than an outcrop of stones running down by bushy streams towards a grey creek where a little salt water came to soak a track of dried-up broom. With a few pines he made a peristyle of rough columns for it, he caressed it in the deep shadow of scaly branches. He framed it with stiff tree-trunks and lofty foliage. But what he preferred was to establish firmly in the foreground the rugged declivities of the ravines in which the Nerte tunnels itself, to heap up fields, to crowd together warm shadows in the cavities of reddish torrents, to pick out a line of red roofs, the bright smile of a farm-

1 A passage on Camille Pissarro in Emile Bernard's *Souvenirs sur Paul Cézanne* would seem to contradict this: 'Until I was forty,' Bernard has Cézanne say, 'I lived as a bohemian, I wasted my life. It was not until later when I knew Pissarro, who was indefatigable, that I developed the taste for work.' Now, Cézanne first knew Camille Pissarro in 1863. This is documented. He was at that time twenty-four. Ten years later, in 1873, he spent a whole season with Pissarro at Pontoise, where they settled together in the hermitage. In 1874, Pissarro engraved the famous portrait in which Cézanne appears, his nose like an eagle's beak, wearing a cap and an overcoat. He was thirty-five years old.

house, and then, like a shoulder hunched against the wind, a harsh chunk of sea set in all its intensity into the sky. And best of all, to place a village at the foot of a hill, among green tracks and harvested fields, to have square hovels and grassy gardens nestling among factory chimneys and purple brickworks, while at the very top of the canvas, a thin sky, fluid and tender, light as a child's glance, lets fall a thick tapestry, a fleecy carpet, hanging down to the islands below, where sea currents hem it with briny shimmer. He painted . . .

Two years later, within his eternally troubled soul, another dream, the dawn of forest paths, awoke gently. He was tired of the aridity of sea and rocks. All that dazzle of water, those descents of rocks, became sterile through their immense insensibility. The pines were leafless. What he wanted again were the winged shadow, the limpid stirrings of the Ile de France, the close horizon of the forest, the slow pace of river and sun. He was tired of dust. Those blinding holes in the countryside created an emptiness, dug into the canvas with a whiteness nothing could offset. His eyes were aching. In the evenings they were bloodshot and he bathed them with cold water. The continual coolness of the woods would calm them down, the tranquil north would give them relief from the sombre struggle that made them swollen and burning. Another corner of the earth drew him. He left.

In 1873 he was at Auvers-sur-Oise. 'The humble and colossal' Pissarro, as he called him later, became his close friend. They spent a season together at Pontoise, living at the Hermitage. But before long, during the summer of 1874, Pissarro left to go to Brittany. He was alone again. He painted. Sometimes in Paris, sometimes in its environs, on the banks of the Marne or the Oise. He tried some nudes again. He portrayed women sleeping in the sun, bodies in the open air. His large *Femme couchée* had been rejected by the Salon, as usual. But he persisted. Each year he sent a picture; each year it was thrown out. He didn't even bother to collect his pictures. He felt persecuted. One spring, indeed, the jury were particularly beastly. His entry aroused such a riotous outcry that a gang of art students seized the masterpiece, hoisted it on to a hanging ladder and then, hooting at it, howling a topical refrain, in a storm of hue and cry, they marched with it in procession from room to room, amid the mock genuflexions of some, the looks of disgust and the scornful jeering of others. Cézanne was there. . . Until his dying day, this amazing man worked, as he himself said with a mixture of despair and irony, for Bouguereau's Salon. A still-life like the one which sheds its radiance in the Berlin Museum today, the landscape bequeathed by a

proud collector in Florence to the Uffizi, never received the honours of that Salon.

At least at Auvers, in the woods, along the Oise, he was able to forget other people. He gave up the large nudes. The gently stirring leaves enveloped him. Still incapable of setting down on canvas what filled his imagination, he resigned himself with determination to copying. He made it his trade. More and more he immersed himself in nature. It was the moment when Impressionism was asserting itself. He had exhibited beside Claude Monet, Camille Pissaro, Auguste Renoir; but he had passed unnoticed. Théodore Duret, the friend of Manet and Whistler, and Arthur Chocquet* bought a few pictures from him; they were virtually the only ones who noticed and drew attention to the first works of a great painter in the making. Zola's old enthusiasm was wavering. He did not write the telling article, the sensational pamphlet which would have recommended his friend and this new art to the public.

Lack of understanding devastates the strongest of men. The artist cannot exist alone. He exaggerates everything, when a glimpse, no matter how impalpable, a foretaste of recognition, a friend's look or word does not come to support his effort. He lives for admiration, as for bread. He requires certainty.

Cézanne, at the height of his struggle, in the prime of life, was completely cut off from all this. For a long time he had realized that his art was startling to his close friends. Always prey to his own doubts, this affected him more than most. Being uncompromising, he turned in on himself. He appeared increasingly rude and peculiar. He suffered. This raging idealist was martyring himself through contact with the real – this real that he thought he worshipped. He had wanted to embrace it, press it to him, transfigure it with his own pious truthfulness. His friends no longer recognized on his canvases the objects he had set there with the devotion of all his being, with the humility and exactness of total dedication.

'—Frenhofer,' he acknowledged one day, pointing silently to his own chest, when someone spoke in his presence of *Le Chef-d'oeuvre inconnu*, 'Frenhofer, that's me.'[1]

Yes, the aim of art is not to copy nature, but to express it. It's only the final brush stroke that counts! Cézanne could lay claim to everything that Balzac puts into the mouth of his old master. And like the young

1 This idea must have haunted him. One day in the Museum at Aix, as I have already related, he showed me his old friend Emperaire and murmured to me: 'Frenhofer'. And in a 'confidences' album which I possess, Cézanne answered 'Frenhofer' to the question: 'Which fictional character do you find most sympathetic?' The anecdote I quote above is taken from Emile Bernard's *Souvenirs sur Paul Cézanne*.

Nicolas Poussin in the story, faced with the layers of colours with which the old painter has covered all parts of his figure in his effort to perfect it, most people looking at Cézanne's canvases during this sad period of his life which we have reached, looking at his first masterpieces, in all sincerity saw nothing but a chaos of colours, a sort of shapeless fog. And some of them, the most foolish, ventured to say this to him. Then, when they had gone, he became agitated; he exaggerated his lack of ability by exaggerating his methods. The impossibility of his task incensed him. A flood of invective escaped from this gentle soul. He wept ... When fame, friendship, recognition finally came to him, it was too late. He was disgusted by it. He wanted to die alone. Painting ...

One evening he handed me a sheet of drawing paper covered with a network of curves, squares, geometric figures curiously interwoven; at the bottom he had underlined this phrase in his large handwriting: 'Use up your youth in the arms of the Muse ... Her love is consolation for everything else.' Higher up, he had written 'SIGNORELLI' in capital letters, and in small letters 'Rubens'. One of the squares was lightly tinted with blue watercolour. He handed me the sheet.

'It's from Gautier ...[1] Work, one must work,' he said.

He turned his back on me abruptly, muttering: 'Art consoles one for living.' And snatching the paper back, he tore it into small pieces and said not another word to me until I left.

'Ah, if I'd known you in Paris!' he said to me another time. 'But when I would have needed you, you were still being born ... Anyway, one has to beware of writers. When they get their hooks into you it's goodbye to painting.'

Whom or what did he have in mind? He saw hardly any writers except Paul Alexis, Antony Valabrègue and M. Gustave Geffroy, and he gave away very little about himself to them, as far as I can judge from what Paul Alexis told me about him, and from the rather inexplicable hatred Cézanne professed for M. Gustave Geffroy, in spite of his articles and the wonderful portrait Cézanne painted of him, a loathing expressed to me frequently, either in letters or to my face. On the other hand, he retained a warm memory of a day spent with M. Octave Mirbeau, whom he considered the leading writer of that period.

Was he perhaps referring to his conversations with Emile Zola? The theories about naturalism were his own, and if there had been any influence, it was rather Cézanne, as we have tried to show, who steered Zola away from romanticism. Zola represents him as extremely stub-

1 I quote the phrase from memory. I have searched the works of Théophile Gautier without finding it. I have been told it is by Flaubert.

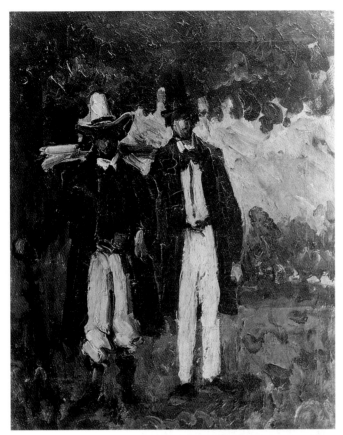

(Left) *Marion and Valabrègue Walking*, 1866

(Below) *Paul Alexis reading a letter to Zola, c.* 1869–70

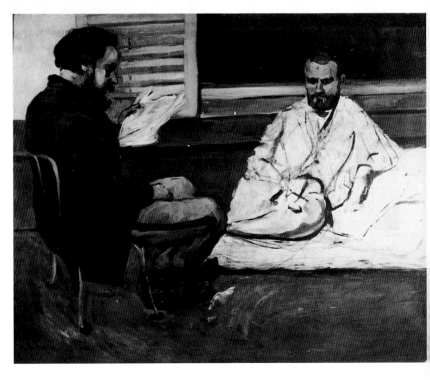

Portrait of Gustave Geffroy, 1895

born, impervious to argument. 'Proving anything to Cézanne,' he wrote, 'would be like persuading the towers of Notre-Dame to perform a quadrille.' One day at a dinner with friends, to which Zola had dragged him, he met his 'fellow countryman' Alphonse Daudet. He approached him quite openly, but Daudet began to make fun of him, of his accent, his painting, his ideas. Silent and reserved during the whole meal, he was an easy target, a victim. But suddenly, with the dessert, as told me by Théodore Duret who was present at this contest, he turned the tables on Daudet, sent him flying, and for an hour took his turn at ridicule, with the laughter on his side, leaving the writer vanquished, speechless, pale and stunned in his corner. No more than Daudet's superficial irony, I imagine, could Zola's more substantial conversation make any impression on Cézanne.

In any case, the painter saw less and less of the writer. I believe that, as a passionate reader of Stendhal, Sainte-Beuve and the Goncourts, he was led by them to restrain his immense lyricism. He was a child of his age, he accepted what was in the air. He sometimes went so far as to praise *Les Bourgeois de Molinchart* by Champfleury, who seems to have impressed him for a long time. People talked about the Japanese and the Chinese. When I led the conversation towards them, he said, 'I don't know anything about them. I've never seen their work.'

He had merely read the two Goncourt volumes on Utamaro and Hokusai, and to the creative mind of a painter a hundred pages of text do not convey the same thing as a line, or two or three brush strokes. If there was a link, which I am far from suggesting – hating as I do the snobbish habit of seeing chance parallels, such as the well-known comparisons between Cézanne's landscapes and the landscapes in tapestries – that link was accidental and in any case purely intellectual. There was no exchange, no potential influence. Cézanne's foundations were all French and Latin. It was only through the Flemish Rubens, basically so Latin himself, that the Lowlanders had some attraction for him, and that was only superficial. In this respect he was unwavering. Poussin, Delacroix, Courbet, Rubens, the Venetians – those were his gods, and grouped in private chapels around this temple, for various reasons, were the Lenains, Chardin, Monet, Zurburán and Goya, Signorelli, and – quite separate – Manet. He was far from being unaware of the others. He hardly ever mentioned El Greco. He was not fond of the Primitives, and it was with a humility much deeper than one might think that he must have used the word as reported of him: 'I am the primitive of my own way.'

To clear this way for himself, and by its means to be more certain of attaining the goal he set himself, he turned away from the grand subjects that intoxicated him. Suffering from his inability to express the whole forest, he applied himself to copying one tree, but its immense vitality made its contours burst apart. He turned his back on a quick triumph, the joys of success, social life, maybe even friendship. He drove himself to pursue the absolute.[1] He was on his own. He worked.

He worked. That is the motto of his whole life, its summing-up. He went on painting. His whole existence depended on it. He worked, as only he and Flaubert did, to the point of ecstasy or of anguish. The rest of his time, so to speak, no longer counted. In 1879, he returned to Aix. It was the moment when the massive planes of Sainte-Victoire, as Mr Elie Faure has pointed out, made his vision concrete. He contemplated them, he seemed to see them for the first time, he brought to bear on them his thoughts and his art, his experiences, his will. He fell in love with the structure of the earth. He read its geological message. He dissected the landscape. The composition of the world became clear to him. He still built up with thick layers of paint the bedrock of this newly discovered universe, but there was already a new fluidity in his work. His palette became brighter. The firmer he felt inwardly, the airier his canvases became by contrast. The first blue touches begin to mingle with his shadows. Air begins to play a role at the edges of his perspectives. Already a brightness rises at the horizon of hills, one which he would be the first to adumbrate, and which from then on, with a kind of magnificent rhetoric, would beat even a Guardi, a Koninck and a Claude. A step forward was taking place in visual sensation. The ambience of mind and eye was enlarged. For the first time the gradual fading away of the planet into the primitive nebula, of which Laplace tells the tale, was being translated and defined in painting. Cézanne was attaining the perspectives of Renan's Heaven or Taine's Axiom. Like them, this great positivist of a painter gives us in his landscapes, better than any metaphysician could do, the concentrated thrill of the cosmos. This man of the earth had a taste for the ideal. He makes us feel the universal. It is a poetry of the exact.

It seemed to him that he had hit a period of blissful power. He was forty. He had reached the peak of his organic prime, of his physical vigour. He felt an assurance that he needed only to persevere in his being in order to develop his gifts fully. Doubts and discouragement would still assail him, and increasingly, but he would never again stray from the path he had chosen once and for all. Without ever achieving it, he

1 The volume of *Etudes philosophiques* which contains *Peau de chagrin, Jésus-Christ en Flandre, Melmoth réconcilié, Le Chef-d'oeuvre inconnu, La Recherche de l'absolu*, completely tattered, dirty and unstitched, was one of his bedside books.

saw from that time 'the formula' he was searching for. And he knew that he was the greatest living painter.

According to M. Emile Bernard, that was the moment when, having lived until then as a bohemian, Cézanne pulled himself together, realizing that he was wasting his life, and dedicated himself to work, following Pissarro's example. We have tried to show that this internal moral revolution took place ten years earlier at l'Estaque, and based on nobody's example. In any case it is certain that at the period we have reached, Cézanne was at a summit; he was convinced of his own truth. He changed nothing in his way of living. He was already working from dawn to dusk, every day there was sun, and he continued in this way, up on his feet with the dawn. But he had made his choice between inspiration without order, haphazard study, and a deliberate, consistent programme of work; between invention and submission. 'Submission is the basis of all improvement.'[1] He would copy the world. He would paint a portrait of the earth. He would work unremittingly to master the soundless passage of the sun on a face or a piece of furniture that gives them life. He would surrender to the object. He would stop dreaming.

Painfully, basing himself on Poussin, he would attempt his poetic *Harvests* or, invoking Lenain, seek to group his Balzacian peasants in his *Card Players*, and in a sort of Olympian debauch he would constantly allow his blessed great nudes of the summer afternoon – never finished, his glorious indiscretion, the *Bathing Girls* – to float over all his other pursuits. But no more of those murder scenes and triumphs he had painted in his youth, no more Christ Descending from the Cross, no more prostrate Mary Magdalenes, wonderful fragments of which have been rescued from the walls of the Jas de Bouffan, no more of those banquets in which, as he said, he wanted to present a pendant to the orgy in *Peau de chagrin*,* nothing from now on but still-lifes, uncompromising and faithful portraits, accurate landscape. If there was a spirit animating the rough faces, chosen for their roughness, the arrangement of fruit, the sunny earth, he had not sought it, had not wanted it. It was there, he avowed, as a bonus, and indeed wasn't it in fact the enemy which, in spite of him, invaded his canvas and prevented him from pursuing to its ultimate subtlety the shadow cast by an eyelash on a cheek, or by a leaf on the grass, or the knife gleaming on the subdued tablecloth? All he wanted was to place the right colours within the exact contours. All he wanted was to juxtapose the suitable hues without any limitations other than the meeting and fusing of true values. His genius was no longer in his own hands. He wanted only to coordinate surfaces

1 One day in my house when he saw this phrase of Auguste Comte's used as the epigraph of a pamphlet by Charles Maurras, he pondered for a long time, then said: 'It's true . . . How true it is.'

and organize planes. He would have liked to have talent . . . What pious tenacity! what god-like self-destruction! were if not that genius, even under the stress of martyrdom, persists, through faith and by its own rules, in proclaiming eternal beauty beneath the transitory rationalism that persecutes it.

I have said this before, but would like the observation to return like a leitmotiv: the most acute sensibility at grips with the most searching rationality – that is the whole drama, the story, the sum of Paul Cézanne's life.

Towards his fortieth year, it seems to me, this rationality and this sensibility achieved a balance, or were in any case close to integration. But he was too much in love with the absolute. He pushed his desire for perfection to the point of madness. This happy time could not last. He was seized with a sudden urge to travel. Was he afraid of Italy? He made a dash through Belgium and Holland to verify his surmises, to look for confirmations. Strangely, Rembrandt does not seem to have detained him. It was Rubens who dazzled him above all others. He remained ecstatic about him right to the end. A photograph of the group of sirens in the Louvre *Marie de Médicis Disembarking at Marseilles* followed him whenever he changed his abode. Sometimes he attached it to the wall of his studio with a drawing pin. It was the only reproduction I ever saw there for more than a month, along with Delacroix's *Sardanapalus*. If he was asked 'Who is your favourite painter?', he invariably answered 'Rubens.' He even put it in writing.

Was he perhaps stirred up again by Rubens, whose opulent lyricism and sumptuous life revived regrets of a kind that the minor Dutch masters, with their narrow outlook and limited abilities, could never have built up in this obsessed spirit always seeking the impossible? He went back to Paris, thought of Zola and hurried to see him, at that time writing *Nana*, the Nana Manet was to paint, in order to confirm his theories about naturalism, to affirm his realism – more, perhaps, to himself than to anyone else. Cézanne spent some time in Médan. He saw a good deal of Renoir, who painted his portrait. The following year, in 1881, he returned to Aix. From then on he divided his work and his time between Provence, Paris and the Ile de France.

When the red ground, the glaring rocks, the dusty ploughed earth tired his burning and often bloodshot eyes he would go back to the Marne and Fontainebleau. He buried himself in the forest, or returned to the banks of the Seine. He painted at Montigny, Marlotte, Barbizon. At Giverny he saw Claude Monet; but he did not spend much time with

(Left) Rubens, detail of the Sirens from *Marie de Médicis Disembarking at Marseilles*, c. 1625

(Below) *Struggling Lovers*, c. 1880

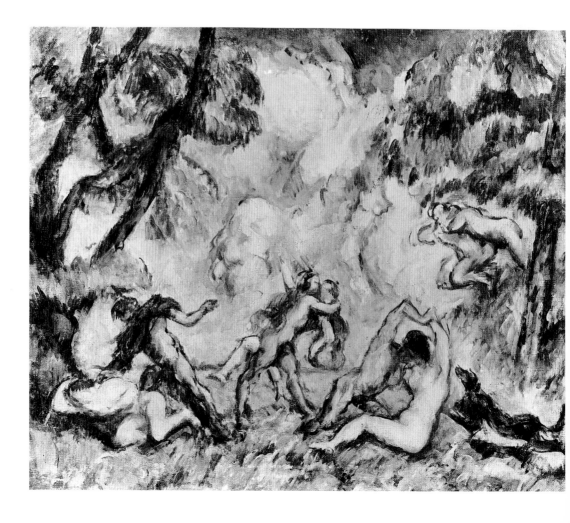

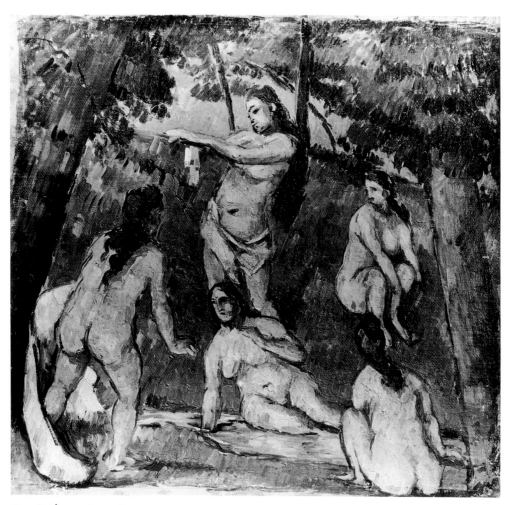

Five Bathers, 1877–78

him, any more than he did with Pissarro, Renoir and Sisley, the only ones he would recall later on of 'the band of Impressionists who lacked a leader or ideas', as he would say sometimes. One whole season, however, he lived side by side with Renoir. He did not care for Degas. 'I prefer Lautrec,' he said. In Paris he sometimes ate at the same wine-merchant's shop as Auguste Rodin, whose peasant cunning, he said drily, he rated higher than his symbolist and safe art.

'He has genius,' he would say, 'and a great sense of money. He used to come with his smock all covered with plaster and sit down among the bricklayers . . . He was sharp, up to all their tricks; but I like very much what he does. He really means business . . . People don't understand him yet, or else get him all wrong. He needs to be tough to stand up to the flattery of those miserable Mauclairs . . . In his place I'd be really on guard . . . He's lucky. He's earning money.'

He also used to see Guillaumin and a few other regular companions in a café in the Batignolles area. He loathed Puvis de Chavannes so much that he wanted me to get rid of a reproduction I had at home of his hemicycle at the Sorbonne.

'What horrible artificiality,' he would say.

He sometimes spoke to me, and always sympathetically, of Van Gogh, two of whose pictures he enjoyed looking at in my house, and of Paul Gauguin; I don't believe he ever went to see them at Arles, as some have claimed. He ran into Gauguin at old Tanguy's and in cafés, but not often.

He had no real friends except trees. From this period date those quivering landscapes, those bridges over ponds, those deep thickets in which the full gamut of green tones gorge on the forest's sap, that trailing greenery reflecting all the breathing water. The canvases are dense, cool, and have a peaceful life, with their noiseless tracks, their cheerful vistas, their houses radiating light; they are restful with their tall, calm poplars, their sleepy rivers in which beautiful clouds reach down to the grass to bathe, their delicate greens, their hazy forest vistas. Round Aix, on the contrary, he sought brutal, massive, almost hostile aspects of the red hills, dramatic profiles of dry ravines, leafless trees, bulky square houses, fiery, scorched roofs, fields full of cicadas where the cracked earth glistens under the shorn stubble. He went back to gentleness and greenery only when he set out, close to his roots, to convey the dreamy associations of the pools and moss-covered lions of the Jas de Bouffan, the façade of the family house, the classical layout of its dark avenues where the chestnut trees, run wild, extended their branches over the

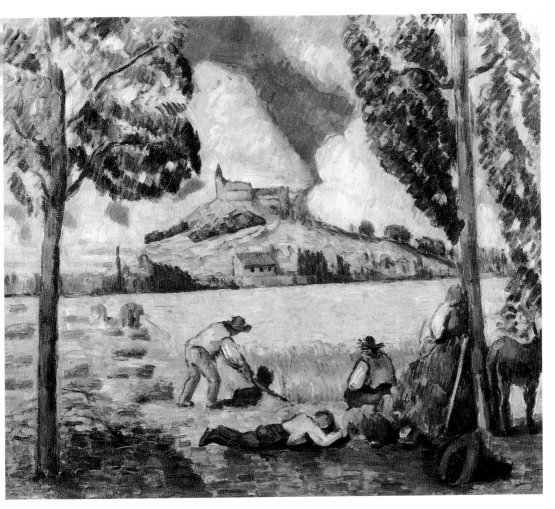

Harvest, c. 1877

sprouting gravel in the abandoned park. He painted a few portraits. He thought about his *Harvest* painting. In a very complete sketch (a replica of which is in the Bernheim-Jeune collection), he presents in the style of Poussin but entirely in terms of the countryside around the Jas, a Biblical plain, half-harvested, with a group of rustics in the foreground resting, eating and drinking in full sunlight. A woman is waiting on them. They are in shirt-sleeves and wearing straw hats. One of them raises a bulging demijohn between his bare elbows and, head thrown back, directs a long jet of wine into his throat. There is a large tree, a twisted pine, nearby. Farther away, other reapers push their way into the abundant corn, a yellow wave under a purple sky which beats against the ordered slopes overlooked by a château, the Bastide du Diable, which Cézanne revisited and praised in his last years, enchanted by its high façade dominating the pine woods of Le Tholonet.

He also painted the *Bathers*, refused from the Caillebotte Bequest to the Luxembourg's eternal shame – the marble-blue sky with apocalyptic clouds, the flickering earth, Sainte-Victoire dwarfed, as if overcome by the cosmic effort taking place, and the indifferent men, the serene bodies, their Michelangelesque strength on the brink of this Judgment of things they don't even suspect. It was in canvases like this that his romanticism blazed up at long intervals and licked his brain with a fever in which he poured himself out. He calmed himself, restrained and 'classicized' himself, if I may put it like that, in his still-lifes, where, in the fold of materials, the arrangement of objects, fixed once and for all,[1] his expansive style was in control and allowed his delicate sensitivity to modulate itself freely, without fear, without any concern except to curb his opulent resourcefulness or find ways of taming his excessive exuberance. In stripping down apples and wine to their essence, disengaging them from anything other then the joy of pure colour, he attained the very substance of his feelings. He satisfied 'the need for harmony and the intense desire for original expression' which formed the basis of his genius. He went beyond Chardin.

He had an unexpected pleasure in meeting Monticelli at Marseilles. They formed an immediate friendship. Carrying knapsacks, they made a month's trip together, rambling, as he used to do with Zola, through the whole countryside round Marseilles and Aix. Smoking pipes at farm doorways, talking endlessly, Monticelli doing quick brush sketches while Cézanne recited Apuleius or Virgil – Monticelli adored this esca-

1 The painter Le Bail, who was later Cézanne's neighbour in the outskirts of Paris and whom Cézanne regarded with affection, told me with what pains he prepared the values of his still-lifes – for example, slipping different colours, one by one, under some peaches until the fruit showed up in the light, with the shades he sought. 'Composition by colour,' he would say. 'Composition by colour! That's the whole secret. Have a look in the Louvre, it's how Veronese composes.'

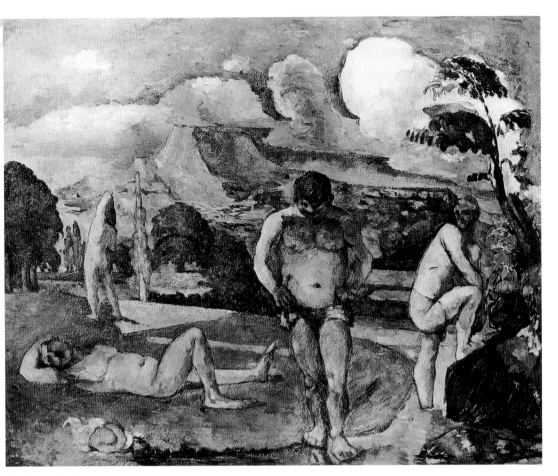

Bathers, 1876–77

pade and had glowing memories of it for a long time. I know this from the painter Lauzet, who engraved a suite of twenty of Monticelli's finest works in a magnificent album. Cézanne himself never mentioned it to me. Regarding certain things he had enjoyed, he was rather reserved; he kept them to himself and fiercely guarded his memories of happy moments. Anything to do with friendship always seemed to him marvellous and profound, with something jealously guarded about it. For example, I learned that he had an old friend in the rue Ballu in Paris, a cobbler with whom he spent long silent hours and evidently helped out in difficult circumstances, but he never breathed a word about him. He was sometimes surprised in the shop that smelled of boot-polish, sitting at his ease, casting an affectionate eye at his friend's wretched work, as if lost in contemplation of the old lasts and the patched boots; but he made a great mystery of it and took to hiding if one went there to look for him. With my father and his old college friends he showed infinite delicacy of feeling. Everyone who came close to him loved him without reservation. With a word, a gesture, a glance, this shy, sentimental man, so demonstrative but so repressed, was able to convey the richness of a charity all the more refined for being the same, so to speak, towards one and all. He had the goodness typical of great men, whose reticence stems from a simplicity and strength that have too often made advances to no avail. And so his susceptibilities were always on edge. He demanded from others the same consideration which he generously gave to them. His sensitivity became almost morbid. He told me that a smile exchanged between a maid and Zola at the top of the stairs, one day when he returned late, laden with packages and his hat battered, drove him away from Médan forever. His misanthropy, deriving from deep tensions and fuelled by increasing anxiety about his work, was transformed, as in the case of Jean-Jacques Rousseau, into crises of mistrust which quickly verged on the idea of persecution. L'Oeuvre had just been published. But he always told me, and he never lied, that the book played no part in the falling-out with his old companion.

In 1885, after staying in Normandy with his friend Chocquet and painting the famous portrait of him against a background of green leaves, Cézanne went to Médan. He spent the month of July there. Zola was writing L'Oeuvre. He must surely have talked a good deal about the book and read important portions of it to Cézanne. The latter always found its first chapters deeply moving; he declared that they contained a truth barely transposed and intimately touching for him as he rediscovered in them the happiest years of his youth. Then later, when the

novel branches off with the character of Lantier in danger of going mad, he was sure there was nothing to it but plot requirements, that he himself was entirely absent from Zola's thoughts, that Zola had, in short, not written his memoirs but a novel, and one that formed part of a large group that had been long in the planning. The character of Philippe Solari, portrayed as the sculptor Mahoudeau, was also much distorted for the purpose of the story, and Solari had no more idea than Cézanne of taking offence at it. His admiration of Zola never weakened. And the latter, when I saw him in Paris fifteen years after *L'Oeuvre* appeared, spoke to me of his two friends with warm affection. That was around 1900. He still loved Cézanne, in spite of his ill-humour, with all the attachment of a generous, fraternal spirit, 'and I even begin,' he told me in his own words, 'to have a better understanding of his painting, which I have always enjoyed, but which eluded me for a long time because I thought it was frenzied, whereas it has an incredible sincerity and truthfulness.'

In September 1885, Cézanne came back to renew his allegiance to Aix. He painted in the surrounding countryside, at Gardanne. He lived with some peasants, renting a room in the farmhouse, sometimes even sleeping in the loft, rolled up in a sheet on the straw, eating at their table, working all day long, This was the time when he carved out the flanks of Sainte-Victoire from the Cengle ridge in paintings without sky; when he stripped the hills of Montaiguet of any shadow, balanced stark pines on receding plains and placed solitary farmhouses within squares of ploughed land and cornfields; when he outlined the blue chain of the Pilon du Roure [sic] against the reflected movement of a hidden sea, which one could divine from the bright moisture, from the watery smile which bathed its summits . . . It was above all the time when he painted in all its aspects the village of Gardanne rooted to its hill, the rugged bell-tower, the tawny flock of houses, the sunburnt roofs, the tall clumps of bushes always providing a freshness, a well of green light somewhere in the heat, and on the parched hillside the two windmills, the two abandoned towers. He simplified. He serried and concentrated lines, but increasingly varied the shadows and, without seeking to, imbued the landscape with humanity. A humanity still thin, paltry, scanty, which lends to objects a sullen quality, to rocks and clouds a cross-grained look, to layers of atmosphere a bulkiness; which strips bare and schematizes; which still shows too much effort; but which, one feels, is henceforward going to grow more profound, feeding on light, fluid, spiritualized, integrated, swallowed by the earth, absorbed by the sky,

all infused in nature, and all of nature infused in it. One has to have seen, piled up helter-skelter in the attic of the Jas de Bouffan, the hundreds of canvases of that period, most of them unfinished, grimy, battered, to understand the quiet, painful labour, the uncomplaining martyrdom with which Cézanne took hold of his soul and this earth, and – so to speak – fitted them together, made them overlap inside one space, one frame. Almost white canvases in which the shoulder of a hill, a joyous tree, a warm path, are outlined with the merest network of blue lines or a few green dabs; almost empty canvases, thickly worked here and there, like the samples in a skein of silk of all the rainbow colours put together; almost geometric checker-boards slashed with long clear shadows; great slabs of walls crumbling on the edge of abysses barely drawn in; blocks of tangled trees, their sparse, fine tufts just indicated with a fleeting tint, their trunks massive, their heavy roots clutching the rock – in this confusion one explores the failures, the flashes, the slow advance of a sensitive mind, the conquest – twenty times abandoned, twenty times resumed – of a logic of colour at grips with an emotion that is always watchful, one descends into deep strata, to the bottom layers of Cézanne's thought. This analysis of inward matter is as subtle and acute as Dostoevsky's voluminous unravelling of human psychology. In its austerity it is equally motivated by and permeated with tenderness and love. It was upon this that Cézanne would establish, *did* establish, his art. The gentle bloom, the downy atmosphere of his most beautiful landscapes would be grounded on this harsh work, would take root in this stubborn toil.

While he devoted himself to this heady task, his father, now fallen into second childhood and so demented in his miserliness that he hid sous under the stones of the Jas, died in 1886. Increasingly Cézanne cut himself off from people. In the evenings a few peasants would chew the cud with him. He grew closer to the soil; emptied himself, in a manner of speaking, of all false culture and all prejudices. The most civilized of men, he became a simple primitive. His stern, inflexible nature, full of such singular refinement, would now use its many seductive powers only on the so to speak openwork charm of his severe canvases. He buried himself in his saintliness, his detachment from everything which was not painting.

There was just one friend, Antoine Marion, Professor of the Faculty of Sciences at Marseilles and Keeper of its Natural History Museum, who came to see him from time to time on a Sunday; set up an easel beside his, drew him back into the world by speaking to him of his own

geological work, of his collaborator, the Marquis de Saporta, an Aixois, with whom he was in the process of establishing an important evolutionary theory about the migration of trees from the Polar ice, and the struggle of vegetable species to adapt among themselves. A man of lively mind and cheerful nature, Antoine Marion, with brush in hand, would expound Darwinian ideas and speak of his own discovery of anthropoidal skeletons at the foot of Sainte-Victoire. He would sketch out the history of the world and the origin in that corner of Provence of the landscapes they painted, their first emergence from under the ice, their ancient transformations, and how the living evidence of their origins is perpetuated in their colours and variations. He became excited. The thrill of science enveloped the two men, lost in a cloud of dust. Cézanne stopped painting . . . Steam rose from the furrows. The pines exhaled their scent. The world's ancient hills took on a blue all the more unreal for being better understood. The painter's immense sensibility wavered again in his quest. The geological mystery added itself to the mysterious torment of loving the earth and the elements for themselves. As always, in that brain haunted by knowledge and love, theories took shape which he immediately introduced into his art. This time it was science that gnawed at him, as literature had done not long ago. He thought. He meditated. He suffered.

He had doubts.

At the moment when he was on the point of attaining fulfilment, this disquiet suddenly devastated him. He wanted to reach to the very structure of the earth under its transient surface and its seasons. He had painted nothing, he had done nothing, he told himself, lacerated by bitterness and hope. He abruptly turned his back on the path he had been following, on the view of nature and himself that he had so painfully mastered. Pitiable spirit always in gestation, perhaps the most phenomenally creative that ever existed, he was affected by everything that touched him. He seized it, used it again and again, absorbed it. A poetic disgust engulfed him for that which had pleased him yesterday. Nothing would ever satisfy him. In order to paint, he had to see nothing but his work. Even his friends, even his passions were detrimental to him, depressed him, distracted him. He had to be alone. What a drama of conscience for an artist starved of affection! Man is never alone. Cézanne, as we shall see later, made a friend of a tree, of an olive. He was a loving person. And the more he wanted to be understood, the more he relied on reason in order to be loved by others – the more he distanced himself from them. His intelligence was his destruction.

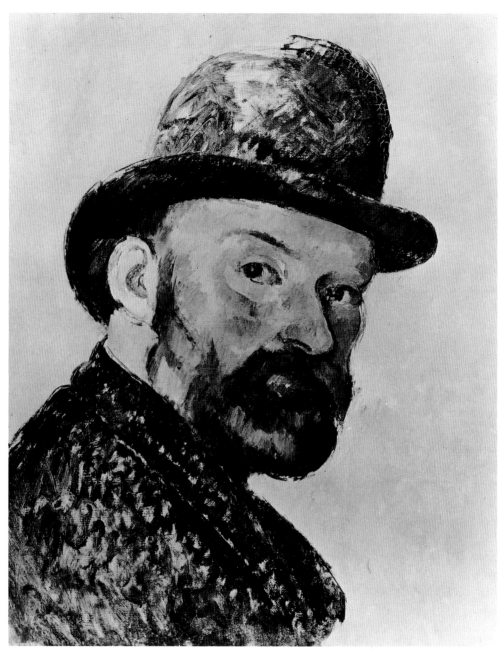

Self-portrait with Bowler Hat, c. 1885

IV

OLD AGE

'A great life is an organic whole which cannot be explained by the mere collection of small facts. A deep feeling has to embrace the whole and give it unity,' says Renan, referring to Jesus in the first volume of his *History of the Origins of Christianity*. I would not dare to touch on the 'deep feeling' that inspired the whole of Cézanne's life and gave it its unity, if I had not been close to it. I learned to know him in 1896. He was only fifty-seven, but, consumed by his inner struggle, discouraged and unwell, he already seemed an old man. His robust frame was still erect, knotted and sinewy in accord with his sturdy breeding, but violent headaches attacked him every evening, and diabetes caused him agony. He was always overtaxing his strength. Nervous, with streaked eyes, racked brain, heart on fire, he was cast down by doubts. Working under happier auspices, he might have painted till he was a hundred, like Titian. He overworked his body, constantly taking those long walks for which he still had a passion, scaling Sainte-Victoire alone with his little game-bag on his shoulder in sunshine or in rain. He often had an abstemious lunch of cheese, bread and a few nuts, right there in his studio. With a glass of good wine and a cup of coffee, this ascetic meal would keep him going until evening. He hated spirits, but he adored the old local wines, which from time to time led to a heavy drinking bout with Solari or Paul Alexis. After a few generous glasses, an unearthly flame would bring him to his feet, brace his rather rounded shoulders, and fire his complexion. A strange lucidity came over him, and a sturdy logic, a concentrated excitement led his emotion to its noblest expression. His lyricism flashed. An irresistible eloquence transported him to the deepest resources of his tongue and his thought. Anyone who has not heard him in one of those episodes, when he appeared utterly sublime, can know nothing of him. His misanthropy and awkwardness fell away. His erudition, his delicacy, his memories all came pouring forth. He connected theories, he refashioned the world, he loved and understood

everything. His persecuted genius was in complete command. Ironic, ardent, joyful, his creative good-will embraced all things. No doubt that was the way he would always have been if recognition had come to him.

The first time I saw him was at a café. Solari, Numa Coste and my father were talking with him. It was on a Sunday, at the apéritif hour. They were at a table in the Cours Mirabeau, on the *terrasse* of the Café Oriental, which Alexis and Coste frequented. Night was falling from the great plane-trees. The Sunday crowds were returning from 'the music'. A provincial evening was settling quietly on the town. His friends were talking; he, with arms crossed, was listening and watching them. With his bald pate and the long, still abundant, grey hair that flowed down to his neck, his goatee and thick, freshly trimmed old-colonel's moustache concealing his sensual mouth, his high colouring, he could have been some ageing retired veteran, but for the broad fore-head bearing the mark of genius, admirable in its curve and fullness, and for the bloodshot, domineering eyes that took in everyone at once and never let you go. On that day, a well-cut jacket enclosed his torso, the robust torso of a countryman and master. A low collar exposed his neck. The black cravat was perfectly tied. He was sometimes negligent about his dress and knocked about in sabots and a tattered hat. He was well turned out when he thought about it. That Sunday he must have been spending the day with his sister.

I was nothing, virtually a child. I had seen two of his landscapes at some exhibition or other in Aix, and the whole of painting had entered into my eyes. Those two canvases had opened up for me the world of colours and lines, and for a week I had gone about drunk with a new uni-verse. My father had promised to introduce me to this painter who was sneered at by the whole town. I guessed it was him sitting there. I came up and murmured my admiration for him. He blushed and began to stammer. Then he drew himself up and gave me a terrible look which made me blush in my turn, burning from head to toe.

'Don't laugh at me, young fellow, d'you hear?'

He gave the table a mighty thump with his fist. The glasses tinkled. Everything fell over. I don't believe I have ever felt greater agony. His eyes filled with tears. He grabbed me with both hands.

'Sit down there ... It's your youngster, Henri?' he said, addressing my father. 'He's a good boy ...' His angry voice became a drawl now, quite softened by kindness, and he turned towards me: 'You are young ... You don't understand. I don't want to paint any more. I've given it all up ... Listen, I'm a wretch ... you mustn't hold it against me ...

How can I believe that you've understood my painting from two can-
vases that you've seen, when all those . . . who turn out stuff about me
have never seen anything in it? . . . Oh, they've messed me up all right
. . . Is it Sainte-Victoire that especially caught your eye? You like that
canvas . . . Tomorrow it will be yours . . and I'll sign it.'

He turned to the others. 'You go on talking. I want to chat with the
boy. I'm going to take him off . . . Shall we have supper together, Henri?'

He emptied his glass and took me by the arm. We pushed off into the
night, on to the boulevards that circled the town. He was in a state of
incredible excitement. He opened his heart to me, told me of his despair,
the neglect into which he was sinking, the suffering of his painting and
life, that 'deep feeling', that 'unity' to which Renan refers and which I
would like to convey. That evening it thrilled me; it was far more than
admiration, almost ecstasy. I was in touch with his genius, his heart. I
could feel it. I would never have believed that a person could be so noble
and so unhappy, and when I left him I no longer knew whether I wor-
shipped his human suffering or his supernatural gift.

For a week, I saw him every day. He took me to the Jas de Bouffan,
showed me his canvases. We took long walks together. He came to fetch
me in the morning, we would not return until evening, dead beat, dusty,
but healthy, ready to begin again the next day. It was a mad week, dur-
ing which Cézanne seemed to find new strength. It was as if he were
drunk. I think it was a common innocence that united my unknowing
youth with his open and solid erudition. All subjects suited us. He never
talked about himself, but, as I was on the threshold of life, he said that he
would have liked to pass his experience on to me. He was sorry that I
was not a painter. The countryside went to our heads. He revealed it to
me, he showed me all its beauties through his poetic gifts and his art. My
ardour gave him new life. What I offered him was nothing, a mere
breath of youth, a faith which helped him to feel young again. But
anything one cast into that great heart, the slightest sound, had tremen-
dous echoes. He wanted to do my portrait, my wife's. He began my
father's. He abandoned it after the first sitting, tempted away by our
excursions to Le Tholonet, to the bridge over the Arc, our meals in the
sun washed down with old wine. It was spring. He gazed at the country-
side with rapture. The first signs of green stirred him. Everything
moved him. He would stop to look at the receding white road or a
hovering cloud. He picked up a handful of moist earth, kneading it as if
to possess it more intimately, to mix it better with the spring in his
blood. He drank at the banks of streams.

'—I'm seeing the spring for the first time,' he kept saying.

All his confidence revived, too. He finally talked to me about his genius. One evening, letting down his guard, he confessed to me: 'I am the only painter alive.'

Then he clenched his fists and fell into a dark silence. He went home with a grim expression. As if a disaster had fallen upon him. He did not come the next day. He wouldn't receive me at the Jas. I persisted in vain for several days. Then I received this note:

'Dear Sir, I am leaving tomorrow for Paris. I beg you to accept my best wishes and my most sincere greetings.'

It was the fifteenth of April. The almond trees had finished flowering round the Jas where I went for a ramble in order to remind myself of the departed master. The friendly rock-face of the Pilon du Roi was disturbed by a pale blue that evening. It was in front of the Pilon, among all those fields, those orchards and those walls, that Cézanne used to paint. Suddenly, on the 30th, I met him coming from the Jas, his bag on his shoulder, on his way to Aix. He had not gone away. My first impulse was to run up to him. He seemed to be walking under a heavy weight, sunk in thought and overwhelmed, taking nothing in. I respected his solitude. An infinite, aching admiration wrung my heart. I greeted him. He passed without noticing, without returning the slightest greeting. The next day I received the poignant, terrible, extraordinary letter that follows . . .

For a long time I have hesitated to transcribe it. It is such an appalling exposure of a soul. But that aching soul breathes in it with such sobbing, with such fierce humility, such tragic humanity, such divine distress, that it would seem to me, on the other hand, to be a betrayal of his venerated memory if I denied these burning tears to the faithful followers who revere him. Perhaps those who laughed at this man, as people do at everything that passes them by with an appearance of weakness, will finally understand him. There are looks which can cause agony to charitable people, and genius is the essence of charity. Read here what the public's lack of understanding of a body of work can lead to, what inner torment anonymous persecution can inflict on an artist full of benevolence and power, born to love and console future ages, but rejected by his own people in his lifetime. Personally, behind these bloodstained lines, I can see my old master's dramatic face, as in a painting he once did of himself, almost wild-looking, huge and gentle, haunted and wilful, with a searching tenderness – and quite liberated, in his dark anger, from the kind of biblical shadow under which Rembrandt had walked.

Dear Monsieur Gasquet,

I met you this evening at the bottom of the path. You were in the company of your wife. If I am not mistaken you seemed extremely angry with me.

If you could see inside me, the man within, you would not be angry. Don't you see the sad state I have been reduced to? Not master of my inner self, a man who does not exist, and it was you who wanted to play the philosopher, who wanted to end up by making something of me. But I curse those x–s and the handful of rogues who have drawn attention to me so that they could get 50 francs to write an article. All my life I have worked in order to be able to earn my living, but I believed one could do a good job of painting without attracting attention to one's private life. Of course an artist wants to raise himself intellectually as far as possible, but a man has the right to remain obscure. The pleasure must reside in the attainment. If it had been permitted me, I would have remained in my corner among a few fellow artists with whom I could have gone drinking. I still have a good friend* from the old days, and if he hasn't made it, well, that doesn't mean that he was not a better painter by a long shot than all those good-for-nothings who are covered with medals and decorations. It makes me sick, and you want me at my age still to believe in something? After all, I'm as good as dead. You are young, and I can understand that you would want success. But as far as I'm concerned, what is left for me to do in my situation but give in, and if it weren't for my great love of the form of my land I would not be here.

But I have annoyed you enough in this way, and now that I have explained my situation to you, I hope that you will no longer look at me as if I had made some attack on your safety.

Please, dear sir, and in consideration of my great age, accept the kindest thoughts and wishes that I may offer you.

I ran to the Jas. As soon as he saw me he opened his arms. 'Let's not talk about it,' he said, 'I'm an old fool. Sit over there. I'm going to paint your portrait.'

I sat no more than five or six times. I thought he had abandoned the canvas. Much later I learned that he had devoted about sixty sessions to it, and that when, during our conversations, he would stare fixedly at me, he was thinking of the portrait and would work at it after I had left. He wanted to catch the life, the facial mannerisms, the actual feeling of words being spoken, and I don't doubt that he used to guide me into an expansive mood in order to take my inner being by surprise in one of those passionate outbursts during a discussion when a hidden eloquence emerges in even the humblest people if they are angry or enthusiastic. It was in any case one of his usual procedures, especially when he was beginning a portrait, to go on working after the model had left. That was the way he painted the beautiful and perceptive portrait of M. Ambroise

Vollard. It seems that during a number of sittings Cézanne barely touched the canvas with his brush but never stopped devouring his model with his eyes. The following day M. Vollard would find the painting advanced by three or four hours of feverish labour. My father's portrait was also painted by this method. I stress this because it has often been claimed that Cézanne could not paint, and even that he had never painted, without the model in front of him. He had a memory for colour and line – there can be no doubt of that; it was by an act of submission like Flaubert's – 'contemplation of the humblest realities' – that he forced himself with terrifying will-power to the direct copying which held his poetic imagination in check. 'The reading of the model and its realization,' he wrote, 'is sometimes a very slow process.' That, I believe, is the origin of the apparent harshness which conceals the humane tenderness of his most beautiful canvases. Here again his creative judgment leant on the austere reality, the better to dominate it and keep his sensitive imagination under control. Once, in his own portrait, he let emotion take over. And the picture might, in an imaginary museum, be hung between a Rembrandt and a Tintoretto; it radiates with the same built-up intensity, the same glorious concentration.

During that whole month of May when I first knew him, I saw him nearly every day. In June he went to Vichy. He took the waters there with his wife and son. He was cheerful.

He wrote to me, 'The rainy, disagreeable weather when we arrived has calmed down. The sun is shining and I am feeling optimistic. I am just off to do some sketching.'

Just off to do some sketching . . . He never stopped working. Barely arrived in a place, he took possession of it. Work was his life. No strolling about, none of those vague excuses that most people make to themselves when they undergo a change of habits, or the fatigue or distraction of travel. Cézanne was at home everywhere. Nature was always there waiting for him. If it was raining, he quickly – even in a hotel room – set up a still-life. If it was fine, he went off to sketch. He was more likely to do without eating than without painting. He would die if he could no longer work.

Towards the end of July, he installed himself and his family in Talloires. The lush countryside of the Haute-Savoie disposed him towards irony.

'It's a temperate zone,' he wrote. 'The height of the surrounding hills is considerable. The lake, wedged in at this point between two narrow valleys, seems to lend itself to exercises in line drawing by young ladies.

It's still nature, to be sure, but a bit as we have been taught to see it in the albums of young female travellers.' His tone was brighter only when speaking of the Hôtel de l'Abbaye where he was staying. 'It would require the descriptive pen of Chateau [1] to give you an idea of the old convent where I'm lodging.'

But at the back of his mind it was Provence that he missed, dreamt about, visualized as sparkling and bare, so well-defined compared with these heavy pastures. In these twilight depths of lakes and mountains where, even in summer, there was always some trailing mist, he reconstructed in his reveries 'all the links that still bind me to my old native soil, so vibrant, so astringent, reverberating the light in a way that makes you blink and bewitches the receptacle of sensations.' He was afraid lest they break and, he added, 'cut me off, so to speak, from the land where I learned to feel without even knowing it.'

The more he was away from it, the more he loved his country. Open to every influence in his youth, he came back to his centre, 'his mental territory', as he grew older. One senses how the green light of Talloires bored him to death. He was entirely won over from then on to the pagan charm of Aix, the ardent refinement of the old Roman province. However, with his usual readiness to meet his family's wishes, he was about to spend the winter in Paris again.

'I have devoted a good many days,' he wrote, 'to finding a studio for the winter there. I very much fear that circumstances are going to keep me for some time in Montmartre where my workshop is located. I am a stone's throw from Sacré-Coeur, with its towers and belfries soaring into the sky.'

He had rented a studio in the Cité des Arts, not far from Carrière's, but he was not seeing anybody. He reread Flaubert. He painted. Age was descending on him.

'I cannot say,' he wrote to a young friend, 'that I envy your youth, that's impossible, but your vigour, your inexhaustible vitality.'

Yet a little success came his way. The art dealers were beginning to wrangle over his works, even abroad. At the Hôtel Drouot auction rooms they were pushing his pictures. There were several on view. Even at a distance, there was a certain speculative attempt to corner him. He remained indifferent and impassive. He chose to ignore all those rumours which remained pointless for him, so long as he was not hung,

1 This was how he always referred to Chateaubriand. Even in a restaurant, he would dumbfound the waiters by ordering 'A Chateau'. And when he was brought a Château-Laffitte, he was as delighted as a child who has played somebody a trick, and while he accepted the bottle, of course, he repeated his request: 'And now a real Chateau!' He had such little traits of charming childishness, which he retained right up to his last days.

as he put it ironically, in M. Bouguereau's Salon. Inwardly, on days when nothing disheartened him, he appealed to posterity. It came slowly. Young painters and a few writers asked to be introduced to him. Maurice Denis was working on his *Hommage*.

When he arrived at an exhibition at Durand-Ruel's, people made way for him, greeted him, gave him a warm reception. He took no notice. Camille Pissarro, Renoir, Guillaumin – those whom he admired – treated him with becoming respect. He didn't visit them often, meeting them only now and then; and yet his solitude weighed on him. One day when I was present, Claude Monet, whom he looked on as the greatest living painter, virtually called him his master, and told him of the immense position he held in contemporary painting and of the renaissance that was going to issue from him. Cézanne smiled vaguely, gave Monet a sharp handshake and pushed his way into the crowd on the boulevard, muttering: 'Right, let's get back to work.'

Worries about his body were added to those of his mind. One might say that at the moment when his health became most important to him, it deserted him. His strong constitution began to fail. Diabetes debilitated him. He had to follow a regimen. But he did not give up his habit of long walks across Paris which exhausted his legs and brain, distracted him from his doubts, and reduced his anxiety. On the rare days when he was not working, he strolled in the mild sun along the *quais*, browsing among the bookstalls, stood on the bridges, spent hours watching Paris roll by. His greatest joy was going once a week to look at the Poussins in the Louvre, remaining a whole afternoon in ecstasy before *Ruth and Boaz* or *The Grapes of the Promised Land*, studying the great Rubenses, the portrait of Hélène Fourment, the *Disembarkation of Marie de Médicis*. What M. Sérusier calls 'Cézanne's spiritual quality'[1] became more and more pronounced in his paintings. Nevertheless, an unquenchable thirst for realism still led him to stress his contours, producing a kind of overweight, emphatic materiality to offset an idealism too lyrical for his taste. Rubens and Poussin fought it out between them. The abundance of the one, the order of the other, both haunted him together. He sought, by submitting to the order, to bring out the fullness of life. And

1 Sérusier says, 'He is the pure painter. His style is a painter's style, his poetry is a painter's poetry. The usefulness, the concept itself of the object represented vanishes before the charm of the coloured form. One might say of an apple by a common painter: "I could eat that." Of an apple by Cézanne, one says: "It is beautiful." One would not dare to peel it, one would like to copy it. That's what constitutes Cézanne's spiritualism. I don't say (and deliberately) idealism, because the ideal apple would be the one which would make one's mouth water and Cézanne's apple speaks to the spirit by way of the eyes . . . One thing to observe is the absence of subject. In his first manner, a subject of some sort, sometimes a puerile one. After his development, the subject disappears, there is only a *motif*.' (Quoted by Maurice Denis, *Théories*, p. 244.)

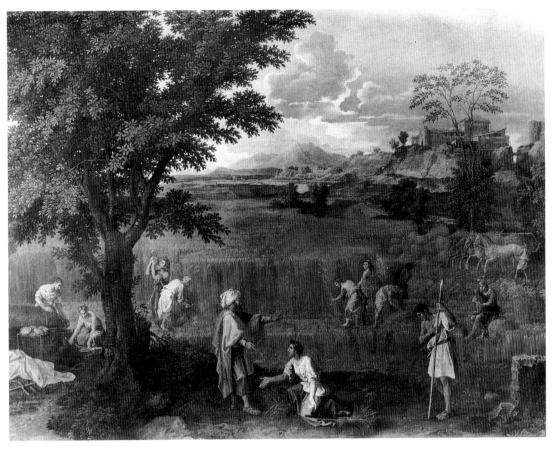

Poussin, *Ruth and Boaz*, 1660–64

he compounded this obsessive search by his stubborn determination never to avoid the closest contact with reality, but to clasp it all the more tightly. 'I have left nothing out,' said Poussin. Cézanne feared that he would never be able to say the same of himself, attracted and tormented as he was by the geat poetic painters. Doggedly he repeated this phrase to himself in front of 'the great works' and their 'astounding richness'; he made it his motto, clinging to it like a handrail. And the moment he left Rubens and Veronese, he would hasten to reassure himself with a quick look at Chardin and a pause in front of *The Burial at Ornans*. Sometimes he pushed on as far as the Egyptians. He prowled round the cool rooms, reading in Gustave Geffroy's *La Vie artistique* the pages on mummies which he knew almost by heart. Slowly he would return home, his mind overwhelmed with images, ideas, memories. His old alacrity was gone. Instead, he was overcome by a great lassitude. He was beginning to dread the approach of evening, the setting of the sun. As night fell, the twilight of old age set in. Everything receded and grew pale. Was it fatigue that made solitude twice as bad?

'I am at the end of my strength,' he wrote shortly after this period. 'I ought to have more sense and recognize that at my age illusions are no longer permitted me, and they will always be my undoing.'

What a stubborn man! He took refuge in Aix again. He rented a *basti-don* at Le Tholonet, on a spur of rock behind a hill, guarded by a cypress shaped like a pyramid that was visible from anywhere on the plain.

'What beans and potatoes we've eaten in this dugout!' he said.

He had gone there in the old days with Zola; it was the country of *Abbé Mouret's Mistake*,* sparkling soil, red mounds of earth, the marble quarries of Les Infernets, the old Roman dam near the Château de Galliffet, the 'little sea' – as they called it in Aix – where, the length of a gigantic wall enclosing an entire valley, the engineer François Zola had collected the water for his canal. The mountain, sometimes massive and overwhelming, sometimes fluid and crystalline, gilded by the setting sun, dominated everything. Cézanne doted on it more than ever. At its foot, in this farmhouse, he spent the whole summer of 1897. He painted ever aspect of it. He would leave Aix at daybreak and not return until the end of the day. He had supper in the evening and slept in his mother's house, enveloping her in care and affection. She was crippled; he arranged outings for her in a carriage, taking her out to the Jas to warm herself in the sun. He carried her, thin and frail as a child, in his still strong arms from the carriage to her armchair. He told her all kinds of affectionate little stories, becoming serious again only as the victoria

turned into the Cours Mirabeau, where they lived. With a kind of bravado, drawn up to his full height, he gave the impression of protecting the fragile invalid beside him on the cushions.

He saw no one. He painted. I often went and spent whole days with him, or I joined him at nightfall with my wife and we would dine under a trellis at twilight; and as the good wine drove away his fatigue he became uplifted and happy. In the carriage that took us home he was already half asleep and mused aloud about the future, like a young man; he outlined his quest and summarized articulately 'the formula' he had achieved, was going to achieve, going to realize, tomorrow. Sometimes Solari came to join us, as well as Edmond Jaloux[1] or some young poet, Joseph d'Arbaud, Emmanuel Signoret, Marc Lafargue, Léo Larguier, whom I introduced to him, or some shy admirer who, wanting to see him at closer range, had come to dine at the same inn and was happily looking on. He would brighten for a moment, welcome the guest and make place for him at the table. They surrounded him and entertained him as an old master. He yielded to this and beamed. He was no longer the grim solitary. The supper turned into a Platonic banquet. The country evening came to life around him with works that he recalled. The youthful company cheered him up. At such brief parties he allowed himself to entertain some hope of fame, 'for,' he said to me, 'young eyes don't lie.

'Perhaps I was too early,' he added. 'I was the painter of your generation rather than mine ... You are young, you have energy, you will stamp your art with a forcefulness that only those with feeling can give it. As for me, I'm getting old ... I won't have time to express myself ... Back to work!'[2]

1 In *Fumées dans la campagne*, Edmond Jaloux gives the following picture of Cézanne: 'Suddenly the door opened. A person entered with an almost exaggerated air of carefulness and discretion. He had the face of a *petit bourgeois* or a comfortable farmer, cunning and at the same time ceremonious. His back was a bit round, his skin sunburnt and brick-coloured, the front of his head was bald, with long strands of white hair, small piercing and prying eyes, a long arched nose a bit red, a short drooping moustache and a military goatee. That's how I saw Paul Cézanne on his first visit, and always thereafter. I can hear the way he spoke, nasal, slow, meticulous, with something thoughtful and caressing. I hear him discoursing on art or nature, with subtlety, dignity, profundity.

'One day when he was lunching at home he looked at some apricots and peaches set in a bowl, and he said to us:

' " – See how the light tenderly loves the apricots, it takes them over completely, enters into their pulp, lights them from all sides! But it is miserly with the peaches and lights only one side of them."

'He made such thoughtful little remarks which no one else seems to have made. Another time, when I was walking beside him along the rue Cardinale, he said, "An artist, you understand, has to make his work, as an almond tree makes its flowers, as a snail makes its slime ..."'

2 I need hardly say that these words, indeed the majority of words I put into the old master's mouth, are fragments from letters which will be published after my death. They sum up perfectly what I have heard him say so often. Whenever possible, I have preferred the evidence of the written word, and written by him, to that of my own notes and memory.

It was the eternal refrain. And he worked. Slowly. Fervidly. Stubbornly. When a work was almost finished, he sometimes abandoned it, left it in the sun or rain, to be reabsorbed by the countryside like dust – a seasonal offering to be replaced by a later growth, another image. By contrast, at other times, when a work was well under way, he would brood over it, care for it like a living thing. One afternoon when the mistral was blowing, in the belief that he was not working, we went to take him by surprise with my friend Xavier de Magallon, and we found him stamping his foot on a rock with his fists clenched, looking with tear-filled eyes at his torn canvas, blown away by a gust of wind. And as we ran to retrieve it from the bushes in the quarry he cried out, 'Leave it, leave it . . . I was nearly there this time. I had it, I had it . . . But it's not meant to happen. No. No . . . Leave it.'

The wonderful landscape in which the Sainte-Victoire shone out above valleys touched with blue, fresh, tender and radiant, was stuck in a thicket where the wind had driven it. Battered, scratched, it was bleeding like a human being. We saw the brown surface of the canvas, ripped by the squall, the red marble quarries, the pines, the jewel-like mountain, the intense sky . . . Confronted by the subject itself, it was a masterpiece that equalled nature. Cézanne, his eyes popping out of his head, watched with us. A great anger, a madness – we couldn't make out what – came over him. He walked over to the picture, grabbed it, tore at it, threw it on the rocks, kicked holes in it with his boots, stamped on it. Then abruptly he subsided and shook his fist at us as if we were responsible: 'Off with you! Out of my sight! . . .' And hidden among the pines we heard him crying like a child for more than an hour.

He had terrible frenzies of this sort. His heart would suddenly sink. Pent-up bitterness would burst out in anger, but tenderness and irony would quickly return. Like his genius, goodness was basic to him. He suffered all his life from an internal conflict, an obsession. A misery that he never confided to anyone. He countered it with work. Happy when it was 'going ahead'. In despair, sick and morose when this consolation eluded him, when an obstacle on his canvas blocked him. Elie Faure, who, even though he never met him, is nevertheless one of those who have analyzed Cézanne best, admirably characterized the human side of his serious moral struggle, this kind of tragic and interior victory that he was obliged all the time to win over himself.

'Nothing in the world mattered to him,' says Faure, 'except the combinations of colour and shape which light and shadow impose on objects, revealing to the eye laws so rigorous that a lofty spirit could

apply them to life itself in seeking its metaphysical and moral aims.'

Cézanne's great wish was to be in harmony with these laws. He pursued himself, searched for himself in them. For him, the key, the basis of everything, was to be a good workman, to do his job thoroughly. To paint well was to live well. He applied himself without reserve, he put everything he had into each of his brush strokes. One has to have watched him painting, painfully tense, his whole face suggesting prayer, to conceive how much of his soul he put into his labour. His whole being trembled. He hesitated, his forehead congested as if swollen with his visible thoughts, his head and shoulders braced, his neck low in his shoulders, and his hands quivering until the moment when – solid, spontaneous, delicate – they placed the stroke, assured and always from right to left.[1] He drew back a little then to consider, and his eyes referred again to the objects; slowly they passed around them, related them to one another, penetrated and grasped them. With a wild look, they fixed on one point. 'I can't tear them away,' he said to me one day . . . 'they're so tightly glued to the point I am looking at that it seems to me they are going to bleed.' Minutes, sometimes a quarter of an hour, would flow by. He seemed to be sunk in a sort of slumber. He was forcing his way down to the deepest roots of reason and the world, where the will of man meets the will of things, to be either regenerated or absorbed. He pulled himself out of it with a shudder, and resumed the course of his canvas, the course of his life, catching with a touch of colour its mysterious emotion, its ecstasy, its secret surprise. In the world of representation he appeased the agony of desire. But nothing – perhaps not even love itself – appeases desire. The torment began again . . .

This helps us to understand Renoir's remark: 'How does he do it? He cannot put two touches of colour on a canvas without its being very good.' One can also understand what Gauguin had to say about him: 'He's always playing the grand organ.'[2] Yes, Cézanne's art is serious, profound, like life itself. He paints with his whole life. Like Baudelaire, whom he liked so much, he forbade himself anything indifferent, at the price of blood. No flourishes, no waste of time or colour. Nothing appealing. Painting was a serious matter. And yet, for all his consummate skill, as proved by certain watercolours, baffling in the way they

1 The unintended caricature Hermann-Paul made of him in his painting of *Cézanne at work* may, however, give that impression. It has all the exactitude of envy.

2 'It's clear that coloured painting is entering a musical phase. Cézanne, to mention one of the older generation, seems to be a student of César Franck. He is always playing the grand organ, that is why I said that he is polyphonic.' (Paul Gauguin, *Racontars d'un rapin.*)

seem dashed off, or by certain delicate, bold marks, for example the mouth and eyelashes of the *Young Man in a Red Waistcoat* and by the first sketch kept of certain projects, he gives the impression to those who have not studied him closely of an ineffectual, painful, chaotic way of working, even when a beneficent peacefulness emerges from most of his canvases with a serenity in which everything is becalmed with a sense of well-being and understanding. He felt the responsibility of his gifts. He often told me that he regarded art as a solace. He kept the effort and the torment to himself, holding up to others the consoling mirror. When he let Antoine Marion outline the earth's physical history, or made me explain Kant's system or the philosophy of Schopenhauer, an analogous idea would suddenly make him sit up and cry, 'An art without feeling is no art at all!'

The farther he went, the more he searched for feeling. The better organized his mind was, austere, sharp, unfailing, the more easily his sensibility put forth the flower of this feeling, like a smile of springtime on the strong foundations and hard slopes of the Sainte-Victoire he was painting.

Yet he left it once again. He spent the winter of 1898 in Paris and virtually the whole year after that. He lived in an apartment in Clichy, close to the studio which he rarely left. There he painted portraits, his big still-lifes, surrendering more and more to his passion for the Venetians and Poussin, and also to despair. The sudden lift afforded him by the young admirers who surrounded him in Aix, faded out in his misty solitude, as the shadow of old age fell. Minor intrigues contrived to make him lose faith in everything. He was increasingly alone. His bitterness doubled. In spite of the success, and now the wealth, that was coming to him, he scorned everything. Only his son, whom he adored, was able to squeeze a smile out of him. His regimen and his unremitting diabetes denied him even innocent pleasures, like the poetry of wine. Nothing had any taste for him any more. Everything that grew under his fingers, on his canvases, seemed to him muddled and insipid. Knowing that people were beginning to make money out of all his works, including unconsidered scraps which he despised particularly, he began now to tear up or burn his unfinished studies, he scraped them down or scratched them out with his palette knife. He had less and less faith in his genius. This kind of success, which he found unenviable, these speculative operations buzzing around his work, upset him.

'They're up to some trick . . . some dirty trick,' he said.

If one of his pictures was reproduced or fetched a good price at the

Hôtel Drouot, or if a few were hung in the place of honour at some important exhibition abroad, the news infuriated him.

'What does that all prove?' he asked.

One day I persuaded him to come with me to an exhibition in the rue Laffitte, where some forty of his paintings were hanging. It was a great success. All the young painters, and all the people who counted in Paris, were suddenly enthusiastic. I had told him this; he had shrugged his shoulders. Now he went in. He walked round the show slowly, like the humblest visitor. Two or three times he blinked in front of a magnificent landscape. As if ashamed, he nervously shook the hand of the dealer who was praising him to the skies. He was visibly in a hurry to escape. We left and were barely out the door when he said: 'It's amazing! He has framed them all.'

Another time I came running to tell him, with the utmost caution, that the Imperial Museum in Berlin had just acquired and hung two of his most beautiful canvases: a landscape once bought by Jacques-Emile Blanche at Père Tanguy's, and a still-life.

'You can depend on it,' he replied, 'now they won't let me into the Salon.'

And that was all.

To someone who said to him the next day, 'You'll be in the Louvre ...' he answered, 'The Louvre, yes ... Just the same, the jury are all swine.'

And with one of those flashes of memory and anger which made him rigid: 'In '67 they turned down Monet's *Summer* ... there you are! ... What effect do you think this has on me? ... They're always the same ... Amateurs. A fine lot!'

At one time some friends set about getting him the Croix d'Honneur.

'Decorate me?' he jeered. 'What a thought! I'm Roujon's* *bête noire.*'

In any case he detested with an almost infantile hatred anything that carried the stamp of officialdom. Baubles, the bourgeois, any form of pretension exasperated him. The Légion d'Honneur seemed to him a puerile joke, 'but damned powerful, since you can use it to lead people by the nose ... Napoleon knew about that. And everything else, the bastard!' he added. 'He got David to alter his picture.'

The Beaux-Arts was a standing abomination. The only exception he made was the University.

'It has a long history,' he said ... 'The Sorbonne and St Louis, the Collège de France and François Ier ... friends of painters, those two kings ... Giotto and Titian scored heavily there ... Besides, I like the

great established bodies, the University, the religious orders, the Salon
... yes, the Salons, if they were what they should be ... all the trouble
comes from those Beaux-Arts geldings ... Ah, Roujon! Roujon! ...
Steps should be taken against men like that who put art into a strait-
jacket, there should be an established institution, some state organ – lis-
ten to me – where one could satisfy one's love of discipline without
losing too much of one's proper Bohemian feelings, if you see what I
mean? ... Personally, I would like to have pupils, a studio, pass on my
love to them, work with them, without teaching them anything ... A
convent, a monastery, a phalanstery* of painting where one could train
together ... You would come and talk to us about Tintoretto or Sopho-
cles, like Taine ... But no programme, no instruction in painting ...
Drawing is still all right, it doesn't count, but painting – the way to learn
is to look at the masters, above all at nature, and to watch other people
painting ... But that's all dreams ... Back to work.'

The scene of these daydreams was the *terrasse* of some boulevard café
where he ended up with me sometimes and amused himself for a little
while observing the passers-by. He rose abruptly. He was surrounded
by pedlars who had passed the signal to one another, for he was known
to buy everything, incapable as he was of disappointing an imploring
pair of eyes. He filled my wife's arms with baskets of paper flowers, lit-
tle fluffy monkeys, sweets, toys.

'Give it to some children,' he said as he hailed a cab. 'Children must be
happy.'

And he himself sometimes played like a child, and had innocent joys
which may have concealed a great shyness. I can see him now, in the
middle of a meal at home among some fifteen of his warmest admirers,
getting fascinated by a little table bell and – just like a child – ringing it
again and again with a look of delight in his eyes.

'It's wonderful! ... Can I have another go?' he asked.

And a quarter of an hour later, forgetting the bell, the table, and all of
us, he became completely immersed in one of his extraordinary im-
promptus on Delacroix.

But this mood of elation in Paris deserted him almost as soon as it
began. He immediately sank back into anxiety and disgust. Work
became more painful. He no longer believed that his paintings would
last, but even so he persisted. Sometimes, in moments of extreme suffer-
ing, colours and lines became confused before his eyes. Then he would
sit down on his old straw chair. From time to time a large tear would fall
on his hand, and this would startle him out of a disturbed slumber into

which he had fallen while wide-awake. He who had always been so meticulous about all the materials of his craft lacked even the energy to get up and clean his palette or wash his brushes. And the night would find him like this, motionless, transfixed – night, old age, feebleness, death.

'For the time being,' he wrote to me, 'I go on trying to find a way of expressing the confused sensations which we bring with us at birth. If I die, it will all be over, but what does it matter?'

Preparing for the end, he returned to Aix in 1900. He spent six years there. Six years of hard work, of virtual solitude, of complete submission to the drawn-out suffering and the approaching void. His mother had died three years before, in 1897. The Jas had been sold. He lived two floors up in the rue Boulegon. At first he had a studio built in the attic under the roof; then, quickly tiring of it, he bought a piece of land on the road going up to Les Lauves and had a small house built on it with a huge studio overlooking the whole plain and the town of Aix. Between times he had rented, above Le Tholonet, the Château Noir, which was also called Château du Diable, the whim of a seller of soot, a prosperous coal-dealer who had had it built and covered from top to bottom with black distemper. Fortunately the wind and the rain had washed the black off its walls. When Cézanne lived in it, it was golden under its red tiles among its green clumps of pine, just as it appears so often in the last great landscapes he painted in those parts.

In this period his life was as regular as a monk's. He arose with the day, went most mornings to first mass, returned and spent an hour – the way Tintoretto long ago had made hundreds of copies of certain heads of the Roman Emperor Vitellius – copying some plaster cast, particularly Michelangelo's anatomical figure from every aspect, walking around it to make sure of all its movements, in pencil, brush, oil, water-colour, setting it sometimes against the blue-grey studio wall, sometimes in the middle of a simple still-life or even against a watering-can, as I saw it for a long time in a room in the Jas de Bouffan. This habit dated a long way back. Then, according to the season and the weather, he worked on the subject in hand – portrait, landscape, still-life – either in the studio or out in the fields. For five minutes between sessions of an hour or an hour and a quarter he would leaf through some book, two or three pages of Sainte-Beuve or Charles Blanc or Tortebat's *Traité d'ana-tomie*, a dusty, venerable work, 'from the Académie des Beaux-Arts,' he emphasized, 'and published in the seventeenth century.' His copy of Baudelaire, tattered and falling to bits, was always lying handy. On the

(Left) Cézanne in his studio in Paris, *c.* 1894

(Below) Cézanne's studio at Les Lauves

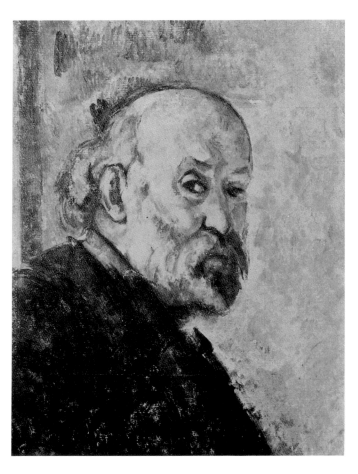

Self-portrait, 1890–94

(Right) *Michelangelo's écorché* (anatomical figure), *c.* 1895

walls were a large engraving of Delacroix's *Sardanapalus* in a black frame, photographs of Rubens' *Sirens* and Couture's *Romans of the Decadence* fixed with four pins. In a red velvet case, on the floor, on the little table for brushes, or on a chair, but always kept locked, was the small ornately framed canvas by Delacroix, *Hagar in the Wilderness*, of which he had made a copy. For a month he also had *The Sabine Women* pinned up on a wall (by 'that David!' he said ironically) and sometimes drawings by Daumier and Forain cut out of newspapers. But these were all piled in a corner, near a shelf of white wood which had several plaster casts on it. The walls were as good as bare, vast, covered with a blue-grey wash, with a bluish line at picture-rail height. No furniture. Canvases were piled up helter-skelter along the wall of the basement. On the walls of the salon at the Jas de Bouffan he had done an admirable, highly coloured, vigorous copy of a Lancret, a dancing scene in a park, and sketched two or three biblical scenes, a Mary Magdalene, also a giant-like man, most impressive, seen from behind, leaning against a rock across from a waterfall, and on the end wall over the sofa were the portrait of his father and the *Four Seasons*. Here there was nothing like that. Ascetic, bare. At the head of his bed in the rue Boulegon there was a Signorelli drawing of one man carrying another, from the Louvre, the famous Delacroix watercolour of flowers he had acquired from M. Vollard after the Chocquet sale, which he was literally mad about, and above his chest of drawers were some of his own watercolours, chestnut trees at the Jas, a boat on the Marne, in simple frames.

One evening when the poet Léo Larguier was reciting one of his poems to the *vieux maître*, he fixed his eye, as he tried to remember the lines, on the watercolour of the boat, a precious reminder of a spot Cézanne must often have painted and obviously a treasured object. 'Take it,' he said. He would have given everything away. His coachman told me later that Cézanne would often offer him one of his pictures, particularly the large still-life of the basket of peaches, but that he hesitated to take it. Cézanne insisted: '—To remind you of me . . . You have always looked after Mother . . . Later on, it will give you pleasure.' In his dining room, there was a landscape of Aix and a still-life. That was the extent of his luxury. His work was all he cared about.

Around 11 o'clock, he would have a shower-bath. 'Mass and the shower-bath,' he said to me, 'are what keep me going.' He had a frugal lunch. Sometimes on foot, more often in a carriage, he would then go off and work 'on the motif' until evening. Children in the street followed after him, tugged at his coat, threw pebbles at him. Propped on the car-

Delacroix, *Bouquet of Flowers*, 1848–50

riage cushions, he pretended to be sleeping. It would rain. One winter evening he was returning from his motif in the rain and the children were throwing mud at him. 'He fell asleep,' the coachman told me, 'he tumbled under the wheels. I picked him up all bruised . . .' The street boys left him alone after that. But in his apparent slumber, what gaping abyss had he looked into? What grief had his coachman roused him from, under those wheels? One cannot help thinking of the end of Balthazar Claes in the last pages of *The Search for the Absolute** . . . Cézanne was nearing his own.

He returned at nightfall, ate very little dinner, at least when he didn't have Solari, the young painter Camoin or some rare guest with him, and he went to bed 'with the chickens'. Occasionally of a winter evening, while waiting for dinner, he leafed through his volumes of Charles Blanc, reading the lives of painters and even amusing himself by copying and slowly recomposing some of the reproductions. And that led him to daydream, to meditate, with pencil in hand. In his declining years, was he searching the barren pages and poor plates of Charles Blanc for what had delighted him in his youth – the dreams and inspiration derived from copies of the *Magasin pittoresque* which fell into his hands? For a brain like his, anything was enough to reawaken the dulled imagination during a break, and to inspire new works and ideas. There is no answer to those who are naive or pretentious enough to forget that Cézanne spent overall one or two years of his life in the Louvre, visited the museums of Flanders, roamed for thirty years through every Paris church and exhibition, travelled rather widely, and as a well-informed tourist, in France, spent days examining photographs of all sorts and devouring a virtual library, he who was, with his deep if not very apparent general culture, incomparably knowledgeable on everything that concerned his art; there is no answer to those who believe or claim that the mediocre volumes of Charles Blanc were his entire equipment or source of reference and that his faulty drawing – faulty drawing! – came from the defective reproductions which presumably introduced him to the old masters. A prodigious power like Cézanne's would seize on everything. In his solitary room at Aix, if Charles Blanc came to hand –what luck, it would be fun to look him up, and some of the set had been missing for ages – he would derive from it everything his poetic appetite hungered for. He became secretly intoxicated by it. He transformed and enlarged the dreary images, as he had done in the old days under his father's lamp, while waiting for supper, with the fashion plates his mother had let him colour. It was always the arrangement, the subject matter, the composi-

tion that excited and involved him. And it was the names of the painters under their reproductions that set him dreaming. Apart from that, none of them had anything to teach him. To dare to pretend otherwise would require one's never having seen him at the Louvre in front of Zurbarán or Jordaens, never having heard him at Durand-Ruel's talking with Monet or Renoir, never having *really* seen him or heard him. It infuriates me. He would have shrugged his shoulders. He turned over the pages of Charles Blanc, reread Stendhal, Goncourt and de Vigny. He adored his old edition of Racine. Apuleius and Virgil always delighted him. It was Apuleius in the original language that he savoured again during the sittings for *The Old Woman with a Rosary*.

On Sundays he had a bit of a wash, went to High Mass at the basilica, and distributed his alms to a row of poor people who looked out for him along the length of Saint-Sauveur and even ended up taking up positions from the cathedral to his house, to be sure of cornering him. He gave away everything he had on him. Towards the end, his sister Marie, whom he always feared and called 'the eldest', though she was at least two years younger than he, a sour-tempered and devout old maid, felt obliged to intervene. It was she who put his housekeeper under strict orders not to let Cézanne carry more than 50 centimes whenever he left the house. Then, hat in hand, he would make his apologies as politely and meekly as a Saint Francis to the beggar who approached him. And sometimes both of them would stand there blushing in the middle of the road, amid the squalling of children.

He decided to get one of them to pose for him in his studio at Les Lauves, the *Old Man with a Cap*, now in the Pellerin Collection, which forms the moving and marvellous pendant to the *Old Woman with a Rosary* in the Doucet Collection.* I believe it was in these two paintings that all Cézanne's faith, goodness and depth of feeling were expressed with the most conscious art, direct sincerity and unrestrained emotion. These two sad faces make him the brother of Rembrandt and Dostoevsky. They should be in the Louvre – in that special corner where humanity is transfigured under the saddest guises and reveals itself in company with the most wretched qualities.

Did they satisfy Cézanne? For eighteen months at the Jas de Bouffan, he worked furiously at the *Old Woman with a Rosary*. When the canvas was finished, he thrust it into a corner. It became covered with dust, lay about on the floor, unrecognizable, trodden on and unheeded. One day I spotted it, found it against the stove under the coal-scuttle, where a drop of condensed steam from the zinc pipe was falling on it every five

minutes or so. I don't know what miracle had preserved it intact. I cleaned it. She appeared before me ... The poor thing was there, all in a heap, stubborn, resigned, unbudging, with her large peasant's hands, worn away like two old bricks, clasped, clinging to the rosary, her large blue cotton apron, her big black devoted servant's shawl, her cap, her caved-in mystic's face. And yet a beam, a shadow of pity soothed her lowered blank forehead with a vague light. Though she was quite wizened and ugly, there was an aura of goodness about her. Her dried-up soul was all atremble, contained in the movement of her hands.

Cézanne told me her story. A nun who had lost her faith, at the age of seventy, in an access of despair, she had climbed a ladder over the convent wall. He had sheltered her, in a decrepit state, hallucinating, prowling about like a wretched animal, had taken her in as a kind of maid, thinking of Diderot and out of natural kindness, then had her pose for him; and now the unfrocked old woman was swindling him, selling back to him his own torn-up napkins and tablecloths as rags for his brushes, mumbling litanies as she did so; but he closed his eyes and kept her on out of charity. His goodness, his sensitive heart is all there, just as the suffering artists's brain is all there, and most strangely, in the episode of the beggar with the cap.

He arranged for the old man to sit for him. Often the poor man was sick and failed to turn up. Then Cézanne would pose himself. He put on the dirty old rags in front of a mirror. And thus, by a strange transference, a mystical substitution – which was perhaps intentional – he mingled together in this profound painting the features of the old beggar with those of the old artist, both their lives at the confluence of the same void and the same immortality. Under the tattered cap one recognizes a disillusioned Cézanne, a pitiable ambition finally going to sleep in the repose gained by disenchantment, and at the same time a softened heart, a trusting look from the poor man who sees fraternal alms coming to him from the kind, rich man who may even envy him. The mournful greens, the runs of colour warm and bluish-black at the same time, the dirt-coloured impasto, the encrusted clothes, the ravaged, feverish face, the whole canvas exudes acute wretchedness, the wretchedness of a robust body wrecked by misfortune and hunger, the wretchedness of a great soul deceived by his dreams and his art ... This *Old Man with a Cap* is indicative of the painter's declining years and his pain. More than a work of art, it is like a moral testament. Perhaps it is here that we must seek and ponder over the ageing Cézanne's last word on life and on him-

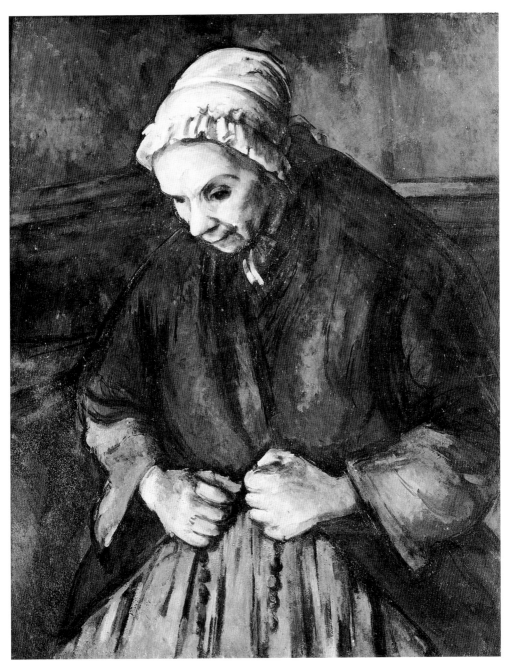

Old Woman with a Rosary, c. 1898

self. By infusing his soul with that body, with that face, he drew from them, like Shakespeare, a sort of unconscious king withdrawn in his saintliness.

On Sundays when he returned from High Mass, he would go to his old sister's for lunch, and pay visits to his other sister and to his young nieces. Before Vespers, he sometimes ventured to the Café Clement to look through the illustrated papers. He especially enjoyed *Rire* and would sit gazing at the Forains. 'He has a bit of Balzac in him – and how well it's drawn ... *There's* somebody who hasn't been through the Ecole ... He knows his business ... He gives you a character, a vice, a passion, in three strokes, and any fool can understand it ... It's rubbing elbows with real life ... Look here.' Sometimes he would copy a silhouette on the corner of the table, on a scrap of paper, or else toss 20 sous to the waiter and take the newspaper with him.

He went to Vespers. He followed the Lenten sermons, especially those given by Abbé Tardif, a man with an intense, open, original mind like his own, whom he sometimes visited, and who one day gave him the pleasure of hearing one of his landscapes described straight from the pulpit of Saint-Sauveur. On his way out he was fond of lingering in the twilit square in front of the cathedral, at the foot of the monument to Peiresc* by his friend Solari, and discussing religion and philosophy with one of the faculty instructors, Georges Dumesnil, whose learned conversation and witty remarks he greatly valued.

'You were lucky to have a good teacher like that!' he said to me. 'That's what I lacked, that's what the new generation of painters lacks – a good teacher, instruction that comes from the heart, from experience, more immediate, based on example more than on dogma and theory ... Dumesnil gives everything he says a warmth, a sort of look straight from the heart that goes right through you and makes you think, whether you want to or not ... When I'm painting the next day I sometimes remember what he said to me the night before, and my work doesn't suffer from it, as when some idea obsesses me at my easel, quite the contrary ... He's very clear and very stimulating, French. It's invigorating to remind oneself, when work is flagging, that close at hand, in the same town, there's a fellow like him who may be bent over his worktable at the same moment.'

He enjoyed this idea of solidarity in labour. In front of his studio in the rue Boulegon there was an important iron foundry; he often went down there in the evening, sat in a corner beside the forge, and, taking a break from his work, observed the blacksmiths' movements, following

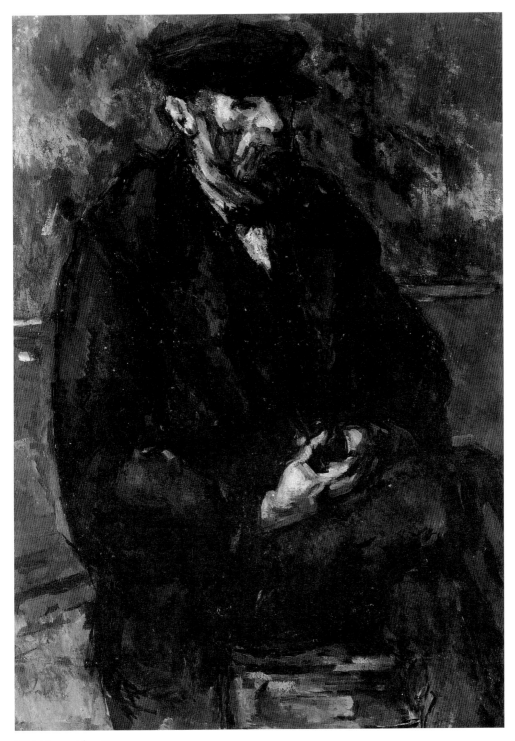

Old Man with a Cap, 1904–05

their dancing shadows on the wall, sometimes sketching in a few strokes an unexpected verse of the poem being sweated out in action.

'Don't move,' he would shout in a thundering voice. 'Just a minute.'

He would jab the paper with indicative marks. Then, suddenly relapsing from his work into his shyness, he would throw a coin on the anvil: '—Drink to my health . . .', and with shoulders bowed he rushed away, brushing against the work benches. He would not be seen again for several days. The workmen were all very fond of him. In some obscure way, humble folk recognize a master and when, as in the case of Cézanne, this hidden authority is united with simplicity and goodness, they are only too ready to show their devotion. I have seen one of these ironworkers following the old master at a distance when he left his house, in order to rescue him from the urchins who, without his being aware of them, were having a game hooting at him.

There were times when too much mental strain, or too long a period of unrelenting research reduced him to such a terrible state, a sort of moral hallucination, that he would go out, hugging the walls, not looking in front of him, still wearing his working clothes encrusted with paint, pockets in shreds, all the buttons gone – walking along and ascribing to some person casually encountered, who had perhaps greeted him, extraordinary motives for persecuting him. He believed that people were following him, spying on him. He hastened his step, struck out at passers-by and fled. Children howled at the grotesque clown. He reached his atelier in Les Lauves, closed all the doors and windows, barricaded himself in, and with clenched fists, in front of some canvas, occasionally slashing it in an access of despair or anger, he wondered what he could have done to people and things to be surrounded this way by such unanimous hostility, he who loved everybody, who wished everyone well and patently sought only to spread warmth and goodwill. He dramatized everything. Nothing ordinary could remain in his mind without his building it up into something tragic.

It must be granted that people were particularly vile to him. There was a group in Aix who, for inexplicable reasons, hated him mortally. The phrase is not excessive. One day one of these louts, as Cézanne was passing by, sneered loudly enough for me to hear, '—Line him up against the wall! . . . They should shoot painters like him.' This was a photographer who had pretensions to sculpture and was regarded as an authority in his small circle. A supporter of the church then voiced his opinion that the Dreyfus affair was easy to explain when the government let such fanatics circulate at large and tolerated the exhibition of

such horrors in Paris, while another person, a notorious radical, had his own explanation of the capital's infatuation with Zola's friend. He had seen with his own eyes the picture at the Salon which had made the flashy reputation of Cézanne and the Impressionists; a man in a balloon relieving himself in the middle of the sky and, ' To be fair,' this connoisseur admitted, 'the excrement falling from the sky was an admirable bit of painting, but there was nothing else to it. The rest wasn't even drawn, it was the painting of a child.' This judicious comment on Cézanne's reputation was made to me at a table of sneering people; if I had not witnessed their inane laughter, their amazed delight, I would not have believed my ears.

In any case, 'We could all do it as well' was and remains the general opinion. One evening, Cézanne was 'on the motif' on the banks of the Arc. A worthy painter, one of the bright lights of Aix, happened to be passing. He stopped. He smiled pityingly at the poor madman who was daubing such crude greens on a kind of draughtboard which he refused to recognize as a landscape. All the same, he felt a vague sympathy for this assiduous old man. He took his brushes from him. Cézanne looked at the man, bewildered, shocked.

'—Let me have your palette . . . I will show you . . . Look here . . . Like this.'

A touch here, a touch there. Two or three times he conscientiously went right up to the branch to verify the colour, to compare his green with that of nature. He came back, applied some paint, got excited, put his wits to work, perspired, succeeded. He stood up and dabbed his face with a scented handkerchief: '—There . . .'

But Cézanne sat down at his easel again. He spoke not a word. He took his palette knife and slowly, with a single broad strike, scraped out the fine tree with all its leaves and even the little figure which the other, in a flash of inspiration, had placed for effect sitting in the shadow of the handsome tree trunk. And then he too said: '—There . . .'

Not long after that, another artist, moved to illustrate a poem dedicated to the great solitary, scribbled below the noble verses a cartoon of a donkey's head, towards which, his eyes closed in horror, a little cupid – entirely in the courtly spirit of the eighteenth century – is shooting a defiant but tasteful arrow. 'You are fond of Cézanne,' the painter was saying, 'I despise him. I am willing to challenge posterity.'

But there were others who added treachery to ridicule. Cézanne had made some good friends among the pious circle surrounding his older sister. Henri Rochefort, who knew nothing of Cézanne's art or life,

published a foul article dragging him through the mud for being Zola's friend, a notorious Dreyfusard and a fraudulent painter to boot. Three hundred copies of it were ordered from *L'Intransigeant* and slipped at night under the doors of everybody, whether close or distant, who might have shown some sympathy for Cézanne. He was shocked by all the malicious gossip directed at him. Threatening letters, uncouth anonymous insults, were addressed to him in the rue Boulegon. They slandered his family, his few friends. They hinted at an ordinance to rid the town he dishonoured of his presence. What can have motivated this pack of hooligans, so intent for a time on hounding Cézanne, other than mindless, idle cruelty, the evil pleasure of mocking an unconventional old dreamer?

It reduced him to tears. He no longer dared to walk along the Cours Mirabeau. The notion of persecution was added to his whole feeling of despair. He could no longer work except in a state of fever or disgust. The brief moments of happiness and encouragement he had derived from the sojourns of Emile Bernard or Charles Camoin in Aix, or the visits Maurice Denis, Hermann-Paul and K.-X. Roussel paid him, went by and slowly faded away. Now he was invaded by a kind of hatred of himself, of the work he had done, and this grew with his loneliness. Never, I believe, had anyone felt such scorn for his life's work. He was completely detached from it. His canvases, the most beautiful of them, lay about the floor, he walked over them. One, folded in four, was used as a wedge in a wardrobe. He left them in the fields, he left them rotting in the *bastidons* where the peasants put them under cover. With his fanatical taste for perfection, his worship of the absolute, they represented for him only a moment, an inarticulate leap towards the formula that he was never to complete. He attached no more importance to them than a saint does to the material aspect of good works accomplished for the love of God. He forgot them right away, to move on to a more significant task. To realize, as he would say; he wanted to realize. He carried this idea inside him as a Pascal carries the idea of salvation. And thus he never was, never could be, satisifed. Every canvas reached a point of perfection which marked for him only a step, immediately overtaken by his ever-moving inspiration. He then became passionate about another which, as long as he worked on it, glowed with the possibility of the ideal. And it was always the same frantic search, the same mystical torment. He had excessive reservations about tackling the great subjects that haunted him. Always the same ones – to do new versions of Poussin's *Harvest*, or Lenain's *Card Players*, to challenge Ingres' *Apotheosis*

of Homer with his own apotheosis of Delacroix, and to crown his endeavours with one supreme image, his *Bathers*.

He told himself that the sculptors and painters of the Middle Ages submitted to their subjects, the Venetians too. There was nothing to do but paint what one saw. An artist must paint everything, must have the same objectivity in his art as Flaubert had in his, a complete submission to the world and the object, and must pursue a certain fatalism of the eye. The humblest subjects might inspire the most magnificent paintings. Yes, there was such a thing as visual fatalism. Temperament makes its choice, perceiving only what releases and reinforces it. The world assumes a character. Everything one sees is beautiful. Did this mean indifference, final detachment from everything? Or did it mean an acute awareness of difficulties multiplied by a poetic ideal in a work to be based entirely on observation and accuracy? The answer was, surely, absolute commitment, absorption of the whole being in the occupation, deep feeling that form alone matters, and that, whatever the theme, it alone gives meaning and permanence to human achievement – provided that, like a prayer, a caress, a gesture of devotion wrested from the abstraction, this intense form should have the power and brotherhood of life.

In this little busybody of a town, with his narrowly religious family at his side, exhausted by life, hounded by persecution upon the first weakening of his splendid intelligence, at the first chill of old age, he developed a hatred of originality, a love of the classics and everything traditional. As he dropped off to sleep and dreamt of death, this fearsome creator of new values sought to support his unsteady hands on something continuous, grand, indestructible. He had his life's work. He didn't believe in it. It was there, vital, immense, immortal and, like a loving daughter, ready to console him, being formed of himself. He did not see her. It was all very well for him to get carried away as he was by the admiration of a group of people who worked in an anarchist circle, to dash at one opponent and exclaim proudly, '—You know perfectly well that there's only one living painter, me!' No, no, he didn't believe it. He no longer believed it. He wrote to me around the same time, in July 1902: 'I despise all living painters, except Monet and Renoir, and I want to succeed by hard work.' And a year later, in September 1903: 'I still need six months' work on the canvas I have started. It will go and see what fate has in store for it at the Salon des Artistes français.' He sought confirmation. For once at least, this independent, solitary man in the evening of his working life wanted to set down the burden of his doubt,

to obtain, if only for an hour and even if it meant humiliation except among those close to him, clear proof that his art as well as the certainty that his life had neither of them been in vain.

This great soul, with the fiery eyes of genius, would have liked to see himself reflected, to know himself finally in the poor mirror of the feeblest eyes. To a shy young painter of whom, I believe, he would have liked to make a disciple, he wrote: 'I will give you a better idea about painting than anyone else.' He said this in all humility. More and more he was attracted by simple people. A Buddhist goodwill softened him towards every being. Perhaps it was this brotherhood of souls that he looked for in the Church. Or the image of a tradition of palpable faith, the embodiment in everyday life of a doctrine that endures in its permanent liturgy and its renewed discipline. Maybe he had soothing visions of a peaceful life which had always escaped him, for an old imagined Aix surviving under its naves, close by the cloister where Granet had painted and the pious streets where Malherbe had daydreamed. In his innocent 'cunning' and in order to have peace, did he, as he sometimes said, want to disarm the Jesuits who buzzed round his old sister and lusted after the Jas? Sometimes when a priest passed, he would murmur with a shudder: '—The curés are terrible . . . they get their claws into you.' And sometimes, to a fervent Catholic, to his friend Demolins,* for example, who asked him: 'Master, are you a believer?' he would answer: 'But good God, if I did not believe I would not be able to paint.' When Emile Bernard suggested the idea of painting a Christ, he objected: 'I would never dare; it is too difficult . . . Others have done it better than I . . .' Thus he placed the respect and pride of his art above the prayer and humility of his faith. But at Le Tholonet I have seen him after Vespers, bare-headed, splendid, in full sunshine with a large circle of respectful young people round him, following behind the platform in the Rogation Day procession and kneeling in the road beside the cornfields, with tears in his eyes. I have heard him – a man normally so down-to-earth – praising the biblical rhetoric of Bossuet and admiring that narrow, dense reasoning which led him to relate every event in the world's history to the coming of Christ. Such lofty syntheses, such Catholic perspectives, enchanted him, whereas at the same time he hated the pomposity of the Lebruns.* But mainly he loved the poor, the humble and the ignorant, and for that reason above all he could be called a Christian. He also had a great respect for the established families, the worthy provincial aristocracy. This went so far that one time, having to pay a visit to a descendant of Mirabeau, M. Lucas de Montigny, who always showed an interest in him, he

had a new suit made for the occasion and never wore it again. I even had to accompany him to 'the gentleman's home', ring the bell and, after the door was opened, close it again behind him; he would never have gone in by himself.

As much as he mistrusted the bourgeois upstart he respected the born aristocrat. But his real passion was for the ordinary people, the worker, the peasant, the industrious. In a manner of speaking, he frequented only them. They all retained a fond memory of him. He showed a royal charity towards them, not only in terms of money, but more particularly in heart and spirit. He would have liked to involve them in his emotions as he involved them in his paintings. His coachman told me that when they drove 'to the motif', Cézanne would sometimes abruptly stand up in the carriage, taking him by the arm: '—Look . . . those blues, those blues under the pines . . . That shadow there . . .' He glowed with ecstasy, and the other, who saw only trees and sky, always the same as far as he was concerned, nevertheless felt, as he confessed to me, an emotion, like a vague force, overcoming him which emanated from Cézanne, standing, transfigured, his hands clasping the fellow's shoulder, and full of a conviction which sanctified him.

Another time the sun was beating down. They had reached the mid-point of a harrowing climb. The exhausted horse and coachman had gone to sleep. Cézanne, without a word or movement, in order not to disturb them, waited in the oppressive sunshine for them to awaken; innocently rubbing his eyes, he gave the impression that it was he who had fallen asleep.

In the steep streets of Eguilles his instinctive move was always to help others, to push the overladen cart of a peasant, to take from an old woman's faltering hands the jug of water she was carrying. He loved animals. He loved trees. Towards the end, in his need of merciful solitude, an olive tree became his friend. When he had had a good session in his studio at Les Lauves, he would go down at nightfall to his front door, and watch as the day and the town went to sleep. The olive tree was waiting for him. On his first visit there, before buying the land, he had noticed it at once. While the house was going up he had a little wall built around the tree to protect it from any possible damage. And now the old twilit tree seemed vigorous and fragrant. He touched it. He spoke to it. When he parted from it at night he sometimes embraced it. At its foot the whole town had just faded away, laying to rest its rose-coloured roofs and calm boulevards. In the distance the blue hills stood out a little. One was aware of the sea. The honey and salt belfries, the

towers of the Horloge and Saint-Esprit showed their Italianate intervals against the sky. A peaceful murmur rose from the poor streets. The russet night spread its smoke and autumn over Aix and across the landscape. Alone, Cézanne listened to the olive tree . . . Its wisdom entered his heart.

'It's a living being,' he said to me one day, 'I love it like an old friend . . . It knows everything about my life and gives me excellent advice . . . I want to be buried at its feet . . .'

For his end was approaching. Solari had gone, dying in hospital. He no longer saw anyone. At long intervals he would pensively drink a bottle of old wine, yielding of an evening to that sad consolation which gave him the illusion of some deadly joy, only to fall back the next day into regrets all the more savage, a solitude all the more unbearable, which even his art, his work, could no longer fill. His illness tortured him; his swollen legs and running eyes cause him acute pain. Then new worries tormented him, attacked him at his most vulnerable points, and convinced him that because he had suffered all his life from a visual disorder he had unknowingly deformed reality. Everything, even faith in his past, deserted him. Why do the best people have to undergo such martyrdom and loss of belief? What does nature have against us? He suffered in body, heart and mind. And, a new kind of saint in life as well as art, he fell asleep bathed in artistic visions of man's future which closed his eyes. Detached from everything, including his pain, he didn't even appreciate any virtue in it. In the last months he could hardly follow a conversation any longer. When somebody played for him on the piano the overture to *Der Freischütz* which had stirred his dreaming soul in the old days, he fell asleep. Heavily. The sudden urge to do a portrait still came over him occasionally. But he soon abandoned it. Sleep would step in and overtake him wherever he happened to be, in the coach, at home, and even in front of the canvas he was working on. Instead of painting, he went out in quest of a marvellous 'motif' in which to express his whole nature. He searched the outskirts of Aix for a landscape to compose as a confirmation of his concept of the world of colours, in which the drama of his reason and his sensibility would be resolved in one logic, one feeling. He was still working all the time, but more from thought and inward searching than directly copying, and always struggling against that dream of nothingness which took possession of his eyes, his mind, his flesh. A forefinger between his eyes, using his hand as a screen, he planted himself in the streets of Eguilles, on the slopes of Le Tholonet, on the banks of the Arc, before a portion of earth and sky:

'—What a cunning fellow old Chardin was with his eyeshade, eh?' he said. He shook his head and dropped his arms, discouraged. '—One must see the planes ... clearly ... That's the whole thing.' He pondered. An impalpable ash fell over his eyes, veiling from him the world that was suddenly rent by lightning. He wept.

One morning, having set up his easel in front of Sainte-Victoire, he was painting desperately in the depths of this mist. He concentrated on his motif. He painted on. One of those grey days that he loved now, a pale smile, one of those soft mornings when the world seems old. He went on painting ... When his carriage went to fetch him, the coachman found him shivering, palette in hand, drenched to the skin. It had stopped raining. A silver sky shed its calm over the fields. The rainbow formed a halo round the tragic mountain. Cézanne saw nothing, he could barely climb into the carriage. A book, his old Virgil, fell into the mud.

'—Leave it, and leave my picture,' he croaked. He was feverish, delirious. He was put to bed. All night long he saw it again, on the horizon of his canvas, there, on the horizon of his thoughts and his life, a Sainte-Victoire such as he had never admired before. He was painting it in all its glory. He saw it shining, supernatural, in its veritable, eternal essence. Perhaps he can see it still ... He never got up again.

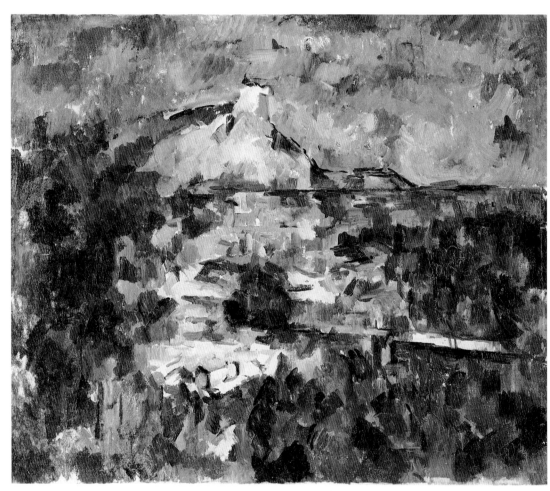

Mont Sainte-Victoire from Les Lauves, 1904–06

PART TWO

What he told me

I have told just about everything I learned, either from being with him, or from people who were in contact with him, everything I know about Cézanne's life. It is the life of a saint. I have excluded as far as possible his theories about art, reporting a conversation only when it helped to bring out a hidden aspect of his character, or clarified another side of his mysterious spirit. These matters are infinitely delicate. However objective one would like to be, a little of oneself is always unconsciously creeping in. And then I am not a painter, and I'm afraid that, however deep my respect, I may unwittingly be guilty of misrepresenting some of his profound teaching, the education that can be obtained from all these talks. However, my faithful memory has gathered them together in a spirit of reverence. I shall try to transcribe them word for word, with the aid of his letters, the ones he addressed to me as well as the ones I have been able to gather or which have been published by those who received them, such as the precious correspondence M. Emile Bernard provides at the conclusion of his *Souvenirs*. Wherever I can, I shall transcribe Cézanne's own words. I shall invent nothing – except the order in which I present them. After much deliberation I have decided to group them all into three long dialogues to give a clearer impression of their scope. Round these imaginary conversations, out of a hundred others that I really had with him in the country, in the Louvre or at his studio, I have put together everything I was able to collect and everything I can remember of his ideas about painting: this was the way he talked and, as I believe, thought.

I

THE MOTIF

'Nature is more depth than surface.'

One day we were sitting under a tall pine tree on the edge of a green and red hill, looking out over the Arc valley. It was in the neighbourhood of Blaque, not far from Mille and three-quarters of an hour from Aix and the Jas de Bouffan. The sky was blue and the air fresh, with a first hint of autumn on that late-summer morning. Hidden behind a fold in the hills, the town could be located by its smoke. We had our backs to the ponds. On the horizon, to our right, lay Luynes and the Pilon du Roi, and a glimpse of sea. Before us were the huge mass of Sainte-Victoire, hazy and bluish in the Virgilian sunlight, the rolling hills of Montaiguet, the Pont de l'Arc aqueduct, the houses, rustling trees and square fields of the Aix countryside.

This was the landscape Cézanne was painting. He had planted his easel in the shade of a clump of pines. He was at his brother-in-law's, where he had been working for two months on one canvas in the morning, another in the afternoon. The work was 'going well'. The session was nearing its end and he was in a happy frame of mind.

The painting was gradually becoming denser and more balanced. The preconceived image, well thought out and linear in its logic, which he must have touched in with rapid charcoal strokes in his usual manner, was already emerging from the patches of colour defining it throughout. The landscape seemed to shimmer, for Cézanne had slowly worked round each object, taking samples, as it were, of each colour; day by day, imperceptibly, he had brought together all these values with an unerring sense of harmony, in a relationship at once subdued and glowing. The volumes were becoming more solid, and the canvas was now reaching that maximum point of equilibrium and colour saturation which, according to Elie Faure, characterizes all Cézanne's paintings. The old master was smiling at me.

CÉZANNE

The sun is shining and I'm feeling optimistic.

MYSELF

So you're having a good morning?

CÉZANNE

I'm at grips with my motif . . . (*He clasped his hands together.*) This is a motif, you see . . .

MYSELF

How do you mean?

CÉZANNE

All right, look at this . . . (*He repeated his gesture, holding his hands apart, fingers spread wide, bringing them slowly, very slowly together again, then squeezing and contracting them until they were interlocked.*) That's what one needs to achieve . . . If one hand is too high, or too low, the whole thing is ruined. There mustn't be a single slack link, a single gap through which the emotion, the light, the truth can escape. I advance all of my canvas at one time, if you see what I mean. And in the same movement, with the same conviction, I approach all the scattered pieces . . . Everything we look at disperses and vanishes, doesn't it? Nature is always the same, and yet its appearance is always changing. It is our business as artists to convey the thrill of nature's permanence along with the elements and the appearance of all its changes. Painting must give us the flavour of nature's eternity. Everything, you understand. So I join together nature's straying hands . . . From all sides, here, there and everywhere, I select colours, tones and shades; I set them down, I bring them together . . . They make lines. They become objects – rocks, trees – without my thinking about them. They take on volume, value. If, as I perceive them, these volumes and values correspond on my canvas to the planes and patches of colour that lie before me, that appear to my eyes, well then, my canvas 'joins hands'. It holds firm. It aims neither too high nor too low. It's true, dense, full . . . But if there is the slightest distraction, the slightest hitch, above all if I interpret too much one day, if I'm carried away today by a theory which contradicts yesterday's, if I think while I'm painting, if I meddle, then whoosh!, everything goes to pieces.

MYSELF

What do you mean, if you meddle?

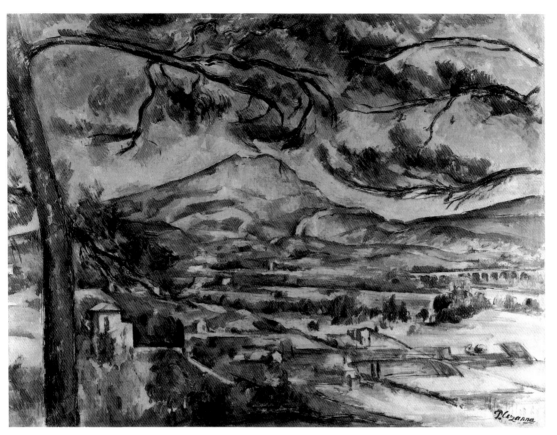

The Great Pine with Mont Sainte-Victoire, 1885–87

CÉZANNE

The artist is nothing more than a receptacle of sensations, a brain, a recording machine . . . A damned good machine, fragile and complex, above all in its relationship to other machines . . . But if he intervenes, if he dares to meddle voluntarily with what he ought merely to be translating, he introduces his own insignificance into it and the work is inferior.

MYSELF

In short, you consider the artist inferior to nature.

CÉZANNE

No, that's not what I'm saying. You're on the wrong track. Art has a harmony which parallels that of nature. The people who tell you that the painter is always inferior to nature are idiots! He is parallel to it. Unless, of course, he deliberately intervenes. His whole aim must be silence. He must silence all the voices of prejudice within him, he must forget, forget, forget, be silent, become a perfect echo. And then the entire landscape will engrave itself on the sensitive plate of his being. After that, he will have to use his craft to fix it on canvas, to externalize it; but this craft, too, is always ready to obey, to translate automatically, familiar as it is with the language, with the text to be deciphered, with the two parallel texts, nature as it is seen and nature as it is felt, the nature that is there . . . (*he pointed towards the green and blue plain*) and the nature that is here (*he tapped his forehead*), both of which have to fuse in order to endure, to live that life, half-human and half-divine, which is the life of art or, if you will . . . the life of God. The landscape is reflected, humanized, rationalized within me. I objectivize it, project it, fix it on my canvas . . . You were talking to me the other day about Kant. It may sound like nonsense, but I would see myself as the subjective consciousness of that landscape, and my canvas as it objective consciousness. My canvas and the landscape are both outside me, but while the one is chaotic, transient, muddled, lacking in logic or rational coherence, the other is permanent, tangible, classifiable, forming part of the world, of the theatre of ideas . . . of their individuality. I know. I know . . . I am interpreting. I am no university professor. I would not dare to venture into these realms with Dumesnil* . . . Good Lord, how I envy you your youth and its impetuousness! But time is pressing . . . Maybe I am wrong to run on like this . . . No more theories! Works . . . Theories are man's downfall! You need a powerful constitution and inexhaustible energy to withstand them. I ought to be more sedate, ought to realize that I am getting too old for these bursts of enthusiasm . . . that they will always be my ruin.

He had become gloomy. He was often depressed like this after an excited outburst. And it was no good trying to cheer him up. That only made him furious. He felt bad . . . There was a long silence. He picked up his brushes again, looking in turn at his canvas and his motif.

No. No. Just a moment. That's not it. There is no overall harmony. This canvas has no smell. Tell me what scent it gives off. What odour? Go on . . .

Myself

The odour of pine trees.

Cézanne

You say that because of the two large pines whose branches are counterbalancing one another in the foreground . . . But that's a visual sensation . . . Besides, the pure blue smell of pine, which is sharp in the sun, ought to blend with the fresh green smell of meadows in the morning, and with the smell of stones and the distant marble smell of Saint-Victoire. I have not achieved that effect. It must be achieved, and achieved through the colours, not by literary means. As Baudelaire and Zola succeed in doing, mysteriously perfuming a whole verse or phrase by the simple juxtaposition of words. Whenever sensation is at its fullest, it harmonizes with the whole of creation. Nature's stirrings are resolved, deep down in one's brain, into a movement sensed equally by our eyes, our ears, our mouth and our nose, each with its special kind of poetry . . . And art puts us, I believe, in a state of grace in which we experience a universal emotion in an, as it were, religious but at the same time perfectly natural way. General harmony, such as we find in colour, is located all around us. For example, if I shut my eyes and imagine the hills of Saint-Marc – the corner of the world I love best, as you know – it's the scent of scabious that comes to me, my favourite scent. Weber's music, on the other hand, evokes for me the fragrance of woods and fields. And behind Racine's verses, I sense a local colour that suggests Poussin, just as from certain of Rubens's purples an ode emerges, a murmur, a rhythm like Ronsard's.

You know that when Flaubert was writing *Salammbo* he said he saw purple. Well, when I was painting my *Old Woman with a Rosary* I saw a Flaubert colour, an atmosphere, something indefinable, a bluish russet colour that seemed to me to come from *Madame Bovary*. I was afraid for a while that it might be too literary, and therefore dangerous, so I tried to get rid of my obsession by reading Apuleius, but it didn't help.

Nothing would eradicate it. That wonderful blue and russet colour had a hold on me. It struck a chord in my heart. It was flowing all around me.

MYSELF

Did it come between you and reality? Between your eyes and the subject?

CÉZANNE

Not at all. It floated, as on other occasions. I carefully examined all the details of the woman's clothes – her cap, the folds of her apron – and I deciphered her sly expression. Only later did I register that the face was russet, and the apron bluish, just as it was not until after the picture was finished that I remembered the description of the old servant at the agricultural show. What I'm trying to convey to you is something more mysterious, more entangled in the very roots of being, in the impalpable source of all sensation. But that's the very thing, I believe, that constitutes 'temperament'. And it's only this initial force, i.e. temperament, which can carry a person forward towards the goal he's aiming at. I was saying to you just now that while an artist is at work, his brain should be unencumbered, like a sensitized plate, a recording machine, and no more. But after repeated dipping in experiences, this sensitized plate reaches such a level of receptivity that it becomes saturated with the exact image of things. Prolonged work, meditation, study, suffering and joy – the whole of life – have prepared it for this. Constant meditation on the methods used by the old masters. And then this element in which we habitually move ... this sunshine, here's another thing ... The chance fashion in which its rays fall, the way it moves, infiltrates things, becomes part of the earth's fabric – who will ever paint that? Who will ever tell that story? The physical history of the earth, its psychology. All of us, to a greater or lesser degree, all things animate and inanimate, are a bit of solar heat that has been stored up and organized, a reminder of the sun, a little phosphorus burning in the membranes of the earth's brain. You ought to have heard my friend Marion on that subject. Personally, I'd like to extract this essence. Perhaps the earth's diffused morality represents the effort it's making to return to its solar origin. Therein lies its idea of God, its feeling, its dream of God. Everywhere a ray is knocking on some dark door. Everywhere a line is surrounding a colour, holding it prisoner. I want to free them. In the great classical lands – our Provence, Greece and Italy as I imagine them – the light has a spiritual quality, and the landscape is like a hovering smile of

acute intelligence ... The delicacy of our atmosphere is linked to the delicacy of our qualities of mind. They exist one within the other. Colour is the place where our brain and the universe meet. That's why colour appears so entirely dramatic, to true painters. Look at Sainte-Victoire there. How it soars, how imperiously it thirsts for the sun! And how melancholy it is in the evening when all its weight sinks back ... Those blocks were made of fire and there's still fire in them. During the day shadows seem to creep back with a shiver, as if afraid of them. High up there is Plato's cave: when large clouds pass overhead, notice how the shadow falling from them quivers on the rock as if it were being burnt up, instantly consumed by a fiery mouth. For a long time I was quite unable to paint Sainte-Victoire; I had no idea how to go about it because, like others who just look at it, I imagined the shadow to be concave, whereas in fact it's convex, it disperses outward from the centre. Instead of accumulating, it evaporates, becomes fluid, bluish, participating in the movements of the surrounding air. Just as over there to the right, on the Pilon du Roi, you can see the contrary effect, the brightness gently rocking to and fro, moist and shimmering. That's the sea ... That's what one needs to depict. What one needs to know. That's the bath of experience, so to speak, in which the sensitized plate has to be soaked. In order to paint a landscape well, I first need to discover its geological structure. Think of the earth's history as dating from the day when two atoms met, when two whirlwinds, two chemical dances, joined together. When I read Lucretius, I drench myself with those first huge rainbows, those cosmic prisms, that dawn of mankind rising over the void. In their fine mist, I breathe in the new-born world. I become sharply, overwhelmingly, aware of colour gradations. I feel as if I'm saturated by all the shades of the infinite. At that moment, I and my picture are one. Together, we form a blue of iridescent hues. I come face to face with my motif; I lose myself in it. My thoughts wander hazily. The sun penetrates my skin dully, like a distant friend, warming, fertilizing my laziness, and together we germinate. When night falls again, it seems to me that I shall never paint and that I have never painted. Only with nightfall can I withdraw my eyes from the earth, from this corner of the earth with which I've merged. A lovely morning follows; gradually the geological structures become clear to me, the strata, the main planes of my picture, establish themselves, and mentally I draw their rocky skeleton. I see rocks just below the surface of the water and feel the pressure of the sky overhead. Everything steadies into place. Outlines are pale and trembling. Red earth masses emerge from an abyss. I begin to dis-

tance myself from the landscape, to see it. With this first sketch, these geological lines, I detach myself from it. Geometry – the measurement of earth. A tender feeling comes over me and from the roots of this feeling rises the sap – colour. A sort of deliverance. Colour that expresses the radiance of the heart, that gives an outward form to the mystery of vision, that links earth and sun, the ideal and the real! An airy, coloured logic suddenly ousting sombre, stubborn geometry. Everything becomes organized: trees, fields, houses. I am seeing. In patches of colour. The geological foundation, the preparatory work, the world of the drawing, gives way; it has collapsed as if struck by a natural disaster. A cataclysm has carried it off and breathed new life into it. A new stage begins. The real one! The one where nothing escapes me, where everything is dense and at the same time fluid, natural. Only colours exist now, and in them brightness, the being whose thoughts they are, this aspiration of the earth towards the sun, this exhalation from the depths towards love. It would take a genius to immobilize this upward surge in a moment of equilibrium, and yet suggest its thrust. I'd like to catch hold of this idea, this burst of emotion, this vapour of life hovering over the universal fire. My canvas begins to feel heavy; a weight is pressing on my brushes. Everything is falling. Everything is falling again below the horizon. From my brain onto the canvas; from my canvas to the ground. Heavily. Where is the air, where is that dense lightness? With genius, one could evoke the meeting of all these elements in mid-air, in the same ascent, the same desire. A minute in the life of the world passes. To paint that minute in its precise reality! Forgetting everything else for its sake. To become that minute. To be, in other words, the sensitized plate. To convey the image of what we see, forgetting everything that appeared before.

MYSELF

Is that possible?

CÉZANNE

I've tried to do it.

He lowered his head, raised it again suddenly, looking out over the landscape, and then gazed lovingly at his canvas. There was a faint smile on his face.

Who knows? It's all so simple, and yet so complex.

MYSELF

You were saying one must forget everything. Then why this preparation, this meditating in front of the landscape?

CÉZANNE

Alas, because I'm no longer innocent. We're civilized beings. Whether we like it or not, we have the cares and concerns of classical civilization in our bones. I want to express myself clearly when I paint. In people who feign ignorance there is a kind of barbarism even more detestable than the academic kind: it's no longer possible to be ignorant today. One no longer is. We come into the world armed with facility. Facility is the death of art and we must rid ourselves of it. When I think of those first men who carved their hunting dreams on the walls of a cave, or those good Christians who painted their Paradise in fresco on the walls of catacombs, who created themselves, who created everything for themselves, their craft, their impressions, their very soul . . . To confront a landscape in that way. To evoke its religious aspect. It seems to me on some days that I paint naively. I'm the primitive of my way. Armed with all the faith of my naive clumsiness, I'd like to find the answer . . . to realize fully. For whatever anyone may say, it's the worst kind of decadence to play at ignorance and naivité. Senility. Today one can no longer fail to know; one can no longer learn anything on one's own. We start breathing our profession at birth. And do it badly. On the contrary, this should all be properly arranged. Wherever we are, we're plunged into this vast lay school that makes up society. Yes, there's a classicism which goes with the products of this school and which I abominate above all else. I suppose that, as with God, as the saying goes, a little knowledge takes us farther away, but a lot of knowledge leads us back. Yes, a lot of knowledge leads us back to nature. Because it teaches us the inadequacy of mere professionalism.

MYSELF

The inadequacy of professionalism?

CÉZANNE

Yes, professionalism on its own finally dries up; its rhetoric becomes thin and strained. Look at the Bolognese painters. They no longer have any feelings at all . . . Having at one's disposal an idea, a thought, or a word is no good when it's feeling you need. Big words are thoughts which don't belong to you. Clichés are the leprosy of art. Mythology in painting is an example; if you trace its course backwards, you see that it's the history of professionalism taking over. When you have painted

goddesses, in the end you no longer have painted women. Go around the Salons. A bloke can't paint reflections in water beneath foliage, so he sticks in a naiad. Result: Ingres' *Source*! What does that have to do with water? . . . And with you writers it's the same: you dress things up and exclaim, 'Venus', 'Zeus', 'Apollo', when you can no longer say with any depth of feeling 'sea foam', 'clouds' and 'bright sunlight'. Do you believe in that Olympian rubbish? Well?

Rien n'est beau que le vrai, le vrai seul est aimable.

MYSELF

What about Veronese, Rubens, Velasquez and Tintoretto? All those painters you love? . . .

CÉZANNE

Them? They had such vitality that they made the sap flow again through all those dead tree-trunks – their own sap, that prodigious life force of theirs . . . The flesh they paint is warm-blooded; you feel as if you could stroke it . . . When Cellini brandished the bloody head in Perseus' hand, he really knew what it was to kill, he had felt a warm jet making his fingers sticky . . . A murder per year, that was his average . . . Those artists knew no other truth. That was nature to them, those bodies of gods and goddesses. They glorified mankind through madonnas and saints in whom they no longer believed. Look how cold their religious painting is. Tintoretto constantly goes beyond his subjects and pleases himself. Titian's *Saint Jerome* in Milan, with all his animals, his snail, his teeming rocks, is he an ascetic, a stoic, a philosopher, a saint? We don't know. He is a man. An old chap with a stone in his hand, all ready to crack its secret, to strike a spark of truth out of the mysterious flint. This truth issues out of the whole reddish-brown colour scheme of that dour picture. It doesn't flow from the arms of the cross, which you don't notice at first, since it's there only because the picture was commissioned by some order or church. There's a painter for you . . . One of the real pagans. In that renaissance there was an explosion of unique truthfulness, a love of painting and form, the like of which has not been seen again. Then come the Jesuits and everything is formal; everything has to be taught and learned. It required a revolution for nature to be rediscovered, for Delacroix to paint his beach at Etretat, Corot his Roman rubble, Courbet his forest scenes and his waves. And how miserably slow that revolution was, how many stages it had to go through! You arrange your subject . . . That's Rousseau, Daubigny and Millet. You compose your landscape like an historical scene . . . I mean, from the outside. You

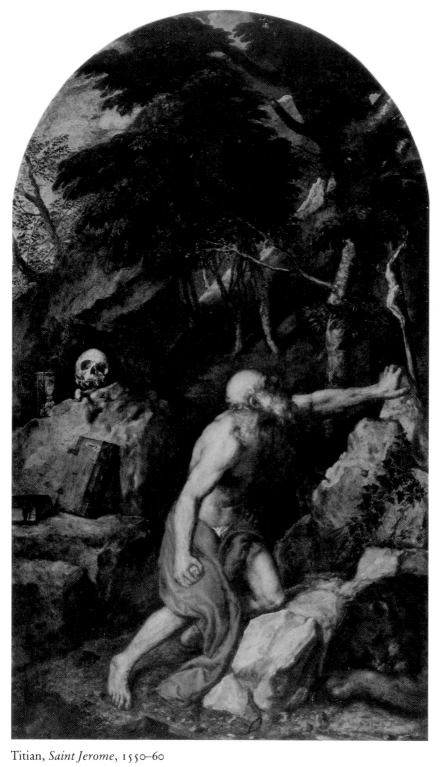

Titian, *Saint Jerome*, 1550–60

create the rhetoric of landscape, a phrase, effects handed down from painter to painter. Contriving the landscape, which Rousseau used to say Dupré had taught him to do. Then there's Corot himself. Personally I prefer a more firmly based painting. These artists had not yet discovered that nature has more to do with depth than with surfaces. I can tell you, you can do things to the surface, you can decorate it and make it look pretty, but by going deep you automatically get to the truth. You feel a healthy need to be truthful. You'd rather strip your canvas right down than invent or imagine a detail. You want to know.

MYSELF

Know?

CÉZANNE

Yes, I want to know. To know, the better to feel, and to feel, the better to know. While being the first to work in my way, I want to stay simple. Those who know are simple. The half-knowing, the amateurs, only half-realize. The fact is that the only amateurs are those who make bad pictures. It was Manet who said that to Gauguin. I wouldn't want to be one of those amateurs. What I want is to be a true classic and rediscover a classic path by means of nature, by sensation. My ideas used to be all muddled before. Life! Life! That was the only word on my lips. Like an idiot I wanted to burn down the Louvre. One has to go to the Louvre by way of nature and come back to nature by way of the Louvre ... All the same Zola really captures me in *L'Oeuvre* – maybe you don't remember it – when he bellows: 'Ah, life! life! to feel it and capture it in its reality, to love it for itself, to see in it the only true beauty, eternal and changing ...'

His memory failed him momentarily, then he finished it in one go.

'... not to entertain the foolish idea of ennobling it by castrating it, to understand that so-called blemishes are what make character stand out, to make things live, and to create men, the only way of being God.'

He gave a hearty laugh.

Yes, that's all right ... But there's better. Simplicity, being direct. Everything else is just a game, just building castles in the air. I'm laying it on with you today, I don't know why. Basically, I don't think of anything when I paint. I see colours. I strive with joy to convey them on to my canvas just as I see them. They arrange themselves as they choose,

any old way. Sometimes that makes a picture. I'm a brainless animal. Very content if I could be just that . . .

He considered.

Is good health the painter's primary requirement? It's everyone's. What stops me from realizing my aims is that I'm not always well . . . not always in good health.

With his head tilted slightly forward, he looked up at me, watching me closely. He was irritated, though he didn't entirely show it. He tried to shake off his black mood.

This old path is a Roman road. They're always admirably sited. Just follow me. From every point along it you get a view. The Romans had a feel for landscape, whereas our engineers don't give a damn about it.

He burst out angrily.

And what about me? . . . You know as well as I do that I'm out of sorts. Eyes, yes, eyes! . . . I see planes overlapping . . . At times, straight lines seem to me to be falling. Well, what do you want me to do about it? . . . It's all a joke.

He half-closed his eyes.

Until you've painted a grey, you're not a painter.

He sensed my depression and softened again.

I'll tell you something . . . I was at Talloires, a drab little village if there ever was one. It has as many greys as you could ask for! And greens. All the grey-greens of the atlas. The surrounding hills had seemed to me quite high; yet they appeared low and it was raining! . . . There was a lake between two gulleys, an English ladies' lake. Leaves out of watercolour albums falling off every tree. It was nature, all right . . . But not nature as I see it. Do you get me? Grey on grey. You're not a painter as long as you haven't painted greys. Grey is the enemy of all painting, said Delacroix. No, you're not a painter until you've painted grey.

MYSELF

Provence is often grey.

CÉZANNE

Never. Silvery, perhaps. Blue, bluish . . . Never grey, no more grey than

crude, or yellow, or noisy, like the flakes of confetti with which all those unseeing observers pollute its image . . . Yes, the earth here always has a vibrant quality, a sharpness which makes the light tremble and the eye-lids flicker, but feel how subtle, how soft it is. Drawn out by an even cadence.

> *N'aime que les jeux et la dance,*
> *Ne cherche en tout que la cadence,*

as your friend Magallon* says. It's very Provençal. Nothing here jars. Everything becomes intensified, but in the smoothest manner. You've only to let yourself go. If I only had your youthful vigour, and the mag-nificent brain power of a Titian, painting till the age of a hundred, the old bugger . . . If the plague hadn't carried him off, he'd be painting still . . . If I were able, I'd always be working, and without getting over-tired. Then you'd see. I'd be the ordinary people's great painter. Nature speaks to us all. And yet, no one has ever really painted the landscape. A landscape without a human being, but one that is completely human. That great Buddhist invention, nirvana, consolation with no desires, no stories – colour! It would just be a matter of gathering it all in, of allow-ing oneself to flower there. The country here supports you . . . I tell you, even as far away as Paris, I'm still conscious of it. Promise me, if I leave it . . . though I'd have difficulty going far away, what with you here and my age . . . promise me the favour of writing to me from time to time, so that my ties with it won't be completely broken, and I'll never feel entirely cut off from a place where I've always, even unawares, been in touch with my feelings . . . Make others feel the same way about it. Without their realizing it! That's the meaning of art! . . . Yes, what I'm aiming for is the logical development of what we see and feel when we observe nature; only then am I concerned with the process, processes being for us no more than simple ways of getting the public to feel what we ourselves are feeling, and of making our point. The great artists we admire have done no more . . . Shall we have lunch?

The game bag hung on a branch and the bottle was keeping cool in a stream. We sat down near a little pool in the sun-streaked shade of the pines. Lunch was frugal but, like Phaedra under her plane-tree beside the Ilissus, Cézanne talked while he ate. A blue midday haze caressed the rolling contours of the countryside. The white roads, the cheerful roofs, the clumps of trees, the river gliding between the hills, everything that lay at the foot of Sainte-Victoire seemed to be taking part in our con-

versation. A dog had appeared, and the old master was throwing it pieces of bread.

I'm running on a bit today. And yet chatting about art is virtually useless.

<div align="center">MYSELF</div>

Don't you think it brings artists together?

<div align="center">CÉZANNE</div>

You either see a picture at once or you never see it at all. Explanations are no help. What's the point of making comments? They never amount to more than an approximation. We have to chat as we're doing because it's entertaining, like drinking a good glass of wine. Even so, if you work hard and make progress in your art, that's compensation enough for the fact that imbeciles fail to understand you. Here's a point. A writer like you expresses himself in abstractions, while the painter turns his sensations and perceptions into something concrete through drawing and colour. If they're not there on his canvas, visible to others, no explanation whatsoever will help to make them understandable. I don't like literary painting. To write below a person what he's thinking and what he's doing is to admit that his thought and his intention are not conveyed by the drawing and the colour. And wanting to force nature to say things, making trees twist and rocks frown, as Gustave Doré does, or even painting it like da Vinci, that's literature too. There's a logic of colour, damn it all! The painter owes allegiance to that alone. Never to the logic of the brain; if he abandons himself to that logic, he's lost. Allegiance to the logic of his eyes, always. If his feeling is right, then his thinking will be right too. Painting is first and foremost an optical affair. The stuff of our art is there, in what our eyes are thinking . . . If you respect nature, it will always unravel its meaning for you.

<div align="center">MYSELF</div>

Does that mean that nature offers some meaning to you? Isn't it the meaning you yourself put into it?

<div align="center">CÉZANNE</div>

Perhaps . . . Yes, basically you're right. I've wanted to copy nature, but I haven't managed to. All my attempts to track it down, all my twists and turns, have got me nowhere. It's unassailable. From every direction. Nevertheless I was pleased with myself for discovering that the sun, for example, cannot be reproduced, but has to be represented by

some other means . . . by colour. All the rest, theories, drawing (which has a logic of a sort – a bastard logic, falling between arithmetic, geometry and colour – and is a still-life version of nature), ideas, even sensations, all of them are nothing but detours. Sometimes you think you're taking a short cut, but you've gone the long way round. There's only one road to a full rendering, a full translation: colour. Colour, if I may say so, is biological. Colour is alive, and colour alone makes things come alive. Basically I'm a human being, right? Whatever I may do, I cannot get rid of the notion that this tree is a tree, this rock a rock, this dog a dog . . .

He suddenly stopped eating and talking. He had just been struck by something or someone.

And yet I don't know. With peasants I've sometimes wondered whether they really know what a landscape is, or indeed a tree. Perhaps that seems odd to you. Sometimes when I've been out walking, I've gone along with a farmer behind his cart when he was on his way to sell potatoes in the market, and that farmer had never seen Sainte-Victoire. These people know what's been sown here and there along the road, what the weather will be like tomorrow, and if Sainte-Victoire has its cap on or not; they can smell it, the way animals do, just as a dog knows what a piece of bread is when he sniffs at it. They register only what's important to them. I don't really believe that most of them either know or sense that trees are green, and that this green is a tree, that this earth is red, and that these disintegrating reds are hills; those are things which lie outside their practical needs, hence beyond the scope of their unconscious register. Without losing any part of myself, I need to get back to that instinct, so that these colours in the scattered fields signify an idea to me, just as to them they signify a crop. Confronted by a yellow, they spontaneously feel the harvesting activity required of them, just as I, when faced with the same ripening tint, ought to know instinctively how to touch in the corresponding colour on my canvas in order to obtain a square of waving corn. Touch by touch, the earth would thus come alive. By tilling my field, I would start to grow a lovely landscape . . . Remember Courbet's story about the pile of sticks he was painting. He asked what it was over there that he was putting in. Someone went to look. And it was sticks. It's the same with the world, the whole wide world. To paint it in its essence, you need to have the kind of painter's eyes which see the object in terms of colour alone, capture it, and relate it, as it is, to other objects. You can never be too scrupulous, too sincere,

or too submissive to nature, while still remaining more or less in control of your subject and especially of your means of expression. You must adapt these to your motif. Not bending it your way but bowing to it. Allowing it to be born, to germinate within you. Painting what is in front of you and persevering in expressing yourself as logically as possible, but a natural logic, of course; I have never done anything else. You have no idea what discoveries await you then. You see, it's only through nature that you can make progress, and the eye educates itself by contact with nature. By dint of looking and working, it becomes concentric.

MYSELF

How do you mean, concentric?

CÉZANNE

I mean that on this orange I'm peeling or, indeed, on an apple, a ball, or a head, there is a culminating point, and despite tremendous effects – light, shade, colour sensations – this point is always the one nearest our eye. The edges of objects recede towards another placed on your horizon. Once you've understood that . . .

He smiled.

Oh well, you'd have to be a painter to understand. Good heavens, I've invented enough theories about it! . . .

He took a piece of crumpled paper out of his pocket.

I've written to a painter who came to see me, someone you don't know, who does a bit of theorizing himself. I'll sum up what I said to him in my letter.

He read in a drawling, timid but dogmatic voice:

'Treat nature in terms of the cylinder, the sphere, and the cone, the whole put into perspective so that each side of an object, or of a plane, leads towards a central point. Lines parallel to the horizon give breadth, whether a section of nature or, if you prefer, of the spectacle which *Pater omnipotens aeterne Deus* unfolds before your eyes. Lines perpendicular to this horizon give depth. Now, nature, for us human beings, has more to do with depth than with surfaces, hence the need to introduce into our vibrations of light, represented by reds and yellows, a sufficient quantity of blue tints to create the impression of air.'

Yes . . . I make a better job of painting than of writing, don't I? I'm not going to outdo Fromentin* yet.

He crumpled the paper into a ball and threw it away. When I picked it up, he shrugged his shoulders.

I was writing that for someone in the trade.* On a rainy day. In wet weather it's impossible to put into practice out of doors all these theories I'm outlining to you and which I know in my heart to be sound. But with perseverence we come to understand interiors like everything else. It's only the old stuff clogging up our brain; it needs a good jolt . . . Everything I'm telling you about – the sphere, cone, cylinder, concave shadow – on mornings when I'm tired these notions of mine get me going, they stimulate me. I soon forget them once I start using my eyes. It wouldn't do for those ideas to fall into the clutches of the amateurs. I can see exactly how they would turn out in the hands of the Rosicrucians or other dabblers of that type. It's like Impressionism. They all do it at the Salons. Oh, very discreetly! I too was an Impressionist, I don't conceal the fact. Pissarro had an enormous influence on me. But I wanted to make out of Impressionism something solid and lasting like the art of the museums. I was saying as much to Maurice Denis. Renoir's a clever fellow. Pissarro's a peasant. Renoir was originally a painter on porcelain . . . His talent is immense, but some hint of mother-of-pearl remains in it. What pieces he's brought off all the same! I don't like his landscapes. His vision is woolly. Sisley? . . . Yes. But what an eye Monet has, the most prodigious eye since painting began! I raise my hat to him. As for Courbet, he already had the image in his eye, ready-made. Monet used to visit him, you know, in his early days, over there, on the Channel coast. But a touch of green, believe me, is enough to give us a landscape, just as a flesh tone will translate a face for us, or even convey a human figure. That is why, perhaps, all of us derive from Pissarro. He had the good luck to be born in the West Indies, where he learned how to draw without a teacher. He told me all about it. In '65 he was already cutting out black, bitumen, raw sienna and the ochres. That's a fact. Never paint with anything but the three primary colours and their derivatives, he used to say to me. Yes, he was the first Impressionist. Impressionism, eh? The optical mixing of colours, isn't it? Separating the colours on the canvas and reconstituting them on the retina.* That was part of the course for us. Monet's cliffs will survive as a prodigious series, as will a hundred other of his canvases. When I think that the Salon rejected his *Summer*! All juries are swine. He'll be in the Louvre, for sure, alongside

Constable and Turner. Damn it, he's even greater. He's painted the iridescence of the earth. He's painted water. Remember those Rouen cathedrals we saw together? What was the line you were giving me, like old Geffroy: that here we had painting corresponding to Renan,* to the latest hypotheses about the atom, to the flow of the biological current, to the movement of all things? Possibly. But where everything slips away in these pictures of Monet's, nowadays we must insert a solidity, a framework ... Oh if you could only see how he paints! His is the only eye, the only hand able to follow a sunset in all its transparent effects and instantly capture its shades on canvas, without having to return to them again and again! Then he's a grand seigneur who treats himself to the haystacks he fancies. If a corner of a field takes his fancy, he buys it up. With a hefty manservant and guard dogs to keep people from bothering him. That's what I need. And pupils. To get an Impressionist tradition going, to pick out its special characteristics! A school? No, no, a tradition.

He fell into a reverie.

But I proceed very slowly, you see, since nature strikes me as something highly complex, and there is endless progress to be made. The Louvre is a good reference book and I haven't failed to use it, but it still ought to be only an intermediary. The real study – and it's a prodigious one – lies in observing the diverse pictures that nature presents. It's what I always come back to: the painter should devote himself entirely to the study of nature and try to produce pictures which may be educative.

MYSELF

Educative? For whom? You mean they should have a social function?

CÉZANNE

Lord, no! Or perhaps it's the term that puts me off. But educative for everyone; yes, I do mean that ... Teaching them how to understand nature from the point of view of painting and how to develop methods of expression. So that everyone can express himself. Personally, as I was saying to you this morning, I need to know some geology – how Sainte-Victoire's roots work, the colours of the geological soils – since such things move me, and benefit me. What I'm saying is that painting in a calm and consistent manner (rather than half-heartedly) must inevitably produce a state of clearsightedness which will help us to gain a firm direction in life. Everything is connected. Believe me, if my canvas is

imbued with this vague, cosmic religious feeling which moves and improves me, it's going to affect others at a point of their sensibility that they may not even be aware of. I need to know about geometry and planes; I need to know anything that will help my understanding. I've asked myself, is shade concave? Hello, what's that cone up there? Is it light? I have noticed that the shade on Sainte-Victoire is concave, bulging. You see it just as I do. It's unbelievable. That's how it is . . . It gave me a great thrill to realize that. If I can convey that thrill to others through the mysterious effect of my colours, won't they get a richer, more delectable – even if more obsessive – sense of the universal? The other evening, when we were going back to Aix, we talked about Kant. I wanted to put myself in your shoes, to understand your point of view. What is there in common between a pine as it appears to me and a pine as it is in reality? If I were to paint that . . . Wouldn't it be the realization of that part of nature which lies before our eyes, presenting us with a picture? . . . Conscious trees! . . . And in this picture wouldn't there be a philosophy of appearance more generally accessible than all the tables of categories, all your noumena and phenomena. Seeing it, one would feel how everything is related to oneself, to man. I said to myself that I'd like to paint space and time so that they become forms of colour sensibility, since I sometimes imagine colours as great noumenal entities, living ideas, beings of pure reason. With which we can commune. Nature isn't at the surface; it's in depth. Colours are the expression, on this surface, of this depth. They rise up out of the earth's roots: they're its life, the life of ideas. Drawing, on the other hand, is a complete abstraction. So that it must never be separated from colour. That would be like trying to think without using words, just figures and symbols. Drawing's an algebra, a form of handwriting. As soon as life breathes into it, and it is dealing with sensations, it becomes coloured. Fullness of drawing always corresponds with fullness of colour. When you come down to it, where in nature do you ever find anything drawn? Where? Where? The things that men build, straight, drawn, walls and houses – just think how time and nature knock them sideways. Nature abhors a straight line. And to hell with engineers! . . . We're not road surveyors. A lot they care for colour . . . Whereas for me . . . Yes, yes, sensation is at the root of everything.

He fumbled in his pockets again.

Let me have that piece of paper.

He smoothed it out and glanced through it, then gave it back to me and found another scrap.

I also made this note.

He read:

'Colour sensations producing light give rise to abstractions which prevent me from covering my canvas or fully defining the contours of objects when the points of contact are subtle and delicate, with the result that my image or picture remains incomplete. Moreover, the planes fall on top of one another, producing the neo-Impressionist effect of a black line, or rim, running round the edge of things, a fault we must fight against with all our might. Nature, duly consulted, gives us the means of attaining this end.'

MYSELF

Which are?

CÉZANNE

Planes in colour, planes! The coloured place where the heart of the planes is fused, where prismatic warmth is created, the encounter of planes in sunlight. I produce my planes with the colours on my palette, do you follow me? . . . You have to see the planes . . . clearly . . . but fit them together, blend them. They must turn and interlock at the same time. Only volumes matter. Let air circulate between objects if you want to paint well. Like sensation between ideas in order to think properly. Bitumen flattens. Logic sells us short. We're painting in caves where there are no longer any planes. We're strangling ourselves with theories which leave no room for intuition. A piece of cardboard must be made to grow into something round. Do you see? Contrasts must be set up through correct colour relationships. The slightest faltering of the eye ruins the whole thing. And in my case, it's terrible, the way my eye gets glued to a tree-trunk or a lump of earth. There's such a strong pull, it's painful tearing it away.

MYSELF

Yes, I've noticed, you sometimes wait twenty minutes between two brush strokes.

CÉZANNE

My eyes, too . . . I expect you've noticed. My wife tells me they pop out of my head, all bloodshot . . . When I get up from painting, I feel a sort

of intoxication, a sort of ecstasy; it's as if I were stumbling around in a fog ... Tell me, am I a little crazy? The painting fixation ... Frenhofer ... Balthasar Claes ... You know, sometimes I wonder if it's true.

I pointed to his canvas. It stood, unfinished, under the big pine tree, every part of it delving deeper and deeper into the mystery of being, down into the roots of the great enigma: a fragment of diamond in which all the world's sunlight was refracted, easing its balanced load. An inner music flowed from it. Its empty spaces were animated by a vital spirit. The as yet uncovered reddish-brown texture of the canvas gaped like a blind man's stare. The solemn greens and pensive blues, the lighter colours alongside, the patches still awaiting paint, were already answering one another, building up the foot of the mountain, the slopes brightening in the air, the greenish columns of sky, the two trees, right and left, reaching out to each other above the countryside with answering branches ... Faced with the evidence of his canvas, with this radiant flow of precise colours, the old master smiled, then turned to look once more at the vast landscape. It was just like his painting, less human but equally beautiful.

Copying ... copying ... yes. It's the only way. But temperament comes into it too. Painting recognizes its own. Personally, I'd like to lose myself in nature, grow again *with* nature, *like* nature, have the stubborn shades of the rocks, the rational obstinacy of the mountain, the fluidity of the air, and the warmth of the sun. In a green my whole brain would flow in unison with the sap rising through a tree's veins. Out in front of us there is a vast presence of light and love, the hovering universe, the tentativeness of things. I'll be their Olympus, I'll be their god. The celestial ideal will be united in me. Colours, you see, are the dazzling flesh of ideas and of God. They make mystery transparent, laws iridescent. Their pearly smile revives the dead face of the vanished world. Where is yesterday, and the day before yesterday? Where are the plain and the mountain I was looking at? In this picture, in these colours. Awareness of the world is perpetuated more fully in our canvases than in your poems, because our paintings embody more materialized sensations. They mark the stages of mankind's journey. From the reindeer on cave walls to Monet's cliffs on pork butchers' walls, you can follow the path of human development ... From the hunters and fishermen peopling the tombs of ancient Egypt, the sophisticated world of Pompeii, the frescoes of Pisa and Siena, the mythological paintings of Veronese and Rubens, the evidence mounts, a spirit emerges which is everywhere the same: memory translated into objective form, the

painted memory of man achieving concrete existence in terms of what he sees. We really believe only what we see. We see in painting all that man has seen. Everything he's wanted to see. We are the same man. I shall add a link to this coloured chain. My blue link. The introduction of true nature, landscape as perceived by the intelligence, the positivism of landscape, what we as civilized beings feel when confronted with a landscape, one that was once overrun by hordes of Salian Franks, and where we now sit and chat about Darwin and Schopenhauer. The Hindu consolation of a natural nirvana falling on our weary senses as we reach the last stage of our journey. Beneath the drama of the clouds, the tranquillity of a cornfield . . . The unapproachable, invisible deity, the sun! . . . Systems, a system . . . Yes, we need a system. But once the system is established, work from nature. One has a system all arranged, then one forgets it: one works from nature. Look at the world's great men. Look at the painters. The Venetians. When you were in Venice, did you see that gigantic Tintoretto in which earth and sea on a painted globe hang overhead, with its shifting horizon, its depth, its watery distances, and flying bodies, and this vast round thing, this globe, this planet flung headlong, falling, rolling in outer space? In that period! It was a prophecy for ours. He already had this cosmic obsession we're bitten with. All the same, I am certain that while he was painting he didn't think about anything but his ceiling, about balancing volumes and relating values. About painting well. But painting well means that, in spite of yourself, you speak for your age in terms that register its most advanced awareness, that you're at the summit of the world, at the top of the human ladder. Words, and colours too, carry a meaning. A painter who knows his grammar and pushes his language to the limit without destroying it, who superimposes it on what he sees, inevitably translates on to his canvas whatever ideas the best-informed brain of his time has conceived or is in the process of conceiving. Giotto answers to Dante, Tintoretto to Shakespeare, Poussin to Descartes, Delacroix . . . to whom? What is senseless is to have a pre-formed mythology, ready-made ideas of objects, and to copy this instead of reality – these imaginings instead of this earth. Bogus painters don't see this tree, your face, this dog, but only a tree, a face, a dog. They don't see anything. Nothing's ever the same. For them a hazy kind of fixed type, which they relay to one another, constantly floats between their eyes – do they have eyes? – and their subject. Yes, grand laws and principles are important; but after the upheavals and mental turmoil which their implementation puts you through, you should innocently copy nature. I'm as much of an intellec-

tual as you could wish, but I'm also a simple animal. I'm playing the philosopher, chatting to you, getting garrulous. But faced with my tubes of paint, and holding my brushes, I'm just a painter, the least of painters, a child. I sweat blood. I no longer know a thing. I paint. It's rather like those people who imagine themselves to be honest because they obey the rules. The honest man's rules are in his blood. The genius becomes a genius through living by his own code of rules. Yes, the genius may know all about other people, but he creates his own method.

MYSELF

A method?

CÉZANNE

Yes, and it's always the same one. The right one. He discovers it, but basically it's always the same. Mine, for instance – and I've never had a different one – is hatred of the imaginary. I would like to be as mindless as a vegetable. My method, my code of rules, is realism. But don't misunderstand me: it's a realism full of grandeur, no doubt about that. The heroism of the real. Courbet, Flaubert. Better still. I'm no romantic. The vastness of the world, its mighty current, in an inch or two of matter. Do you think that's impossible? The colourful cycle of the blood. Rubens.

He went over to pick up a second canvas that was propped against a bush. It was a more peaceful, tender version of the same motif, still waiting to be worked on.

I'm an old beast of burden . . . My method is to love work.

He hung his bag from the tree and took a swig straight from the bottle.

Rubens . . . Rubens . . . Listen. That's another age, all that. We're in the evening of the world. Painting, like everything else, is vanishing . . . I'll be perfectly happy if they just leave me in peace, if they let me go on working in my own little corner till I drop.

He set himself up in front of his new, afternoon motif, ten feet away from the old one. He had picked up his sables and brushes, and a second palette, laid out ready. He looked at the canvas. The sun was beginning to go down.

MYSELF

Who knows, Master? . . .

CÉZANNE

Don't call me Master.

MYSELF

Perhaps we're at a great turning point and you're a forerunner.

He stood up straight. As if it were a face, the canvas riveted his attention.

Perhaps it'll be you, on one of these canvases, that they'll be looking at one day, to find out what the people of our time thought and felt – all those people who don't even know you.

He hunched his shoulders and peered at the landscape through half-closed eyes. He selected a sable and dipped it into some paint on his palette, then held it poised. He put down a touch … He had forgotten about me and 'those people', and the future I had been talking to him about; perhaps even this landscape. All he saw was colours. I took up my book, but he was the text I wanted to decipher, and I did no reading. He gave a last look.

CÉZANNE

Let's get to work.

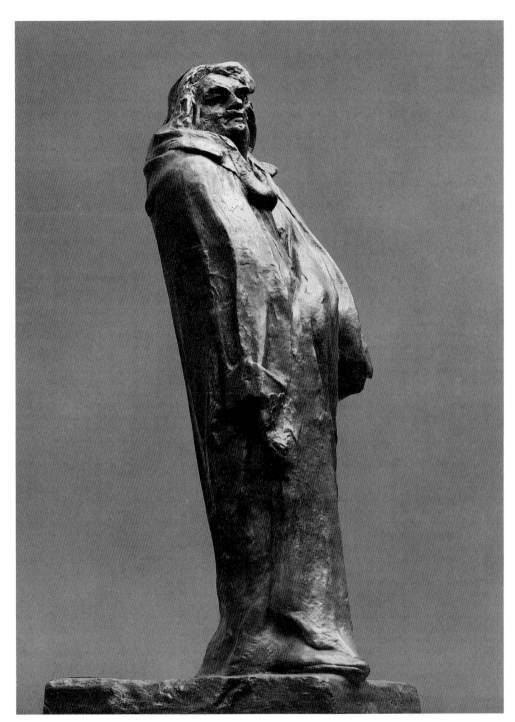

Rodin, *Monument to Balzac*, 1898

II

THE LOUVRE

'The ideal of earthly happiness? ... To have a good formula.'

We were leaving the Galerie des Machines at the Salon. We had gone there to have another look at Rodin's Balzac. *Cézanne had bought a photograph of it to give to me ... It was 11 o'clock, we had a quick lunch and went off to the Louvre on the top of the Passy–Hôtel de Ville tram along the quais.*

It was a clear, invigorating spring day, a Paris afternoon. The trees were tipped with tender green shoots. The Seine was basking in the sun. Centuries of history glittered in the water beyond the bridges towards the Cité. Shop girls were strolling. We could see them on the benches in the Tuileries finishing their frites. *Children ran alongside the carriages offering young couples bunches of violets for sale. Passers-by were making busily towards the hum of the boulevards. But along the river banks all was gentle, spring-like and calm. The Institute, the Louvre, Notre-Dame stood proud in the mild light. After a good cup of coffee Cézanne was expansive and smiling.*

CÉZANNE

Well, well ... Good old France is warming itself in the sun and putting its nose to the window. There you are ... tradition! I am more traditional than people think. It's like Rodin. They don't grasp at all what his real nature is. He's a man of the Middle Ages who makes admirable pieces, but who doesn't see the whole work. He needs to be set in the porch of a cathedral, the way the old sculptors were. Rodin is an astonishing stone carver, with all the sensibility of our time, who will make all the statues anyone wants, but he hasn't a single idea. He lacks a creed, a system, a faith. His *Gates of Hell*, his monument to hard work, someone gave him the idea for it and you'll see, he will never build it. I think Mirbeau is behind his *Balzac*. He certainly has caught him, fixed him, with his prodigious intellect, with those eyes that devour the world and then close themselves on it passionately, eyes which seem to have gone

black from all the coffee he drank the whole time. And the hands, under the greatcoat, which control the whole life of this dedicated man. It's fantastic! . . . And this massive block, you know, it's made to be seen at night, lit violently from below, at the exit from the Français or the Opéra, in that feverish nocturnal Paris where one pictures the novelist and his novels, eh! . . . I don't want to belittle Rodin, really, in saying what I said. I like him, I admire him a great deal, but he is very much of his time, as we all are. We make fragments. We no longer know how to compose.

MYSELF

But don't you think in a portrait like Rembrandt's mother, or a still-life like Chardin's skate, I daren't say like your apples, there is often as much art and thought as in an historical scene, a pagan or Catholic allegory?

CÉZANNE

That depends, that depends . . . Of course if you compare a Chardin with a Lesueur, a portrait by Velasquez or Rembrandt with a feasting scene by Jordaens, my apples to a Troyon landscape, what you say is indisputable. But wait. I'll answer you when we've reached the Louvre. You can't really talk about painting unless you're in front of a picture. Believe me, nothing is more dangerous for a painter than to turn to books. If he takes that short cut he's done for. I know something about it. The harm Proudhon did to Courbet, Zola would have done to me. I'm delighted when Flaubert, if you remember, in his letters, strictly forbids himself to speak of an art whose technique he doesn't understand. That's him all over . . . It's not that I'm in favour of painters being ignorant. Quite the opposite. In the great ages they knew everything. In the old days, artists were the educators of the public. For instance, you see Notre-Dame over there. The creation and the history of the world, the dogmas, the virtues, the lives of the saints, the arts and the professions, everything that was known at that time was taught in its porch and its windows. As indeed in all the French cathedrals. The Middle Ages learnt its faith through the eyes, like Villon's mother . . .

'Le paradis où sont harpes et luths . . .'

That was the true knowledge, and it was all religious art. All those things your friend Abbé Tardif says you find in Saint Thomas – the people looked for them in the statues on the portals of their churches. That form of order, hierarchy, philosophy is as good as the *Summa*, and for

us it has more reality, because it's more beautiful and, what's more, we can understand it without effort. All the symbolism they* talk about – they maintain that even the Kabbala has its place in the rose windows – all the mystical significance slumbering under the Gothic mould of the stones; I don't know and I don't want to know anything about it. But life is always there ... What do you expect? When the forms of the Renaissance burst forth with the paganism of that passionate age, the people turned their eyes away in vain from the austere realism of their chapels, they couldn't help remembering it. It gave their lives a tonic sharpness. They were never really comfortable with works in the grand manner. Ordinary people don't like rhetorical painting, any more than I do. Yes, there's the Gallery of the Battles at Versailles, but it's not paint-ing they're looking at there. It's a kind of newspaper, a big mural news-paper they read there, popular images, like the Sainte-Geneviève series in the Panthéon.* But at Versailles in the château, in the park, people are never moved as they are in a church or a stadium. They have a sense of what is great in their bones. In our case, in Provence, that comes to us from the Romans; here in the north, from the cathedrals ... All the same, it's amazing. For example, here am I, classical; I say to myself, I would like to be classical, but that bores me. Versailles bores me, the Cour Carré bores me. There's only the Place de la Concorde, yes, that's beautiful. Life! ... Life! ... And yet, you see how complicated it all is; life and realism are much more evident in the fifteenth and sixteenth cen-turies than in the elongated figures of the primitives. I don't like the primitives. I don't know Giotto well. I would have to see him. I only like Rubens, Poussin and the Venetians ... Let me tell you, it's easier to represent God by a cross than by the expression on a face.

We had arrived, and got off the tram.

MYSELF

If you could see the Duccios in Siena ... Everything is in those little scenes. Some are dramatic like a Tintoretto, with greens and bluish reds; others, like *Jesus before Pilate*, have a simple tragedy, constructed with the purity of a Racine play; and the women at the tomb facing the great angel – no bas-relief of antiquity has their nobility and their triumphant despair. It's as beautiful as Victory tying up her sandal. If you saw it! ...

CÉZANNE

I'm too old now to go running to Italy. And besides, it seems to me that

everything is here in the Louvre, one can love and understand everything here.

MYSELF

Everything . . . except perhaps the frescoes, the Franciscan movement in Umbrian painting, and what developed from it, Masaccio, Gozzoli . . . But what could Italy and this art add to yours? One could say that you stem from it and that you have studied it all your life.

CÉZANNE

I may shock you. I almost never go into the little room of primitives. It's not my kind of painting. I am wrong, I admit that I may be wrong; but what can I do? When I spend an hour contemplating *Le Concert champêtre* or Titian's *Jupiter and Antiope*, when my eyes are full of the whole animated crowd of *The Marriage at Cana*, what do you expect me to make of Cimabue's clumsiness, the naiveté of Angelico and even Uccello's perspective? . . . There's no flesh on those ideas. I leave that to Puvis. I like muscles, rich tones, blood. I am like Taine,* that's what I am, and in addition I'm a painter. I am a sensual man.

We went up the great Escalier des Dames.

Wait. Just look at that . . . The Victory of Samothrace. It's an idea, it's a whole nation, a heroic moment in the life of a nation, but the clothes follow the body, the wings are beating, the thighs are swelling. I don't need the head to imagine the expression, because all the blood that pulses, circulates, sings in the legs, the thighs, the whole body, has poured into the brain and risen to the heart. It is in motion, the motion of the whole woman, of the whole statue, of Greece. When the head came off, the marble must have bled . . . While up there, among the primitives, you can chop off the heads of those little martyrs with the executioner's sword. A little vermilion, some drops of blood . . . they fly straight off bloodlessly to heaven. You don't paint souls. And look here at the Victory's wings – you don't notice them, I no longer notice them. You don't think about them any more, they seem so natural. The body doesn't need them to fly off in triumph. It has its own impetus . . . But with the halos around Christ, the Virgin and the Saints, that's all one notices. They take over. They annoy me. The fact is one doesn't paint souls. One paints bodies; and when the bodies are well painted, damn it all! the soul, if there is one, of every part of the body blazes out and shines through!

We entered the little room where La Source *hangs.*

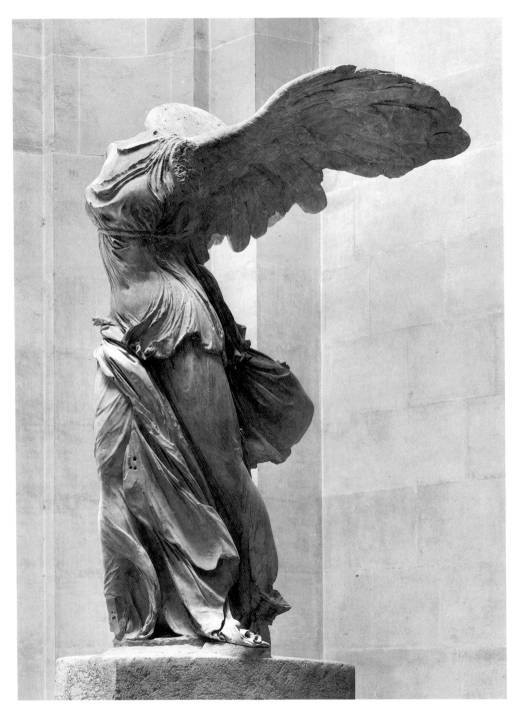

The Victory of Samothrace

Ingres is just the same ... bloodless! He's a draughtsman. The prim-
itives were draughtsmen. They filled in the colours, they were illum-
inators on a large scale. Painting, what is properly called painting, only
began with the Venetians. Taine tells us that in Florence all the painters
started out as goldsmiths. They were draughtsmen. Like Ingres ...
Oh!, it's beautiful enough, Ingres, Raphael, that whole outfit. I can
appreciate them as well as anyone else. I can take pleasure in line if I
want to. But there are snags. Holbein, Clouet or Ingres have nothing
but line. Well, it's not enough. It's very beautiful, but it's not enough.
Look at this *Source* ... It's pure, it's delicate, it's smooth, but it's pla-
tonic. It's an image, it doesn't turn in space. The damp stone of the card-
board rock is not reflected in the marble of this moist – or what should
be moist – flesh. Where is the surrounding penetration? And since she is
the source, she should be emerging from the water, from the rock, from
the leaves; instead she's pasted on them. By setting out to paint the ideal
virgin, he hasn't painted a body at all. And it's not because he couldn't.
Just think of his portraits and that *Age of Gold* that I like so much. It's
because of the idea of a system. False system and false idea. David killed
painting. They introduced the hackneyed formula. They wanted to
paint the ideal foot, the ideal hand, the perfect face and body, the su-
preme being. They banished character. What marks out the great pain-
ter is the character he lends to everything he touches, impulse,
movement, passion, for it's possible to be both passionate and serene.
They're afraid of this, or rather they never dreamt of it. In reaction, per-
haps, to all the passion, the tempests, the social brutality of their time.

MYSELF

But David was up to his neck in it!

CÉZANNE

Yes, but I know nothing colder than his Marat! What a tame, mean
hero! A man who had been his friend, who had just been assassinated,
whom he should have glorified in the eyes of Paris, of all Frenchmen, for
all posterity. Has he patched him up enough with his sheet, watered him
down enough in his bath? He was thinking of what they would say
about the painter and not what they would think of Marat. A bad pain-
ter. And he had the corpse in front of his eyes ... And yet I like bits of
the *Coronation*, the choirboy, the head between the chandeliers, one
thinks already of Renoir ... He was more at ease with these upstarts
than with the sacred heart of that other one that they parade around the
streets of Paris. Now, his caricatures, they are nasty. They suddenly

Ingres, *La Source*, 1856

made me see the grinding mechanics of his mind. But here we have painting.

We entered the Salon Carré. He planted himself in front of the The Marriage at Cana. *He had his bowler tipped back, his overcoat trailing on his arm. He seemed quite carried away.*

There's painting for you. Detail, ensemble, volumes, values, composition, excitement, it's all there . . . Believe me, it's amazing! . . . What's happening? . . . Shut your eyes, wait, don't think of anything. Now open them . . . What about that? . . . One sees only a great coloured undulation, isn't that right? A rainbow effect, colours, a wealth of colours. That's the first thing a picture should give us, a harmonious warmth, an abyss into which the eye plunges, something dimly forming. A state of grace induced by colour. You can feel all these shades of colour running in your blood, don't you agree? You feel reinvigorated. You are born into the true world. You become yourself, you become part of painting . . . To love a painting you need first to have drunk it in like this, in long draughts. You must lose consciousness. Go down with the painter to the dark, tangled roots of things and rise up again from them with the colours, open up with them in the light. Learn how to see. To feel . . . Especially before a great construction such as Veronese builds. My word, there was a happy man. And he brings happiness to everyone who understands him. He's a unique phenomenon. He painted the way we see. With no more effort than that. Just dancing. Those torrents of colour gradations flowed from his brain, just as everything I'm saying to you flows from my mouth. He spoke in colours. It's amazing, I know almost nothing about his life! Yet I feel as if I've always known him. I see him walking, coming, going, loving in Venice, in front of his canvases, with his friends. A beautiful smile. A warm look. A sturdy body. People and things pass into his consciousness through the sun, with nothing in him separating them from the light, without a sketch, without abstractions, everything in colour. In time they emerge, still the same but somehow clothed in a gentle glory. Happy as if they had inhaled a mysterious music. Look how it radiates from this group in the middle, where the women and dogs are listening to it, and the men foster it with their strong hands. Contemplation, delight, health, all combining in fullest measure, that to me is Veronese; the fullness of idea in colour. He covered his canvases with a vast grisaille, yes, they all did it in that period, and that was the starting point of his conquest, like a piece of earth before the rise of day, the rise of the spirit . . .

Veronese, *The Marriage at Cana*, 1563

MYSELF

Like you, when you think about the geology of your landscapes, when you sketch them out in your mind . . .

CÉZANNE

Oh, me . . . Believe me, I'm only a child in arms before all that . . . What I can see, you understand, is that formidable technique, which is so natural, so easy, for them. They had it in their hands and eyes, passed on from studio to studio. The underpainting! That's what I was pointing out. He began with an immense grisaille . . . The bare, anatomical, skeletal idea of his universe, the delicate framework he needed, and which he would then clothe with variations, with its colours and its glazes, while building up the shadows . . . A great pale world in rough draft, still in limbo . . . it seems to me I can see it, truly!, between the material of the canvas and the prismatic heat of the sun . . . Nowadays they build up the paint right away, they go into action crudely like a bricklayer, and they believe that makes them stronger, more honest . . . What rubbish. We've lost this knowledge of preparations, this freedom and vigour gained from the underpainting. To model – no, to modulate. We need to modulate . . . Look what gets done today! Retouching, scraping down, rescraping, laying on thick paint. It's like using mortar. Or take the most summary of painters, the Japanese, they brutally surround their people, their objects, with a harsh, schematic, stressed outline, and fill it in right up to the edges with flat colours. It's as gaudy as a poster, painted like a stencil punched by machine. It has no life in it. Whereas, look at this dress, this woman, this creature, against this tablecloth; one doesn't know where the shadow on its smile begins, or where the light is toying with the shadow, draining it, drinking it up. The colours all interpenetrate, the volumes all turn as they fit themselves together. There's a flow . . . I don't deny that at times in nature there are abrupt effects of shadow and light in contrasting bands, but that's of little interest. Especially if it becomes a device. The wonderful thing is to bathe a whole boundless composition, immense as this one, in the same soft, warm light and convey to the eye the lively impression that all those breasts are really, like you and me, breathing in the golden atmosphere that saturates them. I'm sure that basically it's the underpainting, the hidden soul of the underpainting, which links everything together and gives this strength and lightness to the whole ensemble. You need a neutral beginning. After that, you see, he could paint to his heart's content. Heavens! the taste, the perfect exquisite taste, the audacity of all those

branches, those complementary fabrics, the interlacing arabesques, the extended gestures. Is anything more needed? Seriously, is there? You can examine it minutely. The rest of the picture will always follow you, will always be there. You'll feel it running through your head, whichever part you're studying. You can't subtract anything from the total . . . they weren't painters of bits and pieces, as we are . . . You're always asking me what prevents us, when all is said and done, from loving even a Courbet or a Manet the way we do a Rubens or a Rembrandt, what extra quality there is in this old painting . . . We need to know the truth about it, we need to find it today. To be sure, *The Burial at Ornans* is a staggering thing, so is *The Entry of the Crusaders* and the Apollo ceiling; but compared with this or with Tintoretto's *Paradise* there's something about the moderns that doesn't pass muster. What? . . . Tell me, what? . . . Let's go and see. We'll see . . . Now turn left, there, start from this pillar, is it marble, dear God? and slowly let your eyes travel all around the table. . . Isn't it beautiful? Isn't it alive? . . . And at the same time it's transfigured, triumphant, miraculous, in a different world and nevertheless completely real. The miracle is there, the water turned into wine, the world turned into painting. We swim in the reality of painting. We are drunk. We are happy. For me it's like a wind of colour that carries me away, a music that hits me in the face, my craft running through my blood . . . Oh! they worked in a fantastic tradition, those buggers. We're nothing, I tell you, old fools, nothing. We aren't even fit to understand any more . . . To think that I wanted to burn all that in my time. To invent something new, out of a rage for originality . . . When you don't know anything, you think it's those who do that stand in your way . . . But it's the other way round; if you join them, instead of obstructing you they take you by the hand and help you gently, by their side, to stammer out your little piece. Make studies after Veronese and Rubens, those great masters of decoration, yes!, but do them as you would from nature . . . You see, painting went wrong with David when it tried to be well-behaved and conscientious. That's my greatest horror. He may have been the last who knew his job, but what did he make of it, in God's name? The trouser buttons in *The Surrender of the Standard*. What he should have given us was a psychological study in the manner of Titian, of all those grooms and camp-followers grouped around their crowned scoundrel. Lousy Jacobin, lousy classical painter . . . You know what Taine tells us in his *Origines* about the classical spirit! David is the most appalling example of it. So virtuous! . . . In his art he succeeded in castrating even lecherous Ingres, who adored the female prin-

ciple all the same . . . You have to learn your trade. But you have to learn it here, by yourself, in the company of the masters. I am not talking about techniques, or the apprenticeship (lost, alas!) in everything useful, there's nothing to be seen of it here; that good fellowship of craftsmen, which saved so much time, was killed off by this revolutionary. The old ateliers offered that. We need to get back to it . . . But I'm speaking of the masters. Whichever one you happen to prefer, you must not look to him for anything more than an orientation. Otherwise, you'll only be a pasticheur. With a feeling for nature, whatever it may be, and a few fortunate gifts, you must learn to break free; another man's methods or advice must never lead you to change your way of feeling. If for a time you let yourself be influenced by someone older than you, depend on it, from the moment you have your own feelings, your distinctive emotion will always emerge, will take the upper hand and find its place in the sun. Confidence. You must become master of a good method of construction. A drawing is no more than the shape of what you see. Michelangelo is a constructor, and Raphael, great as he is, an artist always controlled by his model. When he tries to become thoughtful, he falls below his great rival. It's Michelangelo one should be, in one's own way, and he's the one the professors shy away from. There's nothing worse than the domination of professors who use force to drum their ignorance, their way of seeing, into your noodle. Oh! it's important to choose our teachers ourselves, or rather not choose among them but have them all, compare them. Like a man with only one book, I would be anxious about a student of one painter. Jean-Dominique is powerful, very powerful! Yet he's very dangerous. Look at Flandrin, look at them all, even Degas . . .

MYSELF

Degas?

CÉZANNE

Degas isn't enough of a painter; he doesn't have enough of that! With a little bit of temperament one can manage to be a painter. It's enough to have a sense of art, and that sense is no doubt what the bourgeoisie fear most. That's why institutes, pensions and honours are intended only for idiots, buffoons and scamps. But I'm not talking about people like that. They're welcome to go to the Ecole and have teachers by the bushel. I don't give a damn about them. What I deplore is that all those young people you believe in and talk to me about don't travel in Italy or spend their days in this place, Even if it means throwing themselves into nature

later on. Everything, particularly in art, is theory developed and applied in contact with nature. I wouldn't want them to go through the same experiences I did. I know, I know, if the official Salons remain so deficient, the reason for it is clear: they never start work except with more or less long-winded procedures. For a painter, sensation is at the bottom of everything. I will go on repeating it forever. Procedures are not what I advocate. It would be more worthwhile to supply more personal emotion, observation and character. But there's the snag! Theories are always easy. What presents serious obstacles is furnishing proof of your ideas. I believe it is at this point, basically, that the painter begins to think. Faced with nature, he learns to see. It's grotesque to imagine that we spring up like mushrooms when we have all those generations behind us. Why not profit by all that work, why neglect that formidable legacy? Yes, the Louvre is a book which teaches us to read. We must not, however, be content merely to preserve the fine methods of our illustrious forebears. As Delacroix puts it, we have seen a dictionary in which we will find all the words. Now let's go out and study beautiful nature, try to catch its spirit, seek to express ourselves in accordance with our personal temperament. Besides, time and reflection modify our vision little by little, and finally understanding comes to us. God willing, we'll be able – your friends will be able – to produce a masterpiece like this one . . . and to place a silvery harmony like that over there against this rainbow here.

Across from The Marriage at Cana, *he pointed to* Jesus in the Pharisee's House.

That, for instance, is perhaps even more astounding . . . That range of silver . . . The whole prism melting into the white . . . And, you see, what I love about all these Veroneses is that there's no need to expatiate on them. If you love painting, you love them. If you're looking for something literary besides, if you get excited about anecdote, subject-matter, then you don't love them . . . A picture doesn't represent anything, it doesn't need to represent anything in the first place but the colours . . . As for me, I hate that, all those stories, that psychology, that symbolism. Goodness knows, it's there in the painting, painters are not imbeciles, but you have to see it with your eyes, do you understand?, with your eyes. That's all the painter wanted. His psychology is the way he makes two colours meet. That's where his emotion is. That's his personal history, his truth, his depth. For he's a painter, you see, not a poet or a philosopher! Michelangelo did not put his sonnets into the Sistine

Chapel any more than Giotto put his *canzone* into his Life of St Francis. That's just the monks' version. And when Delacroix wanted to fit his Shakespeare into his painting, he was wrong, he came a cropper over it. And that's why, when we came in, I drew a distinction between all that art – moving though it may be – of the Middle Ages and my art, the art of the Renaissance. You understand, that type of liturgical symbolism of the Middle Ages is quite abstract. Think about it. The pagan symbolism of the Renaissance is entirely natural. The one diverts nature from its path in order to demonstrate a theological truth which we don't know, while you can feel the other leading abstraction back to reality, and reality is always natural, it has – if I dare say it – a sensual, universal significance . . . I love the way the apple, in primitive painting a symbol in the Virgin's hand, becomes a toy for the Child in the Renaissance. You, as the author of *Dionysos*, must remember Jacques de Voragine's* story of how the vines all over Palestine blossomed on the night Our Saviour was born. Ah, that's already a Renaissance idea, all right! We painters would do better to paint the blossoming of those vines than the whirlwinds of angels proclaiming the Messiah with their trumpets. Let's paint only what we have seen, or what we could see . . . Like this Giorgione, look here . . .

We were in front of Le Concert Champêtre.

Let us embellish, ennoble our imaginations with a great sensual dream . . . But bathe them in nature. Let's not eliminate nature. Too bad if we fail. You see, in his *Déjeuner sur l'herbe*, Manet ought to have added – I don't know what – a touch of this nobility, whatever it is in this picture that conveys heaven to our every sense. Look at the golden flow of the tall woman, the other one's back . . . They are alive, and they're divine. The whole landscape in its brown glow is like a supernatural eclogue, a moment of balance in the universe perceived in its eternity, in its more human joy. And one takes part in it, one notes every living detail. It's like the one down there, come, I'll show you the *Cuisine des Anges* . . . What an extraordinary still-life!

We arrived in front of the picture.

Murillo had to paint angels, but look, what young Greeks they are, how well their high-mettled feet are planted on the floor. They are truly worthy of peeling those beautiful vegetables, those carrots and cabbages, and of admiring their reflections in those cauldrons . . . The picture was commissioned, wasn't it? . . . He let himself go, for once. He saw the

Giorgione, *Le Concert Champêtre*, c. 1510

scene . . . He saw radiant creatures enter this convent kitchen, celestial young porters, with the beauty of youth and dazzling health, among all these worn-out, tormented mystics. See how he contrasts the yellowish emaciated body, the hysterical ecstasy of the saint calmly praying, with the radiant assurance of these fine workmen. And the pile of vegetables! You can run your eye from the turnips and plates to the wings without any break in the atmosphere. Everything is real . . . And opposite, this sketch of the *Paradise* . . .

He drew me over to it.

I haven't seen the great *Paradise* in Venice. I have seen very little of Tintoretto, but I'm drawn to him, as I am to El Greco – but more forcibly, because he's more wholesome. People are always talking to me about El Greco, and I don't really know him. I would like to see his work . . . Yes, Tintoretto, Rubens – there's the real painter. As Beethoven is the musician, Plato the philosopher.

MYSELF

You remember Ruskin saying that, from the point of view of painting, his *Adam and Eve* is the greatest work in the world?

CÉZANNE

I've only seen a photograph of it. I've ransacked as many books as I could to find his work. It's gigantic. Everything is there, from still-life to God. It's an immense span. Every form of existence, and with unbelievable pathos, passion and invention. If I had ever gone to Venice, it would have been for him. It seems that one can understand him only there . . . I remember in a *Temptation of Christ* – in San Rocco, I believe – an angel with swelling breasts, with bracelets, a demon pederast offering stones to Jesus with a lesbian lechery, yes, it's the most perverse thing ever painted. I don't know, but when you showed me the photograph of your house, it had the effect on me of a gigantic Verlaine, an Aretino with the genius of Rabelais. Chaste and sensual, brutal and cerebral, driven by will as much as by inspiration, this Tintoretto, I believe, knew everything, barring sentimentality, about the causes of human joy and torment . . . Forgive me, I can't talk about him without trembling . . . It's his portraits, so extraordinary, that have made him familiar to me . . . The one Manet copied in the Uffizi* and which is in the Dijon Museum . . .

MYSELF

It's like a Cézanne.

Murillo, *Cuisine des Anges*, 1646

Tintoretto, *Paradise*, c. 1574

Cézanne

Ah! I wish it were so . . . You know, I feel as if I knew him. I see him, exhausted by work, worn out by colours, in that purple-hung room in his little palazzo, like me in my shambles of the Jas de Bouffan, but he was always working, even in the middle of the day, by the light of a smoking lamp, with the sort of marionette theatre where he prepared his big compositions . . . Yes, that epic puppet show! When he left his easels, it seems, he would go there and drop exhausted, always in a sullen mood – he was a grumbler, devoured by sacrilegious desires . . . yes, yes . . . there was a frightful drama in his life . . . I can't bring myself to talk about it . . . In a profuse sweat, he would get his daughter to help him to sleep, make her play the violin for him, hours at a time. Alone with her, among all those glowing reds . . . He sank into this enflamed world, where the smoke of our real world vanished . . . I see him . . . I see him . . . The light purged of all evil . . . And towards the end of his life this man, whose palette rivalled the rainbow, said that he no longer cared for anything but black and white . . . His daughter was dead . . . Black and white! . . . Because colours had become wicked, tormenting, you see . . . I can understand that yearning . . . Have you experienced it? He searched for final peace . . . This paradise. I can tell you, in order to paint this whirlwind of joyous pink you need to have suffered a great deal . . . a great deal, I can guarantee you that. We're face to face with opposite poles. There, that noble prince Veronese. Here, this overworked Tintoretto. This wretch who loved everything, but in whom a fire, a fever, consumed every desire as soon as it began. Look at this heaven . . . his poor gods twist and turn. Their paradise is not a calm one. Their repose is a tempest. They keep up the excitement which has consumed them all their lives, as it consumed him. But now, having suffered so much from it, they find joy in it. I like that . . .

He went up closer to the picture.

And look at this white foot, here, on the left. The underpainting again . . . he prepared his flesh tints in white. Then a red glaze, whoosh!, look at the edge, he brought them to life. Black and white, I want to paint only in black and white, he shouted at the end. What would he have done? How would he have dealt with his torment? With a man of his sort you can expect anything. In his youth he had had the nerve to proclaim: Titian's colour with Michelangelo's drawing. And he achieved it, with Titian at his side.

MYSELF

He's greater than Titian.

CÉZANNE

Yes, I approve of your admiration for the worthiest of the Venetians. Let us honour Tintoretto. Bring your friends to look at him. The need to find a moral, intellectual foundation in works which clearly will never be surpassed keeps you forever on your toes, always searching for a means of interpretation. Make this clear to them. These means of interpretation will inevitably lead them to find their means of expressing nature, and the day they apply them, you can assure them, they will rediscover without any effort and in nature the methods used by the four or five great Venetians . . .

He took a few steps, oblivious of everything.

Oh! to have pupils! To pass on all my experience to someone. I am nothing; I have done nothing, but I have learnt. To link up again with all those great brutes across the last two centuries. In the constant shifts of today, to rediscover a fixed point . . . In vain. It may well be in vain.

He clenched his fists and glared furiously about him.

And all these idiots! . . . A tradition. A tradition could begin again with me, who am nothing. To work with pupils, but pupils you can teach, I mean, not those who aspire to teach you. I've experienced that . . .

He turned round. He drew me, I thought, towards the Salle des Etats, the one he called the Salon Carré of the Moderns.

I don't want to be right in theory, but in nature. In spite of his 'estyle' (as they say in Aix) and his admirers, Ingres is a minor painter. You know who the greatest are: the Venetians and the Spaniards.

He went over to a window and surveyed the lines of buildings caught by the sun.

That's not a bad subject at all . . . Basically, the painter who could render that, quite simply, the Seine, Paris, a day in Paris, could be installed here with his head high . . . You have to be a good workman. To be nothing but a painter. To have a method. To realize.

He gave me a sad, noble look.

The ideal of earthly happiness . . . to have a good formula.

Then, abruptly, he dragged me away at a sharp pace to the Salon Carré of the Moderns. He stopped in front of The Triumph of Homer. *He made a face.*

Yes . . . Orange-coloured to show Achilles' rage and the flames of Troy, green for the travels of Ulysses and the swirling ocean . . . But that's not what I mean by a formula! . . . Yes, yes, a formula that's a straitjacket . . . not for me! All the same, he tries in vain, does Jean-Dominique, to wring your heart with his glossy finish! I said this to Vollard, to shock him, he's very powerful! Nevertheless he's a damned good man . . . The most modern of the moderns. Do you know why I take my hat off to him? Because he forced his fantastic draughtsmanship down the throats of the idiots who now claim to understand it. But here there are only two: Delacroix and Courbet. The rest are scoundrels . . . And I left out another . . . Manet. He'll make it, so will Monet and Renoir.

MYSELF

And you.

CÉZANNE

Oh! me . . . Perhaps I'd be a bad example, don't you think? If one has the privilege of producing something, what one produces is a distortion of what one perceives. And it's terrible. I still haven't done anything that holds up beside those over there. I can tell you . . .

MYSELF

Your *Old Woman with a Rosary*, the large Sainte-Victoires.

CÉZANNE

Tut, tut . . . Maybe people will remember a certain fellow who rescued painting from a false tradition, as wayward as it was academic, and dreamt vaguely of a renaissance of his art . . . however! . . .

He walked up to The Women of Algiers.

You can find us all in this Delacroix. When I talk to you about delight in colour for its own sake, well this is what I mean . . . These pale pinks, these furry cushions, this slipper, all this luminous colour – it seems to me that it enters the eye like a glass of wine running into your gullet and it makes you drunk straight away. You don't know how it happens, but you feel much lighter. These shades are uplifting and purifying. If I had done something wrong, it seems to me that I would come and stand in

Delacroix, *Women of Algiers*, 1834

Delacroix, *The Entry of the Crusaders into Constantinople*, 1840

Delacroix, *Apollo ceiling*, 1850–51

front of this picture to put myself straight again . . . And it's dense. One colour passes into the next, like silks. Everything is sewn together, worked on as a whole. And that's why it's so effective. It's the first time since the great artists that anyone painted a volume. And there's no denying that Delacroix has something, a fever, which is lacking in the old masters. I believe it's the healthy fever of convalescence. With him, painting emerges from the stagnation, the sickness, of the Bolognese. He turns David upside down. His painting is iridescent. Seeing one Constable is enough to make him understand all the possibilities of landscape, and he too sets up his easel by the sea. His watercolours are marvels of tragedy or charm. They can be compared only to Barye's,* you know, the lions in the Montpellier museum. And the still-lifes, you remember the one with the hunter, his game-bag and his haul out in the fields; the whole countryside is there. I'm not talking about the great compositions; in a little while we'll go and look at his ceiling . . . Also, he's convinced that the sun exists and that you can soak your brushes in it, do your washing in it. He knows how to show distinctions. It's no longer like Ingres back there and all those we see here . . . A silk is a fabric and a face is flesh and blood. The same sun, the same emotion plays on them, but is different. He knows how to drape the flank of this black girl with a fabric that has a different aroma from the scented breeches of this Georgian slave girl; he knows it and shows it through these tints. He makes contrasts. Just look how all these dots of colour, for all their violence, make a clear harmony. And he has a sense of the human being, of life in movement, of warmth. Everything moves, everything glistens. The light! . . . There is more warm light in this interior of his than in all of Corot's landscapes and these battle scenes around us. Just look . . . His shadows are coloured. He gives his diminishing tones a pearly quality that makes everything flow together . . . And when he begins painting out of doors! His *Entry of the Crusaders* is a tragedy . . . you might as well say that it's invisible. We don't see it any more. I who am speaking to you, I have seen that picture die, fade away, disappear. It's enough to make you weep. With each decade there's less of it . . . One day nothing will be left. If you had seen the green sea, the green sky. Such intensity. And how much more dramatic the smoke was then, the burning ships, and how the whole group of riders stood out. When he exhibited it, one couldn't help exclaiming that the horse, this horse, was pink. It was magnificent, glowing. But those damned Romantics, in their lofty way, used atrocious materials. The chemists swindled them. It's like Géricault's *Shipwreck*, a marvellous page with

nothing left to see on it. Here, we can still make out the corrosive melancholy of the faces, the sadness of these knights, but all of this, as we remember it, was in Delacroix's colours; and now that they've lost their depth, his spirit is no longer there. Still, I did see those pale kings for myself. They no longer move in a blaze of light, in that Oriental atmosphere, in that legendary land. Constantinople is a sort of Paris, like those streetfronts of the city, look over there, behind the railings. I saw it as it was, as Delacroix, Gautier, Flaubert saw it, and also through the unique magic of colour. That's the point, that's what proves better than anything else that Delacroix is a real painter, a devil of a great painter. It's not the story of the Crusaders – we're told that they were cannibals – or their apparent humanity; it's the tragic quality of his colours which formed his picture and which expressed the corrupted spirit of these dejected conquerors. Originally the beautiful dying Greek girl, the abandoned silk-woman in her rich attire, the old man's beard, the caparisoned horses and the melancholy standards, all took on their full meaning in a singing blend of colours. There was dying, weeping and sobbing. All in the colour. Now only an impression of its remains. There's no substitute for original colour in a painting ... It's as if a Racine tragedy were translated into prose ... *The Women of Algiers* hasn't changed. The *Entry* was just as brilliant. Have you seen *The Justice of Trajan* at Rouen? It's disappearing too, peeling off, eaten away. And in Lyons, *The Death of Marcus Aurelius*? What greens there are in that ... the green cloak! That's Delacroix. And the Apollo ceiling, and Saint-Sulpice! ... do or say what you like, he's one of the giants. He has no need to blush if that's what we call him, even in the same breath as Tintoretto and Rubens. Maybe Delacroix stands for Romanticism. He stuffed himself with too much Shakespeare and Dante, thumbed through too much Faust. His palette is still the most beautiful in France, and I tell you no one under the sky had more charm and pathos combined than he, or more vibration of colour. We all paint in his language, as you all write in Hugo's.

MYSELF

And Courbet?

CÉZANNE

A builder. A rough and ready plasterer. A colour grinder. He's like a Roman bricklayer. And yet he's another true painter. There's no one in this century that surpasses him. Even though he rolls up his sleeves, plugs up his ears, demolishes columns,* his workmanship is classical!

Underneath his swaggering ... He's deep, serene, mellow. There are nudes of his, golden as a harvest, that I'm mad about. His palette smells of wheat ... Yes, it's true Proudhon turned his head with his realism, but actually that famous realism is like Delacroix's Romanticism; he went for it head on, with great brush strokes only in a few canvases, his flashiest and surely his least beautiful. Besides, the realism was more in his subject-matter than in his treatment. His view was always compositional. His vision remained traditional. Like his palette-knife, he used it only out of doors. He was sophisticated and brought his work to a high finish. You know what Decamps said, that Courbet was cunning, that he was a rough painter, but put the finish on top. And what I say is that he puts the power and genius underneath. You can go and ask Monet what Whistler owes to Courbet, when they were together at Deauville and Courbet painted a portrait of his mistress for him ... However broadly he works, he's subtle. He deserves his place in the museums. His *Winnower* in the museum at Nantes, the blonde, bushy haired girl with the great russet cloth, the dust from the wheat, her hair knotted at the back as in the loveliest Veroneses, and her arm, that milky peasant's arm extended in the sun, as smooth as a wash-house stone ... even though it was his sister who sat for him ... You could stick her beside Velasquez, I promise you she'd hold her own ... Is it fleshy, resistant, grainy? Is it alive? That comes across. It hits the eye.

MYSELF

Yes, I remember it ... Courbet is the great painter of the people.

CÉZANNE

And of nature. His great contribution is the poetic introduction of nature – the smell of damp leaves, mossy forest cuttings – into nineteenth-century painting; the murmur of rain, woodland shadows, sunlight moving under trees. The sea. And snow, he painted snow like no one else! At your friend Mariéton's house, I have seen the snowbound coach, that large white landscape, flat under the greyish twilight, without a break, all velvety ... It was tremendous, a wintry silence. Like the *Hallali* in the Besançon Museum, in which the characters are perhaps a bit theatrical, but who, with their hunting coats, their dogs, the snow, the groom, remind me (and they can stand the comparison) of the grand manner, the heroism, the execution of the masters. There you are! ... And the sunset in *The Stag* at Marseilles, the bloody pack, the pool, the tree running with the beast, reflected in the beast's eyes ... All those Savoy lakes with lapping water, the mist that rises from the shores and

Courbet, *Les Demoiselles de la Seine*, 1856

envelops the mountains . . . the great *Waves*, the one in Berlin, extra-ordinary, one of the century's inventions, much more exciting, more wind-blown, with a foamier green and a dirtier orange than the one here, with its wild surf, its tide coming from the depths of the past, its ragged sky and pale rawness. It hits you right in the chest. You recoil. The whole room smells of spray . . .

He looked at the large forest scene of The Stag Fight, *hanging above* The Triumph of Homer.

You can't see a thing . . . How badly it's hung . . . When will they ever put in a painter, a real painter, as director of the Louvre? . . . And when will they ever bring the *Demoiselles de la Seine* in here? Where are they?

He half-closed his eyes. He spotted them.

There, what do you think? One could say it was Titian . . . No. No . . . It's Courbet. Let's not get them confused . . . These young women! A dash, a breadth, a blissful languor, an abandon that Manet did not put into his *Déjeuner* . . . The mittens, the laces, the torn silk of the skirt and the russet colours . . . Their rounded napes, the plumpness of their flesh. The surrounding nature has an air of easy virtue. And the low, broken sky, the sweating countryside, the whole tilted perspective that makes one want to pry into it . . . The moisture, the beads of sweat . . . And it's spirited! As meaty as the *Olympia* is thin, delicate, cerebral . . . Perhaps the two pictures of the century . . . Baudelaire and Banville.* The rich technique, the precise workmanship . . . In the *Olympia*, to be sure, there is something more, an air, an intelligence . . . but Courbet is full-bodied, wholesome, alive. He feeds us a great helping of colour. It's more than we can swallow . . .

 Look here, it's a disgrace that that canvas should not be here, and that *The Burial* should be sacrificed, buried away in that sort of corridor over there . . . You can't see it . . . It ought to shine out, here, on the line, opposite *The Crusaders*, in place of that academic Homer . . . Yes, yes, it's very fine, those feet, that calm, that triumph, but it's a reconstruction, when all's said and done! Whereas *The Burial* . . . This way!

He took me by the arm and dragged me after him with the ardour of youth. All the while he kept on talking.

We're told he painted this after his mother's death. He shut himself up for a year at Ornans. These are village people who posed for him, with-

out really posing. He saw them in his mind's eye . . . In a sort of loft . . .
They came to see their likenesses . . . He mingled these caricatures with
his grief . . . Flaubert . . . but that's the story. Legend is stronger than
history. His mother had not died. She sat for him, she's in a corner . . .
But that tells you how much feeling went into this masterpiece. By a feat
of the imagination, it re-creates life.

We came to Delacroix's ceiling.

We'll come back and see this . . . Just glance at it! Have a look. It's the
breaking storm, the dawn of our renaissance . . . A Michelangelo in
gem-like colours . . . You know, the Michelangelo of the Sistine cor-
ners, of the *Judith* . . . and what games they're up to! An ode by Pindar
. . . The tiger and the woman lying down together, the sand drinking in
her hair . . . The whole sea flung onto a beach . . . You can feel its move-
ment . . . The earth climbing up, reaching out in the sunlight, Envy
plummeting down, these monsters. And what imagination! I can hear
trumpet calls . . . See those arms forging the light with hammer blows
. . . Delacroix painted our future with each stroke of his brush . . . And
the way it soars above us! . . . We'll come back.

He drew me on.

Yes, as Flaubert in his novels borrowed from Balzac, perhaps Courbet
borrowed from Delacroix's romantic intensity, from his expressive
truthfulness . . . Do you remember in *By Field and Shore*, when old
Flaubert was making that journey, the burial he describes and that old
woman whose tears fell like rain . . . Every time I reread that, I think of
Courbet . . . The same emotion, expressed in the same way . . . Have a
look.

*We arrived. He was flushed and beaming. His overcoat, which he was
carrying by a sleeve, swept the carpet behind him. He drew himself up to
his full height, exultant. I had never seen him like that. Usually so diffi-
dent, he cast triumphant looks to right and left. The Louvre belonged to
him . . . In a corner he spied a copyist's ladder. He pounced on it.*

Here's our chance! . . . Let's have a look at it.

He dragged over the ladder and climbed up.

Come and look . . . Dear God, how beautiful it is . . .

Courbet, *The Burial at Ornans*, 1849

The guards came running and shouting.

Leave me in peace . . . I'm looking at Courbet . . . Just hang it in proper light and no one would bother you . . .

He stamped on his little platform.

I ask you, look at this dog . . . Velasquez! Velasquez! Philip's dog is less dog-like, even though it's the dog of a king . . . You know the one I mean . . . And the choirboy, with his apple-red cheeks . . . Renoir might come somewhere near it . . .

He grew more excited and exultant.

Gasquet, Gasquet . . . Courbet's the only one who knows how to put down a black without making a hole in the canvas . . . There's no one but him . . . See here, in his rocks and his tree-trunks over there . . . With a single stroke he could show us one whole side of life, the dismal exist-

ence of one of these tramps, as you can see, and then back he comes, full of compassion, with the simplicity of a gentle giant who understands everything . . . His caricature is drenched in tears . . . Oh, leave me alone down there! Go and get your director. I'll think up a couple of words for him . . .

A crowd was gathering. He started making a real speech.

It's a disgrace, in God's name! . . . No, but really, it's true . . . We're always giving in . . . It's robbery . . . The State, we are the State . . . Painting . . . I am painting . . . Who is there that understands Courbet? . . . They're imprisoning him in this cave . . . I protest . . . I'll get the press, Vallès,* onto it . . .

He was shouting more loudly all the time.

Gasquet, you'll be somebody one day . . . Promise me that you'll get

this picture moved to the place where it belongs, in the Salon Carré . . . For God's sake, in the Salon of the Moderns . . . in the light . . . So that people can see it . . .

The guards picked up his overcoat and his bowler.

Leave me alone, the rest of you . . . I'm coming down . . . We've got a masterpiece like this in France and we hide it . . . Let them set fire to the Louvre . . . right away . . . If they're afraid of something beautiful . . . Into the Salon of the Moderns, Gasquet, the Salon of the Moderns . . . You must promise me . . .

He climbed down the ladder. He swept the crowd around us with a look of victory . . .

I am Cézanne.

He blushed . . . He fumbled in his pocket and threw some louis into the guards' hands . . . He hurried away, dragging me with him . . . He was in tears.

III

THE STUDIO

'*I've sworn to myself that I'll die painting.*'

Cézanne was finishing my father's portrait. I was present during the sittings. The studio was empty, furnished with nothing but the easel, the little table for paints, the chair in which my father sat, and the stove. Cézanne worked standing up ... Canvases were stacked against the wainscot in a corner. There was an even, soft light, given a bluish cast by the reflection from the walls. Two or three plaster casts and books were on a white wooden shelf. When I arrived, Cézanne went to fetch an old armchair that had lost half its stuffing and was lying about in the next room. My father was smoking his pipe. We were chatting.

Even though he had his brushes and palette in his hands, Cézanne spent most of the time looking at my father's face, examining it closely. He wasn't painting. At long intervals, a trembling brush stroke, a delicately applied touch, a lively blue mark, would define an expressive detail, would single out and accentuate a sudden flash of character ... It was only on the following day that I could see the previous day's penetrating work on the canvas.

On that particular day, an afternoon in late winter, the air around the Jas smelt of spring. The honey-coloured sky pressed against the panes. Cézanne opened one side of the window.

CÉZANNE

You won't be cold, Henri? ... The scent of the almonds is coming from the stubble ... It's a fine day. But good Lord! I must close it again ... These damned reflections ... The tiniest thing, you know ...

La peinture à l'huile
C'est bien difficile,
Mais c'est bien plus beau
Que la peinture à l'eau ...

MY FATHER

Singing? ... it must be going well today ...

CÉZANNE

Not badly . . . I hope sitting doesn't really bore you . . . You realize –
I'm not just saying this – that you're doing me a great turn . . . You're so
stable . . .

MY FATHER

(*Joking*) Imagine that!

CÉZANNE

(*Turning towards me*) It's moral stability that I envy him . . . He never
gets worked up, your father . . . Never . . . I'd like to bring that out, to
find the right colours, the exact colour to show it . . . A moral support!
That's what I've looked for all my life.

MY FATHER

The old refrain.

CÉZANNE

Ah, everyone knows his own troubles . . . As far as I'm concerned I
know you because I'm painting you . . . I tell you,, Henri, what you
have is certainty. That's my great ambition. To be sure! Every time I
attack a canvas I feel convinced, I believe that something's going to come
of it . . . But I immediately remember that I've always failed before.
Then I taste blood . . . Now take you, for instance, you know what's
good and what's bad in life, and you follow your own path . . . But me –
I never know where I'm going or where I want to go with this damned
profession. All the theories mess you up inside . . . Is it because I'm
timid in life? Basically, if you have character you have talent . . I don't
mean to say that character is enough, that it's enough to be a good fellow
in order to paint well . . . That would make it too easy . . . But I don't
believe that a scoundrel can have genius.

MYSELF

What about Wagner?

CÉZANNE

I'm not a musician . . . And besides – let's be clear – being a scoundrel is
not the same thing as having the character of a devil, and needing to
work out a way, with that character, to remain somebody . . . A friend
. . . Isn't that right, Henri? . . . To keep your hands clean, I mean. We
artists, damn it – more or less all of us – always go off the rails a bit, this
way and that . . . There are some who, in order to make it . . . But those
are exactly the ones, I believe, who don't have talent. You have to be

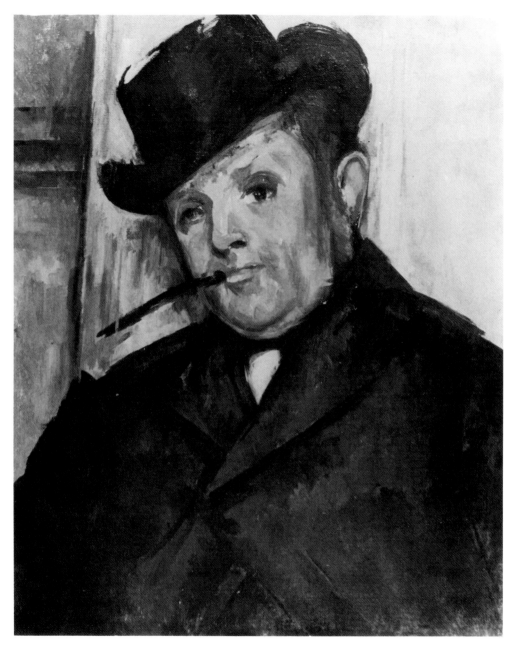

Portrait of Henri Gasquet, 1896–97

incorruptible in your art, and for that reason you have to make an effort to be incorruptible in life . . . Do you remember, Gasquet, how does old Boileau put it?

Les vers se sent toujours des bassesses du coeur.

In other words, there's ability and there's boasting. When you know what you're doing, you don't need to talk about it. It's always obvious.

MY FATHER
But the boy tells me that you don't have the standing you deserve.

CÉZANNE
He can say what he likes . . . As for me, I have to stay in my house, see nobody, work . . . My standing, indeed! . . . That would mean being pleased with myself. And that I never am. That I will never be. I can't be. Until the war, as you know, my life was a mess, I wasted it. It was only at l'Estaque, when I thought things over, that I really understood Pissarro, a painter like myself, whom your boy knows . . . He was a determined man. I was overcome by a passion for work. It wasn't that I hadn't been working before, I was always working. But what I always missed, you know, was a comrade like you, with whom I've never spoken about painting, but who would understand without any need for words . . . Ah, Henri! when I paint you, when I see you there . . . it takes me back more than forty years. May I say that it was Providence that brought us together? If I were younger, I'd say that this was a support and a comfort to me. A man who's consistent in his principles and opinions – it's amazing . . . I feel all that as I watch you drawing at your pipe.

MY FATHER
(*Moved and embarrassed*) And what else?

CÉZANNE
What else? I support wholeheartedly the artistic movement that your son is promoting and hoping to shape. You've no idea how invigorating it is for a friendless old man like me to find himself surrounded by young people who agree not to bury him straight away.

He turned towards me.

Yes, yes, form a group. Launch your review, your *Mois dorés*, your *Pays de France*, uphold the secular rights of our country. Be a rallying point for all the proven, worthwhile causes. I assure you, there's no

question of a man who feels he's alive and who has climbed the peak of life – consciously or not – hindering the progress of those who are just starting out. The people who preceded you are guarantors. In all walks of life. The path they took is a pointer to the way forward and not a barrier against you. They have lived, and that in itself means that they have experience. To recognize what that is doesn't mean diminishing yourself ... You are young, you're lucky, you're full of life ... Ah, Henri ... When we were that age ... Your mother talks to me about it. In your household she's the source of the wisdom you stand for. I know that she remembers rue Suffren, which was our cradle. I can't help getting emotional when I think of those wonderful bygone days, which I'm sure they were, and no doubt they are the reason for the state of mind in which we find ourselves today. Ah! if I only had the right method, that's what I would paint in your face, that's what would appear beneath my colour, that's what would last in your portrait ... Back to the pose. Let's work.

We stopped talking. My father pulled at his pipe. Cézanne's hands were trembling. He made a few dabs. He walked back and forth across the studio. Then he was motionless again in front of the canvas.

MY FATHER
Have you seen Ziem's* exhibition?

CÉZANNE
There's another man with no birthplace ... All those devils who go the East, to Venice, to Algeria to search out the sun; don't they have a cottage somewhere in their fathers' country? If you want to talk about a man from Provence, take Puget.* There's a man who smells of garlic, and Marseilles and Toulon – even at Versailles, unde the copper sun of Louis XIV. Puget has the mistral in him, that's what makes his marble move. And besides, it's decorative sculpture, as sculpture ought to be ... Do you remember, at the Louvre, all that we said in front of the *Perseus and Andromeda*, the great warrior, in the style of Bossuet, with the plump little virgin nestling in his lap, and those holes of shadow that paint everything in deep relief, in colour, as in those drawings by Rembrandt where the sheer quality of the blacks creates all the giddiness of the rainbow. It was Puget who discovered that. Before him, sculpture was balanced, a single block of crystallized light. But Puget worked like a painter, he made shadows. He used the surrounding shadow the way his contemporaries used underpainting. Go and see the effect he

achieves with this under the balcony of caryatids at Toulon. In the photographs and drawings of Saint Sebastian and the great bishop of Genoa it's startling, eloquent. The classical style has not extinguished him.

MYSELF

But what do you really mean by classical?

CÉZANNE

I don't know . . . everything or nothing.

MYSELF

I've heard you say that you were classical, or that you would like to be.

He pondered for a moment.

CÉZANNE

Imagine Poussin completely repainted from nature. That's what I call classical.

He began to paint again. The portrait was well advanced, two white squares remained on the cheek and on the forehead. The eyes were lively. Two fine blue lines extended the drawing of the hat almost to the edge of the canvas. He had begun to cover, to blend in one of these lines as he attacked the background. A bird bumped against a window-pane.

MY FATHER

Come in.

CÉZANNE

(*Pursuing his train of thought*) What I don't accept is a classical style that confines you . . . I want to be in touch with a master who gives me back to myself . . . Every time I come away from a Poussin I have a better idea of myself . . .

He stopped painting and observing his model. He was gathering his thoughts.

He's a piece of French soil completely realized, a 'Discourse on Method'* in action, a period of twenty, fifty years of our national life set down bodily on canvas, with the fullness of reason and truth . . . And what's more, and most important, it's painting . . . He went to Rome, didn't he? He saw it all. Loved it all, understood it all. Well, that's what he put down, that antiquity – a French version of it – without losing any of its vitality, of its own quality. He calmly carried on the succession, everything that he found beautiful from before his own time . . . As for

me, I'd like to carry on in the same way from him, retrieve him from his period, without spoiling him, without spoiling either him or me, if I were classical, if I could become classical . . . But you never know. Study modifies our vision to such an extent that the humble and colossal Pissarro, for instance, finds himself justified in his anarchist beliefs. Personally, I proceed very slowly, as you've observed. Nature seems to me so complicated. There is new ground to be won all the time, without mixing a speculative fantasy into it. Goodness me! A Provençal Poussin, that would fit me like a glove . . . Time and again I've wanted to rework the *Ruth and Boaz* motif . . . As in his *Triumph of Flora*, I'd like to link the curve of women's bodies with the shoulders of hills, or give the delicacy of an Olympian plant and the heavenly ease of a Virgilian line to a girl gathering fruit, as in his *Autumn* . . . Puvis owes a lot to that *Autumn* . . . I'd like to combine melancholy and sunshine . . . There's a sadness in Provence which no one has expressed; Poussin would have shown it in terms of some tomb, underneath the poplars of the Alyscamps . . . I'd like to put reason in the grass and tears in the sky, like Poussin . . . But you have to learn to be content with what you've got . . . You really need to see and feel your subject very clearly, and then if I express myself with distinction and power, there's my Poussin, there's my classicism . . . It's a matter of taste. Taste is the best judge. It's rare.

MYSELF

Like everything beautiful.

CÉZANNE

Ah, what I'm trying to say is that the artist is addressing an extremely limited number of individuals. And the fact is, he always knows too many of them in his lifetime. He has to live in his own corner, with his subjects, his thoughts, his models. To describe . . . And above all, mark me well, he must pay no attention to opinions which are not based on the intelligent observation of character. He must be wary of the literary approach . . . Your boy understands me, Henri . . . That approach which so often diverts the painter from the right path, the concrete study of nature, so that he gets lost too long in intangible speculation. We've said it hundreds of times . . . Oh the critics! These Huysmans!*
. . . I always want to write to them, all those people who circle around me: There are three basic principles in art, which you will never have and towards which I have striven for thirty-five years, and they are scrupulousness, sincerity, submission. Scrupulousness about ideas, sincerity to oneself, submission to the object . . . Absolute submission to the

object is what Sainte-Beuve found in a *Lundi* on Gautier . . . You are the object, Henri, for this quarter of an hour . . . If you're in command of the model and the means of expression, you have only to paint what's before your eyes and to persevere logically. Work without listening to anyone, become strong-minded. Anything else is all rubbish . . .

He took up his palette again. He cast quick glances at my father's face.

I'd really like to see them there lined up in front of your face, all of them who write about us, with my paints and brushes in their paws . . . Thousands of leagues away . . . And God help them if they can't see how you make a mouth look sad or a cheek smile by joining a green shade to a red one. You, at any rate, can feel that every brush stroke I make is a little of my blood mixed with a little of your father's blood, in the sunshine, in the light, in the colour, and that there's a mysterious exchange which goes from his soul (which he doesn't know about) to my eye, which re-creates it and in which he will recognize himself . . . if I am a painter, a great painter! . . . Every stroke, there on my canvas, must correspond to a living breath, to the light over there on his whiskers, on his cheek. We must live in harmony, my model, my colours and I and together catch the same passing moment. If you think it's easy to do a portrait . . . Just listen, first you need the model . . . The soul! . . . Geffroy persuaded me to have a go at Clemenceau's* portrait . . . I began. At first everything went well. He used to arrive fingering his cane, adjusting his flowing tie like a young man, though he was going grey around the ears . . . France was his. I kept busy, he talked. About everything. Amazing, and as malicious as a wasp. Cutting with a scalpel . . . All was going well. At the third sitting, I dug in my toes. A wall. You understand, the model had had a disturbing effect on me. I saw the problem. I tried imagining a bitter blue, biting yellows. Tightening up the drawing at home. No result. A wall. I could see it, I could see it . . . Then, one fine morning, I abandoned the whole thing, the canvas, the easel, Clemenceau, Geffroy . . . That man didn't believe in God. My conscience was clear, you see. To do a portrait, with that . . .

MY FATHER

Please, I'm a believer . . . You won't leave me unfinished?

CÉZANNE

You! . . . What an idea! . . . You make me discover things. I'm copying you, gently, slowly. Using the colours of friendship . . .

He turned towards me.

You were telling me that Elie Faure has written a tribute to Carrière* . . . When Carrière puts the same soft mist around all his family groups, it shows that he is dimly aware of the emotion that colours convey . . . You've seen his painting at the Toulon museum of the girl taking first communion, the two good old people, and that sort of soft dawn that absorbs everything . . . But he doesn't go further than his feeling . . . That's the underneath part . . . One has to go beyond feeling, get past it, have the nerve to give it objective shape and be willing to put down squarely what one sees by sacrificing what one feels – by having already sacrificed what one feels . . . You see, it's enough to feel . . . feeling never gets lost . . . I'm not against it. On the contrary, I often say it – only yesterday, as a matter of fact, to a young man, a soldier, Girier, or Girieud, who was introduced to me at the 'Clement'. An art which does not have emotion as its principle is not an art . . . Emotion is the principle, the beginning and the end; the craft, the objective, the execution is in the middle . . . Between you, Henri, and me, I mean between the factors that make up your personality and those that make up mine, there is the world, the sun . . . what's going on . . . what we see in common . . . Our clothes, our bodies, the play of light . . . that's what I have to work hard at . . . That's where the slightest misplaced brush stroke upsets everything. If there's nothing but emotion for me in it, I send your eye crooked . . . If I weave around your expression the whole infinite network of little bits of blue and brown that are there, that combine there, I'll get your authentic look on my canvas . . . One stroke after the other, one after the other . . . And if I'm cold, if I draw, if I paint as they do in art schools, I'll no longer see anything. A mouth, a nose, done to formula, always the same . . . without soul, without mystery, without passion . . . Every time I face my easel I'm a different man – myself, and always Cézanne . . . How can those people suppose that it's possible to capture changeable, iridescent substance wth plumb-lines, academies, arbitrary rules of measurement laid down once and for all? They turn into idiots, stupefied, addled . . . A lump in their brains, a pane of glass, a system of geometry . . . They would do better to study anatomy, which quickly gives us a grasp of the play of muscles, the movements of skin, if what we want is to compose or construct a standing man without a model . . . Delacroix used to rise at four in the morning to go to the slaughter houses and watch the horses being skinned . . . Now see how they snort on his ceiling . . . Anatomy! . . . They don't see anything any

more. They've never seen anything . . . Their rule is the universal rule, drawing is their drawing. That covers everything for them . . . But infinite diversity is nature's masterpiece . . .

Look, Gasquet, here's your father . . . He's sitting there, isn't he? He's smoking his pipe . . . He's listening with only one ear . . . He's thinking – what about? Also, he's receiving a cloud of sensations . . . His eye is not the same . . . An infinitesimal proportion, an atom of light has changed from within and met up with the unchanging, or almost unchanging, curtain in the window.

Then you see how this tiny, minuscule spot of colour which forms a shadow under the eyelash is out of place . . . Good . . . I'm correcting it. But then my light green nearby, I can see it stands out too much. I tone it down . . . And this is one of my good days, today. I feel braced. My will is in my hand . . . I carry on, with almost invisible touches all around. The eye is more convincing . . . But now, the other one. It seems to me to be squinting. It's looking, it's looking at me. Whereas this one is looking at his life, his past, you – I don't know – something which isn't me, which isn't us . . .

MY FATHER

I was thinking about the trump I held yesterday up to my third trick . . .

CÉZANNE

You see! . . . Well, Rembrandt, Rubens, Titian could do it in a single, wonderful combined operation, they could fuse the whole of their own personality with the body in front of their eyes, animate it with their passion, and sublimate their hopes or their sadness through the likeness . . . With exactness . . . I can't do that.

MYSELF

It's because you're too fond of other people . . .

CÉZANNE

It's because I want to be truthful . . . Like Flaubert . . . To wrest the truth from everything . . . Submit myself . . .

MYSELF

Maybe that's not possible.

CÉZANNE

It's very difficult . . . By putting some part of myself in your father, I would have my complete statement . . . And I would use suggestions of shadow and light . . . I would come close to reality. That's what I really

want . . . Otherwise, in my own way I would be doing what I criticize the Beaux-Arts for. In my brain I'd have my preconceived person and I would be tracing the truth over him . . . Whereas it's myself that I want to trace over it. What am I? . . . To get to the heart of truth, present it as it is. And if I break my back in the attempt, too bad. I will have tried. I will have paved a way. Others more tough, more subtle, will come along . . . and they'll do with the figure what Monet has done with landscape . . . They'll make photographs . . . don't misunderstand me, but they'll do photographs of souls, of characters, of a man . . . And then from these impressions others will derive a great art, a glowing psychology, a philosophy of mankind . . . Rubens attempted that with his wife and children, you know, the extraordinary Hélène Fourment in the Louvre, all russet-coloured, wearing a hat, with her naked infant . . . and Titian, with his Paul III between his two nephews, in the Naples Museum, like a passage from Shakespeare . . .

<div align="center">MYSELF</div>

And Velasquez?

<div align="center">CÉZANNE</div>

Ah! Velasquez, that's another story. He took his revenge . . . You see, here was this man painting away in privacy, getting ready to bequeath to us enough Forges of Vulcan and Triumphs of Bacchus to cover the walls of all the palaces in Spain . . . Some idiot, to do him a favour, speaks about him, drags him along to the king . . . In those days they had not yet invented photography . . . Do my portrait, on foot, on horseback, my wife, my daughter, this fool, this beggar, this one, that one . . . Velasquez became the court photographer . . . the plaything of that madman . . . He was a prisoner . . . Impossible to escape . . . He took a terrible revenge. He painted them with all their blemishes, their vices, their decadence . . . His hatred and his objectivity became one . . . He painted the king and his buffoons the way Flaubert presented his Homais and Bournisien* . . . Velasquez bears no resemblance to his portraits, but look how Rembrandt and Rubens are always there, you can recognize them under all the faces . . . And there's also another precursor, Goya. His *Maja vestida* and his *Maja desnuda* . . . It was love that performed the miracle . . . He was so frightening, so ugly. You've seen the portrait with his enormous top-hat. We always succeed in our own portraits because there we're at one with the model, if you follow me . . . Goya was terrible. When he had held this duchess, this slender aristocrat, this brown body in his arms . . . He didn't have to invent

anything. He was in love. He painted the woman. A specific woman . . .
And after that you find her reappearing everywhere. The moment of
grace did not last. His insatiable imagination swept him away. The
Duchess of Alba is everywhere in his work, as an angel, a courtesan, a
cigar-maker. She became his set type. Like Hélène Fourment for
Rubens, or his daughter for the old Tintoretto . . . These are imaginative
geniuses, Shakespeares, Beethovens. I would like to be . . .

<div align="center">MYSELF</div>

What?

He stammered.

<div align="center">CÉZANNE</div>

Nothing . . . Cézanne . . . I'll show you . . . The sitting is over, Henri.
That's enough for today. Thank you . . . Just a minute . . .

*He went over to the pile of canvases, looking for something . . . He
brought out three still-lifes, and placed them against the wall on the
ground. Warm, profound, alive, they shone out like something supernat-
ural and yet firmly rooted in the most ordinary reality. In one there was a
tablecloth on which rested a fruit dish containing four apples; a bunch of
grapes; a slim-stemmed glass, opening out like a chalice, half filled with
wine; a pile of apples; and a knife. It had a background of flowered ma-
terial. There was a partial signature in the left-hand corner . . . The next
one presented a rough-hewn wooden table on which there sat a huge bas-
ket of fruit half wrapped in a linen napkin, some pears on the tablecloth, a
coffee service – coffee pot, sugar bowl and a sort of pot, a diapered alcar-
raza. On the right, part of the mantelpiece was visible with a palette and
turpentine bottle on it. Close by, canvas stretchers. At the back of the
receding floor was the bottom of a rustic chair, its straw seat cut off by the
edge of the canvas . . . And the third one, elegant, appetizing, lucid, was
an entirely French work, decorative and yet taut – half emerging from a
rich material of subdued flower pattern hanging in broad folds was a
plaster cupid without arms, on his right a plate of pears, on his left a pile of
plums. At the back – unexpected and bourgeois, but so richly painted, so
stunningly wrought – was a Prussian stove of the kind still used in the
bastides of Provence.*

Do you see, maybe I've managed here, in these still-lifes, something
I've never yet been able to achieve, something I shall never achieve with
figures, with portraits . . . I've kept scrupulously to the object . . . I've

copied ... Tell me, what would seem to you the most lamentable fate? To be destitute, don't you agree? Very well, I've put quite a bit of myself into these. In years to come I won't be completely destitute if, as you are kind enough to assure me, people will still take a little notice of me after my death ... There you are ... Look at that ... Give me your frank opinion ... And you too, Henri.

MYSELF

But it's greater than anything painted since the Venetians ... There is some green fruit by Tintoretto at San Rocco, a bit of his *Crucifixion* which has been folded up and miraculously preserved in all its freshness, some apples that look like that ... But how beautiful it is! How beautiful! There's more life in that fruit than in many faces ...

CÉZANNE

You get so carried away ... Come, I don't delude myself ... That basket there, I offered it to my coachman as something to remember me by, later on, you understand, he looks after Mother, this man ... Fine. He was happy, he thanked me ... But he left the canvas behind ... He forgot to take it away ... What more can I say? ... Go on painting, for that's my lot.

MYSELF

Master ...

He raised his arms with a calm, sceptical gesture and dropped them again with an expression of despair, ironic looks, but undaunted determination.

CÉZANNE

I've sworn to myself that I'll die painting rather than sinking into that degrading senility that threatens old men who let themselves be ruled by passions that stupefy their senses ... God will be my judge.

MYSELF

And even if you don't share our certainty that you're one of the greatest painters that has ever ...

CÉZANNE

Be quiet.

MYSELF

At least you have the consolation of work.

Still-life: Fruit Bowl, Glass and Apples, 1878–82

The Kitchen Table, 1888–90

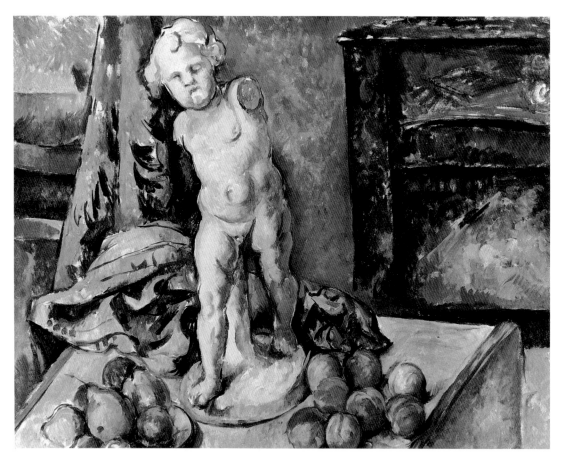

Still-life with plaster Cupid, c. 1895

CÉZANNE

That's all I care about. And painting . . . It's so good and so frightening
to sit down in front of an empty canvas. That one, I can tell you, is the
result of months of work. Of tears, laughter, grinding of teeth. We were
talking about portraits. People don't think of a sugar-bowl as having a
face, a soul. But it changes every day too. You have to know how to
catch them, how to win them over, those gentlemen . . . These glasses
and plates, there's talk going on between them. Endless confidences . . .
As for flowers, I've given them up. They wilt right away. Fruit are more
faithful. They love having their portraits done. It's as if they're asking to
be forgiven for fading. They exhale their message with their scent. They
reach you with all their smells and tell you about the fields they've left,
the rain that made them grow, the dawns they've watched. When I'm
outlining the skin of a lovely peach with soft touches of paint, or a sad
old apple, I catch a glimpse in the reflections they exchange of the same
mild shadow of renunciation, the same love of the sun, the same recol-
lection of the dew, a freshness . . . Why do we divide up the world? Does
this reflect our egoism? We want everything for our own use. There are
days when I get the impression that the universe is nothing more than a
stream, an ethereal river of reflection, of dancing reflections around the
ideas of man . . . The prism is our first step towards God, our seven beat-
itudes. The celestial atlas of the great eternal whiteness, the diamond-
studded zones of God . . . Do I seem a bit cracked to you, Henri? . . .

MY FATHER

No, no. The boy understands you.

CÉZANNE

Objects enter into each other . . . They never stop living, you under-
stand . . . Imperceptibly they extend beyond themselves through inti-
mate reflections, as we do by looks and words . . . Chardin was the first
to have glimpsed that and rendered the atmosphere of objects . . . He
was always on the look-out . . . Do you remember his fine pastel, in
which he portrayed himself equipped with spectacles, and a tilted eye-
shade . . . A cunning fellow, that painter . . . Notice how a light trans-
versal plane straddling the bridge of your nose makes the values more
evident to the eye . . . Well, he noticed that before we did . . . He
neglected nothing. He also perceived that whole encounter in the at-
mosphere of the tiniest particles, the fine dust of emotion that surrounds
objects . . . But he's a little dry . . . maybe even a bit too rigid . . . Draw,
draw, yes, by heaven, draw, but it's the enveloping reflection, the light,

from the general reflection, it's the envelope . . . That's what I'm after
. . . And that's why these three still-lifes – to tell you the truth – since I
began talking to you – no longer please me.

MYSELF

What, master? . . . It's just the opposite for me: the more you talk, the
more I can see in them, the more I like them and understand them . . .
It's as if they're brought to life again by everything you say.

CÉZANNE

Listen to me, when you begin to pull Chardin to pieces, as I've just
done, you have to produce different results.

MYSELF

But Chardin doesn't have this light, he would look dead alongside this
bluish basket, this Cupid . . . Chardin's like a coloured print compared
to . . .

CÉZANNE

Be quiet . . . You'll make me believe that you don't understand anything
about what I'm trying to do . . . You see, I don't find that living, enve-
loped . . .

He pointed to the plaster cupid in his still-life.

Look here, this hair, this cheek, they're drawn, they're skilful, there,
the eyes, the nose, they're painted . . . and in my ideal of a good paint-
ing, there's a unity. The drawing and the colour are no longer distinct; as
soon as you paint you draw; the more the colours harmonize, the more
precise the drawing becomes. I know that from experience. When the
colour is at its richest, the form is at its fullest. Contrast and relationship
of colours – that's the secret of drawing and modelling . . . All the rest is
poetry. Which you need in your head, perhaps, but which you must
never try to put on your canvas, lest it turn to literature. It finds its own
way there.

He went to fetch a book off the shelf, his old Balzac. He leafed through
Peau de chagrin.

Yes, you have your metaphors, your comparisons. Though it seems to
me that constantly multiplying 'likes' is similar to us when our drawing
is too obvious. You don't have to tug people by the sleeve . . . But we
have nothing but our colours, what can be seen . . . Listen. Here's Bal-

zac describing a table laid for a meal. He paints his still-life, but in Veronese's style.

He read aloud:

'A tablecloth white as a bed of freshly fallen snow on which the places were laid in orderly array, crowned with honey-coloured rolls.'

All my early life I wanted to paint that, the tablecloth of fresh snow ... Now I know that it's wrong to want to paint 'the places laid in orderly array' and 'honey-coloured rolls'. If I paint 'crowned' I'm done for ... Do you understand? And if I truthfully balance and relate my places and my rolls as they are in nature, you can be sure that the crowns, the snow, and all the excitement will be there ... There are two things in a painter: the eye and the brain, and they need to help each other, you have to work on their mutual development, but in a painter's way: on the eye, by looking at things through nature; on the brain, by the logic of organized sensations which provides the means of expression. I go no further than that. I said that to you one day, I believe, in front of the motif. I repeat it to you now. There is, in an apple, in a head, a culminating point, and this point – in spite of the effect, the tremendous effect: shadow or light, sensations of colour – is always the one nearest to our eyes. The edges of objects recede to another point placed on your horizon. This is my great principle, my conviction, my discovery. The eye must concentrate, grasp the subject, and the brain will find a means to express it ... And then I've already made a note of this in the margins of the *Chef-d'oeuvre inconnu*, a first-class book, between ourselves, gripping and profound in a different way from *L'Oeuvre*, and one which every painter should reread at least once a year ... I made a note ... This is incontestable, I'm very positive ...

He read aloud.

'An optical sensation is produced in our visual organ which makes us classify as light, half-tone or quarter-tone the planes represented by colour sensations.'

He chuckled.

That implies that light doesn't exist for the painter.

He resumed.

'As long as we're obliged to go from black to white – the first of these abstractions being a kind of support for the eye as much as the brain – we

flounder about, we never manage to gain control or become our own masters. During this period we go to the admirable works handed down to us by the ages, and find in them a comfort, a support, like a board for a swimmer . . .'

He threw down the book.

But as soon as we're painters, we're swimming in real water, in actual colour, in full reality. We're grappling directly with objects. They lift us up. A sugar-bowl teaches us as much about ourselves and our art as a Chardin or a Monticelli. It has more colour. It's our pictures which become lifeless copies of nature. Everything is more iridescent than our canvases; all I have to do to have the most beautiful Poussins and Monets in the world is open my window . . . Shadow piled on, painted shadow, light assassinated, horrors! the brightness gone dead . . . We're walking in a land of blind people . . . What means have you of knowing that the sun exists? Our pictures are like wandering, groping night . . . The museums are like Plato's caves. I would engrave on the door: 'No admittance to painters. Sunlight available outside.' A painter begins to paint, what's properly called painting, at the age of forty – that is, a painter of our time. The others, when there were no museums, had almost finished their work at that age. Nowadays a painter knows nothing. Up to the age of forty, yes, let him visit the museums, I order him to. After that let him return to those graveyards only to rest and ponder his impotence and death . . . Museums are odious places. They stink of democracy and school. I paint my still-lifes, these still-lifes, for my coachman who doesn't want them; I paint them for children on their grandfathers' knees to look at while they drink their soup and babble. I don't paint them for the German Kaiser's pride or the Chicago oil magnate's vanity. People pay 10,000 francs for one of these trashy things; they would do better to give me a church wall, a room in a hospital or a town hall and say to me: 'Do your worst there . . . Paint us a wedding, a convalescence, or a nice harvest scene . . .' Maybe then I'd extract what I have in my guts, what I've carried there since I was born, and that would be painting . . . But I'm dreaming, getting tipsy, carried away . . . Where does it lead? It prevents me from working better . . . To work! . . . That's all there is . . . I'm telling you, Henri, painting is the devil . . . You keep thinking you've got hold of it, but you never have . . . Your portrait is just a fragment, and you know how backbreaking it is to do a face, eyes that really look, a mouth that speaks . . . And that's only the beginning. In order to make pictures, you'd almost have to get down a fragment

like that every day . . . Tintoretto did it, and Rubens . . . And that was all dealing with the figure . . . It's the same thing with these still-lifes. They too are dense and complex. There's method for every object. One never knows one's method . . . It seems to me that I wouldn't know anything even if I painted a hundred years, a thousand years, without stopping.

As for the ancients, good Lord, I don't know how they set about knocking off commissions by the kilometre . . . I devour myself, kill myself, in order to cover fifty centimetres of canvas . . . Never mind . . . That's life . . . I want to die painting . . .

He suddenly fell into one of those reveries that were customary with him. He looked at his closed fist. He followed on it the passage of light into shadow.

That's not it at all . . . Listen – that was all just a joke . . . What I want is to do with colour what one does in black and white with a stump.

Another long silence. Then he looked at me, and I felt dazzled by the sensation of his eyes looking right into me, past me, deep into the future. There was a broad smile of resignation on his face.

Someone else will do what I haven't been able to do . . . Maybe I'm just the primitive of a new art.

Then a sort of bewildered indignation passed over him.

Life is terrifying!

And I heard him several times murmuring like a prayer as the dusk was falling:

I want to die painting . . . to die painting . . .

APPENDIX I

Chronology of Joachim Gasquet's Life

APPENDIX II

Chronology of Paul Cézanne's Life

TRANSLATOR'S NOTES
SOURCES OF ILLUSTRATIONS
INDEX

Cézanne's studio at Aix

Appendix I

Chronology of Joachim Gasquet's life

1873 Born. Son of Henri Gasquet, a baker in Aix, an old school friend of Cézanne's.

1877 Acts in a Corpus Christi play as the infant Jesus. The future poet, Jean Royère, aged 6, plays the part of an archbishop.

1880 Henri Gasquet helps the Jesuits on their expulsion from Aix by hiding their silver in his barn.

1886 Edits a school magazine, *The Grasshopper*.

1889–89 Is taught by Louis Bertrand at Lycée Mignet and by Georges Dumesnil at the Collège Bourbon.

1891? Edits *Le Syrinx* with the help of college friends; André Gide and Paul Valéry are among its contributors.

1892 Begins *Narcisse*.

1896 23 January, marries Marie Girard. April. Meets Cézanne. June. Fêtes Félibréennes. Marie Gasquet is 'Reine du Félibrige'.

1897 Edits *Les Mois dorés*. Reviews Cézanne's work in it. Helped by Maurras, Bertrand and Dumesnil, attempts to sketch a national philosophy.

1898 Visits the Louvre with Cézanne. Finishes *Narcisse*.

1899 *Les Mois dorés* becomes *Les Pays de France*. The Gasquets put up Cézanne in their house in the rue Arts et Métiers, Aix. Joachim writes *Il y a une plaisir dans la douleur . . .* (a novel).

1900 Cézanne advises him to give up imitating Pindar. Sessions rereading Victor Hugo with Cézanne and Jean Royère.

1901 Writes *Les Printemps (mystique, païen, funèbre)* (published 1909).

1902 The Gasquets move to Eguilles (7 miles from Aix). Joachim publishes *Mardrus* (a version of the Arabian Nights).

1903 Writes *Les Chants séculaires*, hailed by Maurras as starting a classical revival.

1905 Writes *Le Coeur de poète* (Indian myths).

1906 The Gasquets live in Paris for 6 months while Joachim edits *Le Témoin* as co-director. His *Dionysus*, a dramatic poem, staged at Orange, set to music.

1907–14 Travels in Russia, Germany and Italy.

1909–13 Writes *Le Bûcher secret* (lyrics).

1912–13 Writes *Cézanne*.

1913–14 In *La Jeune Europe*, following Nietzsche, he tries to put across the notion of a European culture and order.

1914 Enlists, becomes Lieutenant-Porte-Drapeau of his regiment.

1915 Wounded at Verdun, cited for bravery in despatches.

1916 Invalided home.

1917 Returns to the trenches but proves unfit. Publishes *Les Bienfaits de la guerre*.

1919 Publishes a Pindaric victory hymn in *L'Action française*. Publishes *L'Art vainqueur* (a book of essays) and *Les Hymnes*.

1921 April. *Cézanne* published (Bernheim Jeune, Paris).

1921 8 May. Dies of cancer of the bile bladder. Publication of *Il y a une volupté*. Preface by E. Jaloux.

1925 Publication of *Les Chants séculaires* (written 1903).

1926 Second edition of *Cézanne*.

1928 Publication of *Des Chants de l'amour et des hymnes*, with a biographical appendix by Marie Gasquet and a tribute by Louis Bertrand, delivered at the unveiling of his memorial in Auteuil by Xavier de Magallon in this year.

1931 Publication of *Narcisse* (foreword by E. Jaloux).

1950s Gasquet's letters left to the Bibliothèque Méjane at Aix by his widow, including 18 from Cézanne to Gasquet.

Appendix II

Chronology of Paul Cézanne's Life

1839 Born 19 January at 28 rue de l'Opéra, Aix. His father, a hatter, acquires the only bank in Aix in 1848.

1849 Enters the Pensionnat Saint-Joseph.

1852–58 Interne at the Collège Bourbon. Meets Zola and Baille.

1858/59 Summers. Cézanne, Zola and Baille meet, although Zola has gone to live in Paris.

1859 Louis-August Cézanne buys the Jas de Bouffan, the old residence of the governors of Provence, having earlier rented the grounds.

1859–60 Cézanne studies law, meanwhile attending the Ecole de Dessin at Aix. He begins painting the murals in the salon of the Jas.

1861 April. First visit to Paris. Lives in the rue Coquillière, rue des Feuillantines, rue d'Enfer. Works at the Académie Suisse, where he meets Pissarro. Fails to pass the entrance into the Ecole des Beaux-Arts. September. Begins to work in his father's bank. Attends the Ecole de Dessin at Aix for a third year.

1862 November. Returns to Paris. In the rue des Feuillantines, rue de l'Est, rue Beautrellis (where he lives, when in Paris, till 1869). Returns to the Académie Suisse. Meets Guillemet, Bazille, Guillaumin, Sisley, Monet.

1862–65 Cézanne's work refused by the Salon. Summers (except 1863) spent at the Jas de Bouffan.

1866 Cézanne writes to the Superintendent of the Beaux-Arts requesting the re-establishment of the Salon des Refusés (his work having been rejected for the fifth year running by the Salon). Zola publishes *Mon Salon*, and dedicates it to Cézanne. Spends the summer at Bennecourt with Zola and other Aix friends. Autumn at Aix.

1867 Salon entry refused. Paints *L'Enlèvement*.

1868 Salon entry refused.

1869 Salon entry refused. Meets the model Hortense Fiquet, aged 19, who becomes his mistress.

1870 At 153 rue Notre-Dame-des-Champs, Paris. Salon entry refused (portrait of Achille Emperaire). 18 July. Franco-Prussian war breaks out. Settles Hortense at l'Estaque, concealing her existence from his father.

1871 Armistice signed 28 January. Cézanne shares an apartment with Solari at 5 rue de Chevreuse, then moves to rue de Jussieu.

1872 January. Paul Cézanne (*fils*) born. February to November. At the Hôtel du Grand Cerf, Pontoise, with his family; painting with Pissarro. Autumn onwards. In Dr Gachet's house at Auvers.

1873 At Auvers.

1874 January. Moves to 120 rue de Vaugirard, Paris. Exhibits *La Maison du Pendu* and *Une moderne Olympia* at the first 'Impressionist' exhibition, boulevard des Capucines.

1875 Moves to 13 quai d'Anjou. Paints with Guillaumin. Meets Chocquet.

1876 Paintings refused by Salon. Paints at Aix and l'Estaque. Chocquet buys two views of l'Estaque.

1877 At 67 rue d l'Ouest, Paris. Shows 16 paintings, including watercolours, at the third Impressionist exhibition (rue Le Peletier). Working at Pontoise with Pissarro, at Auvers and at Chantilly.

1878 Spends a year in the south, with his family at Marseilles, though living in Aix himself. His father discovers his liaison and cuts his allowance. Cézanne gets financial help from Zola.

1879 March to May. Paris. Work refused by Salon. Refuses to take part in fourth Impressionist exhibition. At Melun from May onwards, with a visit in late September to Médan, where Zola has bought a house.

1880 Leaves Melun and returns to Paris (32 rue de l'Ouest). Again at Médan. Meets J. K. Huysmans there.

1881 Spring. At Pontoise working with Pissarro. Meets Gauguin there. October. At Médan. November onwards. At Aix.

1882 Renoir stays at l'Estaque. March. Paris, 32 rue de l'Ouest. Thanks to Guillemet has a picture accepted at the Salon. September. At Médan. October. At the Jas de Bouffan.

1883 At Aix or l'Estaque. Excursions with Monticelli.

1884 Works at the Jas, l'Estaque, and surrounding villages. Salon refuses his entry. The younger generation begins to admire his work at père Tanguy's.

1885 Falls in love with Fanny, servant at the Jas. June/July at La Roche-Guyon, Villennes and Vernon, and Médan. August onwards at Aix. Paints views of Gardanne.

1886 At Gardanne with his family. Salon entry refused. March. Zola publishes *L'Oeuvre*, in which Cézanne recognizes himself as the failed painter,

Claude Lantier. April. Last letter to Zola. 28 April. Marries Hortense Fiquet. 23 October. His father dies, leaving him without financial worries.

1887 Mostly at Aix. Hires a hut in the grounds of the Château Noir which he keeps until 1902. Salon entry refused.

1888 Renoir stays at l'Estaque. Salon entry refused. In Paris, 15 quai d'Anjou. Working at Chantilly, by the Marne, and in the outskirts of Paris. Huysmans publishes an article about him in *La Cravache*.

1889 Cézanne's *Maison du Pendu* is hung in the Exposition Universelle. June, Cézanne stays with Chocquet at Hattenville. July onwards, at Aix. Renoir and his family rent Montbriant, the house belonging to Maxime Conil, Cézanne's brother-in-law, outside Aix. December. In Paris.

1890 Sends three works to Brussels (the XX Group). Does a five-month trip to Neuchâtel, Berne, Fribourg, Vevey, Lausanne and Geneva with his wife and son. Signs of diabetes appear. On returning to Aix, begins the Card Players series.

1891 At Aix. Refuses an invitation to exhibit at the Salon des Indépendants. Leaves his wife and son in Aix and goes to Paris. A fervent Catholic from this year onwards. His work is mentioned in the *Mercure de France*, and *L'Echo de Paris*.

1892 Partly at Paris, 2 rue des Lions-Saint-Paul. At Fontainebleau, and at Aix.

1893 At Aix, Paris and Fontainebleau.

1894 Mostly at Paris (rue Lions-Saint-Paul) and at Alfort. Gustave Geffroy writes an article about him in *Le Journal* (25 March). November. Stays with Monet at Giverny. Dinner there with Geffroy, Mirbeau, Rodin and Clemenceau.

1895 Spring. Portrait of Gustave Geffroy. Three of his pictures from the Caillebotte legacy accepted for the Luxembourg. December. More than 100 of his paintings exhibited at 39 rue Laffitte, Paris, by the dealer Ambroise Vollard. Renoir, Pissarro, Degas are deeply impressed. Enthusiasts begin to buy. After the exhibition Vollard comes down to Aix to buy up any privately owned Cézannes he can find.

1896 April. Invited to exhibit two paintings by the Amis des Arts, Aix. *La Sainte-Victoire au grand pin* is noticed and admired by Joachim Gasquet. Meets Joachim Gasquet. Paints Henri Gasquet, then Joachim. 2 May. An article by Zola in *Figaro* entitled 'Peinture', referring to Cézanne as 'an aborted great painter', comes out. June. Goes to Vichy with his wife and son for a diabetes cure. Paints Lake of Annecy.

1896–97 September to April. Living in 73 rue St Lazare. Finds a studio in Montmartre.

1897 Gasquet reviews Cézanne's work in *Les Mois dorés*. June onwards. In Aix, working at Le Tholonet and in the Bibémus quarry. 15 October. Death of his mother, aged 82.

1898 February. Dreyfus affair. As Zola's friend Cézanne is subjected to a smear campaign in Aix. May–June. Vollard holds a second exhibition of 60 of his paintings. Summer. Paints at the Château Noir and at Montgeroult.

1898–99 Autumn–spring. Living with his wife and son at 23 rue Hégésippe-Moreau, Paris. Paints Vollard (116 sittings). Visits the Louvre and Trocadéro regularly in the afternoons. Takes Gasquet to the Louvre. October. Gasquet leaves Cézanne out of an article in the *Memorial d'Aix*.

1899 Summer. Cézanne paints at Pontoise with the young painter Louis Le Bail. Sale of the Jas de Bouffan. Autumn. Cézanne stays with the Gasquets while waiting to move into his flat and studio in 23 rue Boulegon. November onward. Becomes friendly with the poet Louis Aurenche. Exhibits in the Salon des Indépendants. December. Vollard holds a third exhibition of his work.

1900 Maurice Denis paints his *Homage to Cézanne*. Cézanne stays in Aix.

1901 November. He buys land at Les Lauves and starts building a studio. Meets the poet Louis Larguier (on national service at Aix) and the young painter Charles Camoin, the latter introduced by Vollard.

1902 Moves into his new studio. 29 September. Death of Zola whom he has not seen for 16 years. Octave Mirbeau suggests to Roujon, Director of the Beaux-Arts, that Cézanne be awarded the Légion d'Honneur, but it is refused.

1903 At Aix.

1904 At Aix. February. Emile Bernard stays at Aix and has conversations with Cézanne. Abortive arrangements to meet the Gasquets. At the Salon d'automne (founded 1902), 30 Cézannes are exhibited. Cézanne pays a short visit to Paris, then Fontainebleau for a month, before returning to Aix.

1905 At Aix. Visited by painters Rivière and Schnerb.

1906 Visited by Maurice Denis, and by Osthaus. 22 October, dies.

Translator's Notes

p. 42 *Jacques le Fataliste* (1796), by the Encyclopedist Denis Diderot, an account of the conversations between Jacques and his master; a critique of story-telling.

p. 48 Thursdays = market days.

p. 52 Jean Royère (1871–1956), poet and critic, a disciple of Mallarmé and close friend of Gasquet; published his memoirs under the title *Jadis et naguère*.

p. 55 Gilbert in the original, but probably Joseph-Marc Gibert (1808–84), painter in Aix, is intended.

p. 62 Frenhofer, visionary artist in *Le Chef-d'oeuvre inconnu*, a story from Balzac's *Etudes philosophiques* (see fn. p. 95).

p. 62 Charles-Augustin Sainte-Beuve (1804–69), the famous literary critic, whose articles appeared in *Le Constitutionnel* and other papers on Mondays, and were subsequently published in *Causeries de Lundi*, the *Nouveaux Lundis* and *Premiers Lundis*. (See also p. 212).

p. 65 Epinal = the capital of the departement of the Vosges, which gave its name to a long series of popular prints which offered stylized images of French life and history.

p. 68 *Emile ou L'Education* by Jean-Jacques Rousseau (1762).

p. 71 Mahoudeau is the name of the character based on Philippe Solari in Zola's *L'Oeuvre*.

p. 74 Octave Mirbeau (1848–1917), playwright and novelist; one of the first defenders of Impressionism, close friend of Monet and Zola, old acquaintance of Cézanne.

p. 78 Barbey d'Aurevilly (1808–89), critic and novelist, who succeeded Sainte-Beuve on *Le Constitutionnel*; royalist and Catholic, wrote novels set in his native Cotentin.

p. 78 Auguste Pellerin (1852–1929), industrialist who made one of the finest collections of Impressionist paintings ever assembled; it included 90 Cézannes which were specially exhibited in 1907 after Cézanne's death. The *Large Bathers* referred to here is in the Barnes Foundation, Merion, PA.

p. 86 Thérésa may refer to Marie-Thérèse Grevier, who married Emile Ollivier (see next note) when she was 20, in 1869, just before he came to power. She was the daughter of a cotton manufacturer in Pondicherry and the great grand-niece of Admiral Suffren. Her youth and simplicity were seen as characteristic of the new liberal empire and a criticism of the corrupt regime of Napoleon III. In this way she was a subject for enthusiasm.

p. 86 Emile Ollivier (1825–1913) was a liberal politician of democratic sympathies whom Louis Napoleon was forced by public opinion to appoint in 1870 to head the last disastrous ministry of his reign. Gasquet did not include him among his list of Provençal notaries.

p. 88 He actually did not marry Hortense Fiquet until 1886.

p. 90 Arthur Choquet, mistake for Victor Choquet, a senior customs official introduced to Cézanne by Renoir; he was an enthusiastic collector and sat for Cézanne and Renoir.

p. 96 *Peau de chagrin*, one of the stories in Balzac's *Etudes philosophiques* (see fn. p. 95).

p. 113 'A good friend' refers to Achille Emperaire.

p. 117 *Abbé Mouret's Mistake*, story by Alphonse Daudet.

p. 123 Henri Roujon (1853–1914), director of the Beaux-Arts and Secrétaire perpetuel de l'Académie française.

p. 124 phalanstery = a Utopian cooperative community. The first of a series associated with the socialist Charles Fourier and Victor Considérent was created in 1838. Their influence is discernible in the works of George Sand and Zola.

p. 130 *Le Recherche de l'Absolu*, one of the stories in Balzac's *Etudes philosophiques* (see fn. p. 95).

p. 131 *Old Woman with a Rosary* is now in the National Gallery, London.

p. 134 Nicholas-Claude Fabri de Peiresc (1580–1637), astronomer and specialist in coins.

p. 140 Jean-Marie Demolins, referred to in a letter from Cézanne to Gasquet (12 May 1902) as 'collaborator . . . of the Revue which you edit.' This letter also speaks of an ex-maid of Demolins as the model for Cézanne's *Old Woman with a Rosary*, thus contradicting Gasquet's account on p. 132 above.

p. 140 The Lebruns; refers to paintings by Charles Le Brun (1619–90) epitomizing La Grande Epoque.

p. 150 Georges Dumesnil (1855–1916), philosopher; was Gasquet's teacher at the Lycée Mignet in Aix.

p. 160 Xavier de Magallon, Provençal poet who was instrumental in having a statue erected to Gasquet in Auteuil in 1931.

p. 164 Eugène Fromentin (1820–76), painter and art historian, author of the classic *Les Maîtres d'Autrefois*, consisting of essays on Dutch and Flemish painters.

p. 164 'someone in the trade' = Emile Bernard.

p. 164 For the background of this statement, see P. M. Doran, *Conversations avec Cézanne*, Paris 1978, p. 209.

p. 165 Ernest Renan (1823–92), Hebrew scholar, philologist, historian and critic, a major representative of French intellectual life. His *Life of Jesus* (1863) denied the supernatural element in Christ's life.

p. 175 Reference to the Rosicrucians and their mysticism.

p. 175 The Sainte-Geneviève series = murals by Puvis de Chavanne.

p. 176 Hippolyte Taine (1828–93), critic, philosopher and historian; believed that physical and psychological factors were responsible for social and cultural development. He stressed racial inheritance, the environment and time as the essential factors.

p. 186 Jacques de Voragine (The Blessed Jacques de Verazze, 1228–98), author of *The Golden Legend*.

p. 188 Gasquet is wrong here; it is the Louvre self-portrait that Manet copied.

p. 196 Antoine-Louis Barye (1796–1875), sculptor and painter famous for his animals, especially lions, serpents and elephants.

p. 197 During the Paris Commune, Courbet was among a group of protesters who managed to pull down the column in the Place Vendôme.

p. 200 Théodore de Banville (1823–91), poet and dramatist with a remarkable facility for rhyming; wrote comedies, ballads and songs with irony and wit.

p. 203 Jules Vallès (1833–85), writer and journalist who took part in the Paris Commune of 1871 and was exiled to England. He returned to Paris and became a prominent left-wing journalist, denouncing injustice. He would have died 15 years before the visit to the Louvre described here.

p. 209 Félix Ziem (1821–1911), painter of Romantic landscapes of Venice and the East.

p. 209 Pierre Puget (1620–94), sculptor; presumably not the Puget referred to on p. 48.

p. 210 'Discourse on Method' (1637) by Descartes, propounding the theory of progress by deduction from the most obvious truths (known by intuition) to the most remote. 'I think, therefore I am' is the starting point which leads to the notion of infinity and the existence of God.

p. 210 J. K. Huysmans, influential art critic and novelist, author of the decadent novel *A rebours*.

p. 212 Georges Clemenceau, the great Premier of France who, at the age of 80, represented his country at the Versailles Peace Conference. His advanced left-wing and anti-clerical views made him antipathetic to Cézanne.

p. 213 Eugène Carrière (1846–1906), painter associated with the Symbolists; produced sensitive but somewhat blurry and monochromatic portraits, and studies of mothers and children.

p. 215 Homais and Bournisien are characters in Flaubert's novel *Madame Bovary* (1857). Homais, an apothecary, is a self-satisfied and pretentious purveyor of clichés. Bournisien is the priest whose attempts to give religious advice and comfort are mercilessly parodied.

Translations of Poems

p. 39 Inanimate objects, do you have a soul
That attaches itself to our soul and forces it to love?

p. 52 For in this lethargic world,
Always prey to old regrets,
The only logical laugh left
Is that of the dead.

p. 59 Lord, you made me powerful and alone,
Let me fall asleep in the sleep of the earth.

p. 156 Nothing is beautiful but truth, truth alone is the object of love.

p. 174 Paradise where there are harps and lutes . . .

p. 205 Painting with oil
Is quite difficult
But it is much more beautiful
Than painting with watercolour.

p. 207 Poetry always represents the depths of the heart.

Sources of Illustrations

Numbers refer to the pages on which the illustrations appear (t = top; b = bottom, l = left, r = right)

Aix-en-Provence: Musée Granet, Palais de Malte 47 (photo Bulloz), 49t (photo Bernard Terlay, Aix); Basel: Kunstmuseum 144; Copenhagen: Ny Carlsberg Glyptotek 108; Giraudon: 226; London: Courtauld Institute of Art 149 (Courtauld Collection); National Gallery 37, 133; Paris: Galerie Bernheim-Jeune 61; Louvre 77 (photo Giraudon), 98t (photo Giraudon), 117 (photo Giraudon), 129, 177 (photo Hirmer), 181 (photo Giraudon), 187, 189t, 189b (photo Réunion des Musées Nationaux), 193 (photo Giraudon), 194 (photo Giraudon), 195 (photo Archives Photographiques); Musée de la Ville de Paris, Petit Palais 66l, 66r, 67l, 67r, 199 (photo Archives Photographiques); Museé du Luxembourg 218t; Musée d'Orsay 6 (photo Giraudon), 73 (photo Giraudon), 87, 179 (photo Bulloz), 202 (photo Réunion des Musées Nationaux), 218b; Melbourne: National Gallery of Victoria 172; Merion, PA: Barnes Foundation 14, 49b, 53, 99, 103; Milan: Pinocateca di Brera 157; New York: Metropolitan Museum of Art 45 (H.O. Havemeyer Collection, Bequest of Mrs H.O. Havemeyer, 1929); Philadelphia: Museum of Art 79 (Wilstach Collection); Prague, National Gallery 2; Private collection 51, 58 (photo Bulloz), 69, 84, 92t, 93 (photo Réunion des Musées Nationaux), 101 (photo courtesy Christie's), 127t, 127b; J. Rewald 126b; San Antonio, TX: McNay Art Institute 207; São Paolo: Museu de Arte de São Paolo 92b (photo Giraudon); Stockholm: Statens Konstmuseer 219; Washington DC: National Gallery of Art 98b (Gift of the W. Averell Harriman Foundation in memory of Marie N. Harriman), 135 (Gift of Eugene and Agnes Meyer, 1959).

Index

of artists and writers who influenced Cézanne
or otherwise figured in his life